Martyn Goddard

BLONDIE IN CAMERA 1978

ACC ART BOOKS

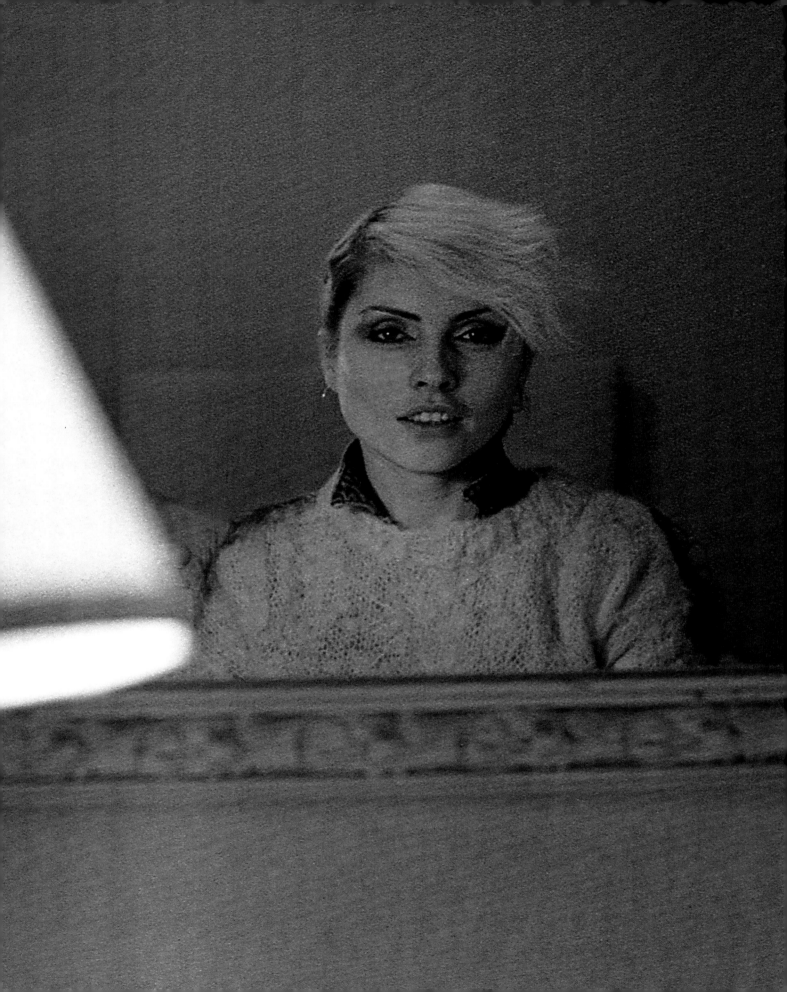

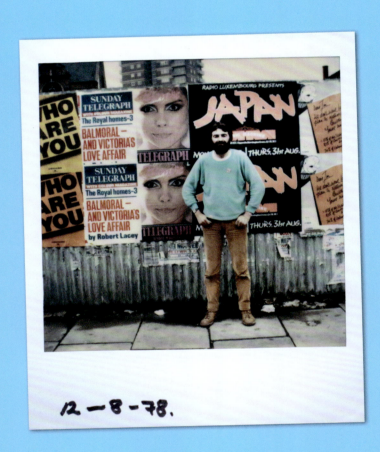

12-8-78.

CONTENTS

1. DESTINATION: NEW YORK —— 10
2. 'WELCOME BACK BLONDIE' —— 16
3. POLAROIDS AND GOLD DISCS —— 46
4. SHOOTING AT THE GRAMERCY HOTEL —— 58
5. NEW YORK STREETS —— 88
6. 'BLONDIE IS A GROUP!' —— 104
7. RECORDING VOCALS —— 138
8. LIVE AT THE SPECTRUM —— 152
9. BLONDIE IN CAMERA —— 202
10. LEGACY/POSTSCRIPT —— 228
11. PICTURE CAPTIONS —— 238

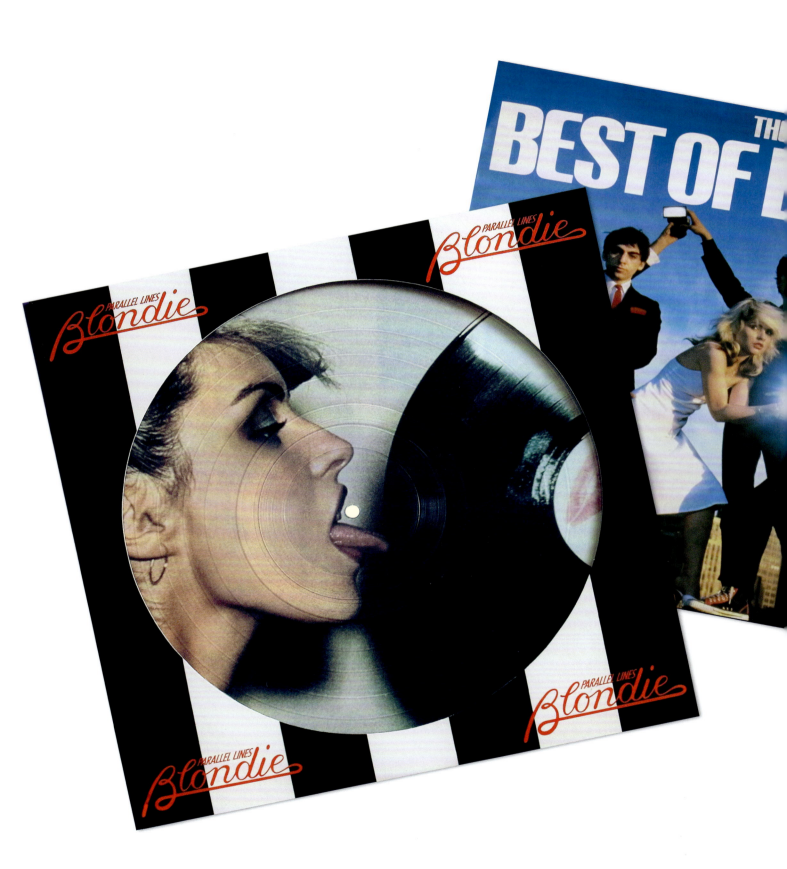

When I boarded the plane in May 1978 to photograph Blondie's lead singer Debbie Harry in New York, I could not have conceived that there would still be a demand for my images 45 years later. This was confirmed when, at a book signing in London 2016, a man purchased a book to sign and asked if I had shot the photo of Debbie Harry licking the white label vinyl record with the kiss. I replied, 'yes, indeed'. He said, 'I show that image to every band I sign'. He was Craig Kallman, CEO of Atlantic Records. That image was taken on my first visit to the Big Apple for my first major photo assignment for *Telegraph Sunday Magazine*. Over a period of four months, I worked on four major assignments with Blondie, which produced a body of work that resulted in magazine cover stories, album and single covers, tour programmes, posters and a photo exhibition. The year 1978 also marked the transition of the New York punk group from cult band to mainstream with their album *Parallel Lines*' chart success and later, their single 'Heart of Glass' reaching number one in the charts. From then on, Blondie had tracks played on FM radio and slots on national TV shows, which promoted headline tours both in the UK, Europe and USA. This book is my visual record of 1978, along with my recollections of working with such an important rock band at a seminal time in their history.

MARTYN GODDARD

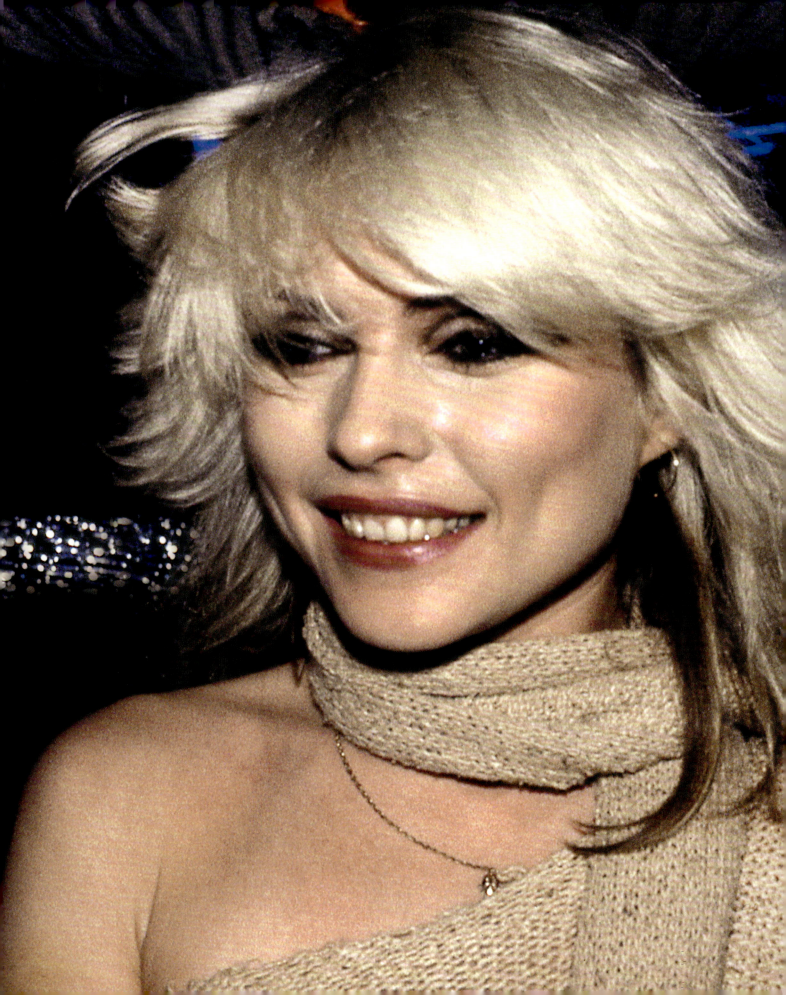

What I remember most about Martyn was his use of light. A fundamental talent needed by photographers. When shooting with him at the Gramercy Hotel in New York City (where Chris and I were living since our apartment had burned down), we were permitted to use a rooftop suite that was not a part of the hotel's usual rentals. It was full of light and Martyn took great pains to capture these brilliant moments of me in a Halston dress, as well as other shots at this location. He liked shooting on rooftops in NYC and wasn't concerned as much with studio lighting, though he did use additional accent lights as well. It is not easy shooting groups and achieving getting everyone in focus at the same time. Martyn's patience worked magic and we ended up with beautiful photos and artwork. Martyn used a hand-held flash that was triggered by the camera in the group shot which I was holding. We worked the rooftop magic light show to perfection with Mr Goddard. Blondie never looked better!

YOURS, DEBBIE

1 · DESTINATION: NEW YORK

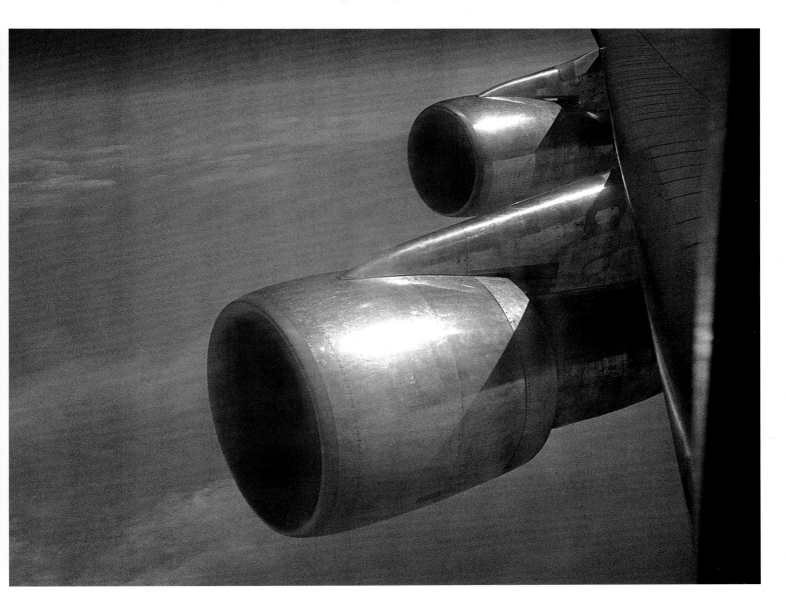

In January 1978, my career as a freelance photographer was gaining momentum. After graduating from Harrow College of Technology and Art in 1973, I was asked if I would like to work as a freelance assistant to celebrated music photographer Gered Mankowitz. I took the job, which turned out to be a smart decision as it gave me the opportunity to see how working in the real world of rock 'n' roll played out; how to deal with artists, managers and record companies. What's more, Gered was well-versed in all the techniques of cinema and big stills productions. As he wasn't interested in shooting live bands, I was sent out by the studio to shoot the odd concert. I was never going to stay in the Soho studio setting up lighting and loading film backs, hence in 1974, I took the plunge as a rock photographer. I soon realised that my portfolio was somewhat limited, so I started targeting the teen magazines on the bottom shelf of WHSmith's newsstands. *Fab 208* was one such magazine. It was packed with pop-music stories and, because of its association with Radio Luxemburg, it had access to all the latest pop stars. While they had their own photographer, they often needed cover when he was away. That's when I got the chance to shoot groups, from the Bay City Rollers and Showaddywaddy to Chuck Berry and Queen.

It was in Birmingham in 1974 that I took a set of images of Queen, using cinema multi-prism lenses that, in conjunction with the band's amazing light show, produced a set of fantastic images. I showed these to John Reid, Queen's manager, which resulted in a special Queen poster magazine and bookings to shoot a series of the band's stadium gigs. This lit the blue touch paper, and assignments and bookings at our Kensington Church Street studio came flooding in from record company art directors and band managers. This was the time of punk and New Wave, and I shot album covers for The Jam, Sham 69 and The Cure. I had also taken my portfolio to *Telegraph Sunday Magazine*, who risked booking me to shoot some features.

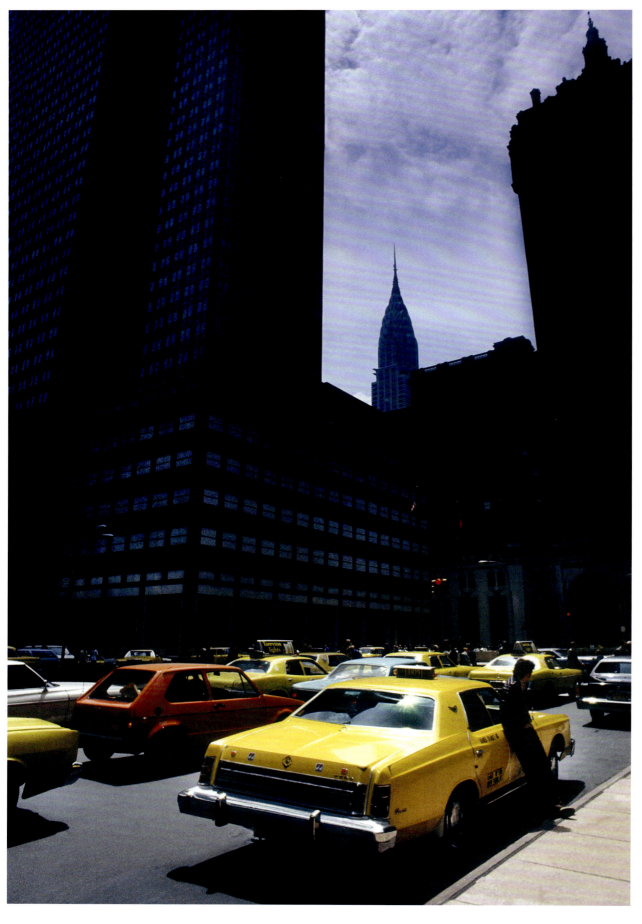

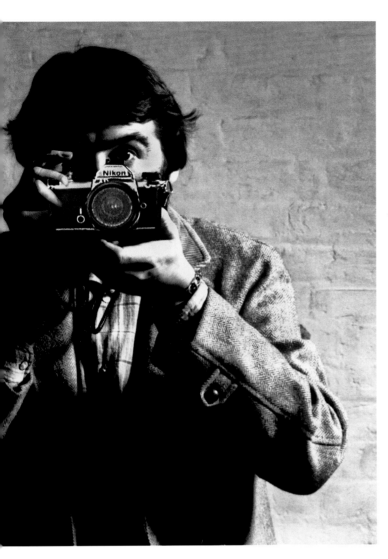

By early 1978, I had a good working relationship with picture editor Alex Low and art director Geoff Axbey, so over lunch at The Cartoonist pub on Shoe Lane, I pitched the idea of photographing Debbie Harry, the lead singer of New York punk band Blondie. 'She would make a great cover story', I suggested, after showing them an *NME* feature. After Low and Axbey agreed to pitch the idea to the tyrannical editor John Anstey, I then contacted Chrysalis to see if Blondie would be up for the project. I secured the assignment mainly by offering to fund my own flight, with the record company picking up hotel expenses. The magazine didn't promise a cover but would wait to see what I delivered.

The editor's brief was to shoot Debbie Harry for a cover story to be published in *Telegraph Sunday Magazine*. This was my first visit to New York, and I was to spend a week with the band, staying in the Gramercy Park Hotel where the group were in residence. I remember sitting in the back of a banana yellow, beat-up taxi en route from JFK airport to the hotel. As I was crossing the Queensboro Bridge, taking in my first view of the Manhattan skyline, I was pinching myself, checking this was all really happening.

My chequered cab headed south on Lexington Avenue to the Gramercy Park Hotel, which looked like it had seen better days. Little did I know of its bohemian reputation and past guests, however, which included Bob Dylan, David Bowie, The Clash and – this month – Debbie and Chris, who were staying there as they were homeless with no apartment after being on tour. While recovering from my flight in the hotel bar, the barman told me it was the place bands stayed at on their way up and on their way down. After I had said hello to Chris Stein and Debbie Harry in their suite, I savoured a beer, while planning my shoot. You could fly with a reasonable amount of luggage back then and I had planned to build a studio in their hotel room for *The Telegraph* portrait shoot later in the week.

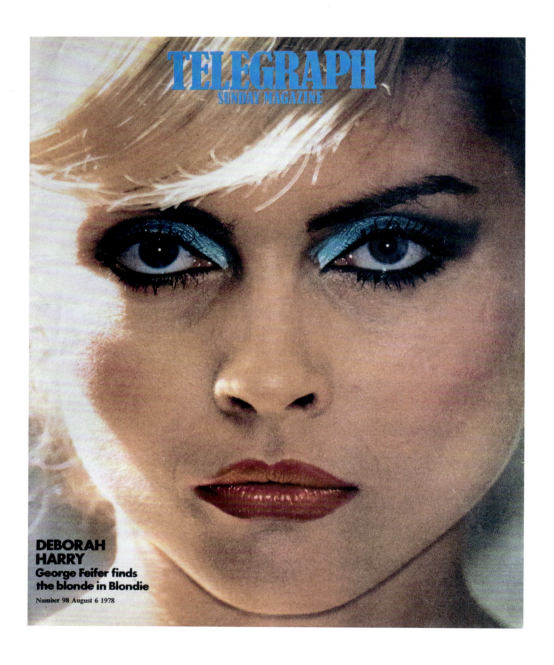

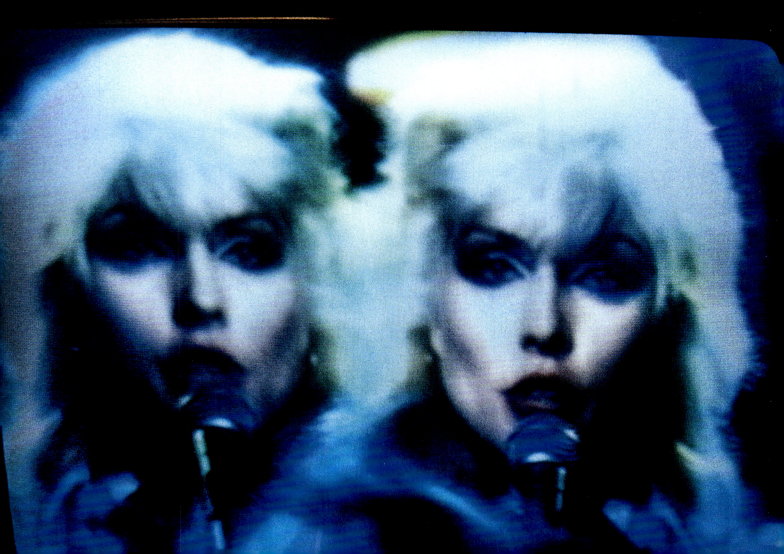

2. 'WELCOME BACK BLONDIE'

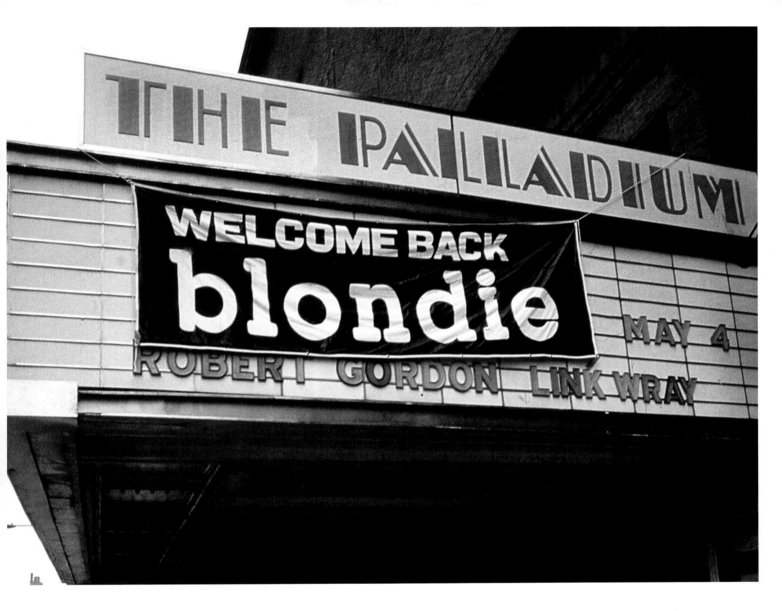

The morning of the 4 May, I met up with the band and we talked over what I hoped to achieve, with Chris Stein laying on his bed and Debbie having a late breakfast sitting at her dressing table. They suggested a schedule but first up was the 'Welcome Back Blondie' gig and party at The Palladium theatre. The venue was packed with the likes of New York punk royalty David Johansen of the New York Dolls, as well as Terry Ellis of Chrysalis Records. Still suffering with jet lag, I was hustled into the band's limo, then backstage for the sound check. There was a buzz as a member of the crew broke the news that the Sex Pistols had split up that day.

Sound check completed, I went outside to shoot the buildup to the show. A 'Welcome Back Blondie' banner had been hastily strung up and a couple of Hollywood searchlights scanned the sky as fans filled the venue. The show was opened by Robert Gordon and Link Wray, followed by the headliners. Blondie hit the stage with opener 'X Offender'. I only shot a couple of rolls of film at the show as I was convinced The Telegraph would not be that interested in live shots, and I wanted to conserve film stock for the photo sessions later in the week. The show ended and I tagged along with the band in their limo to a Manhattan loft party. Out came my Minox pocket camera to shoot Dave Edmunds, Nick Lowe and Andy Warhol as I mixed with the glitterati, way out of my comfort zone, managing to hide safely behind my camera. Talk, talk, talk and a few drinks later, I took a taxi back to the hotel.

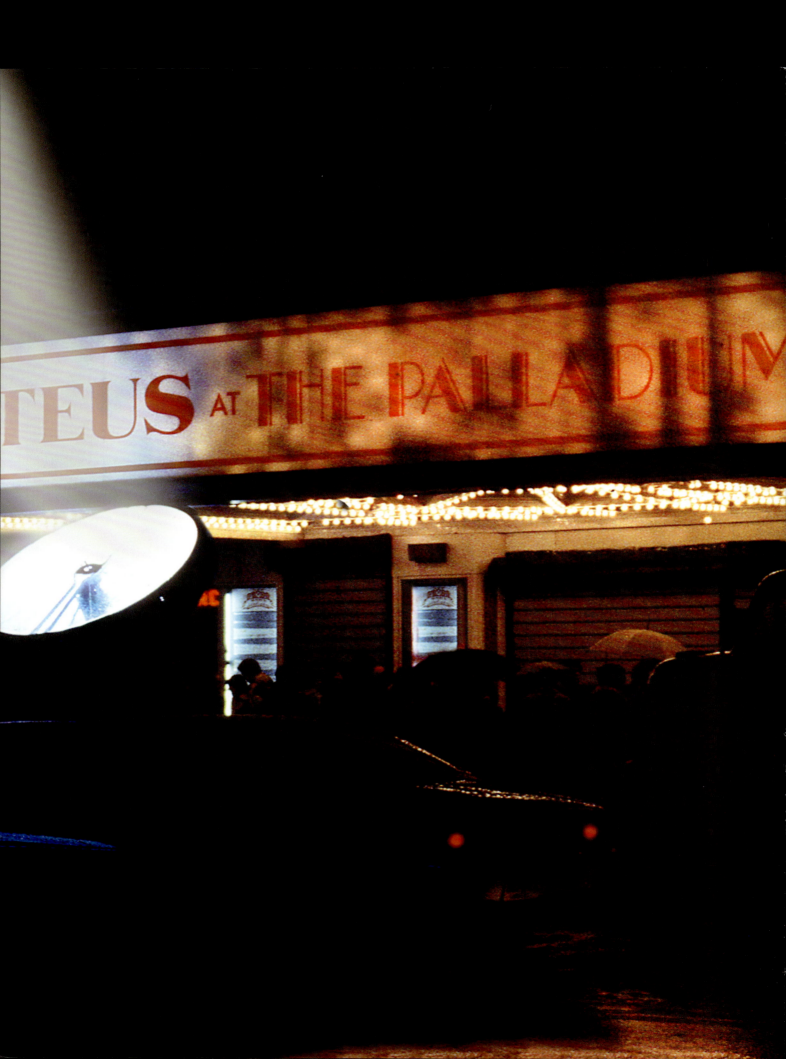

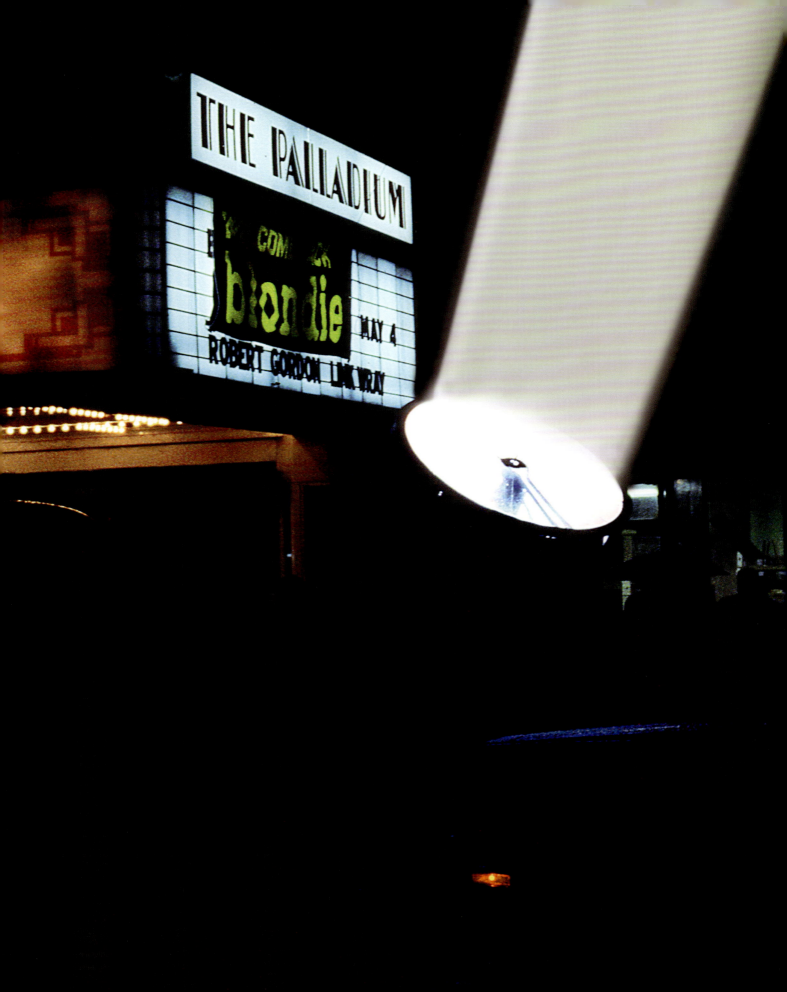

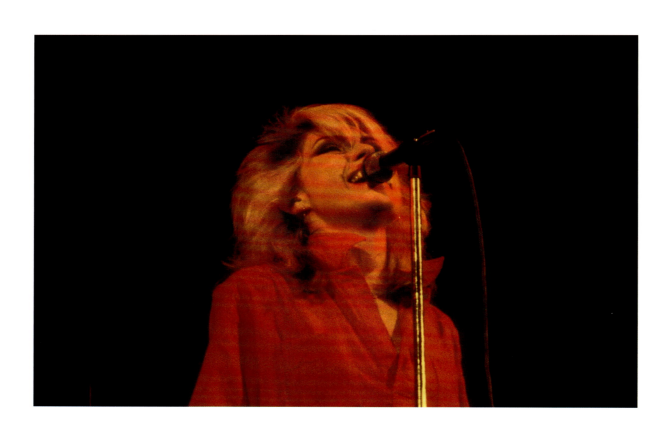

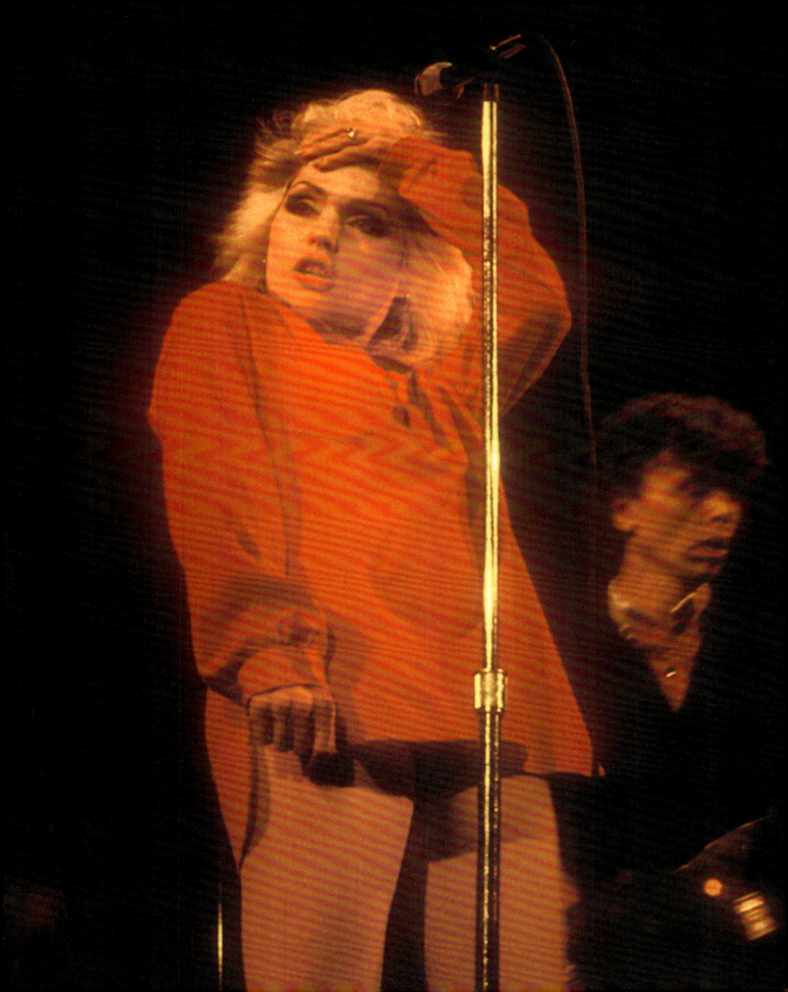

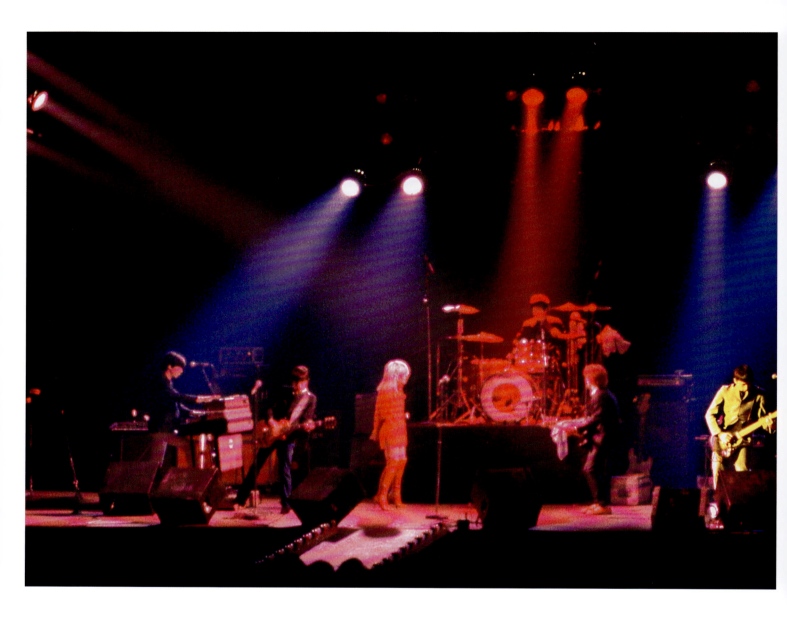

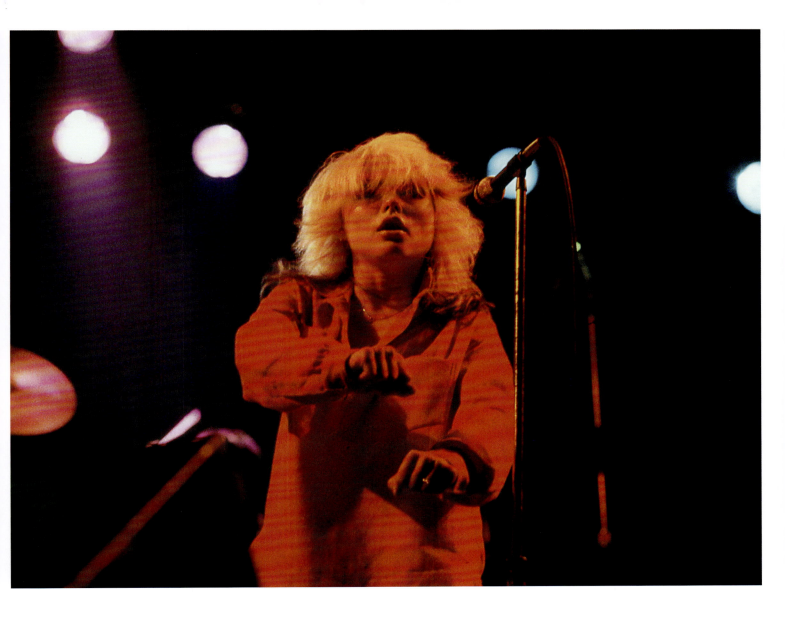

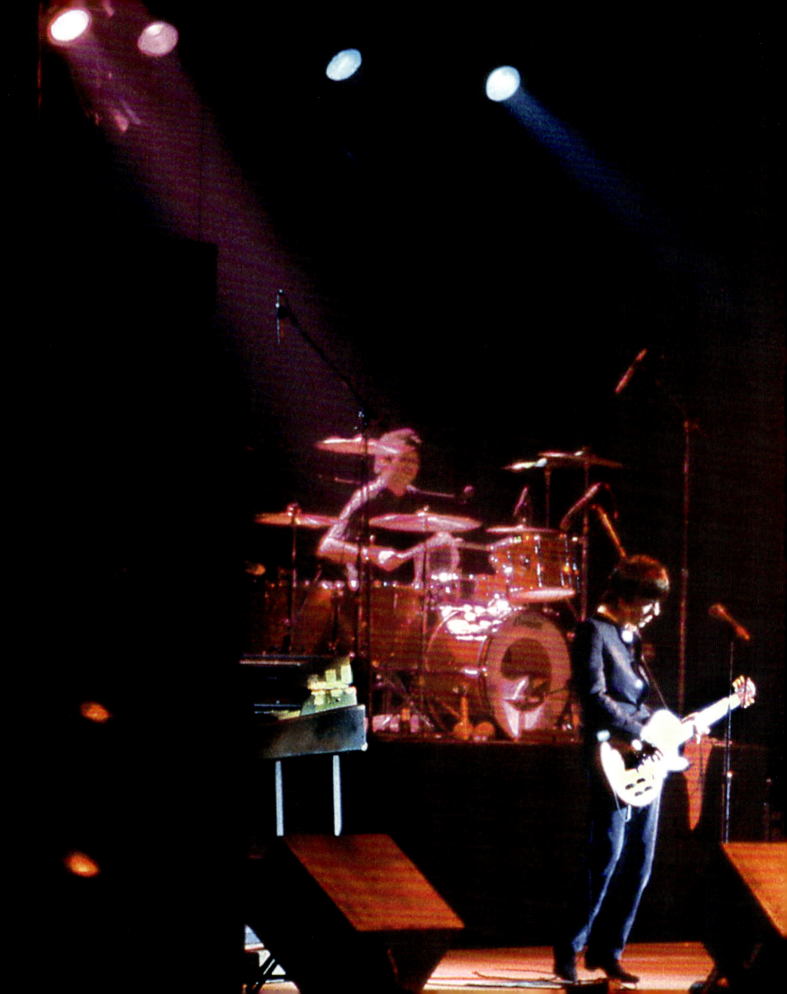

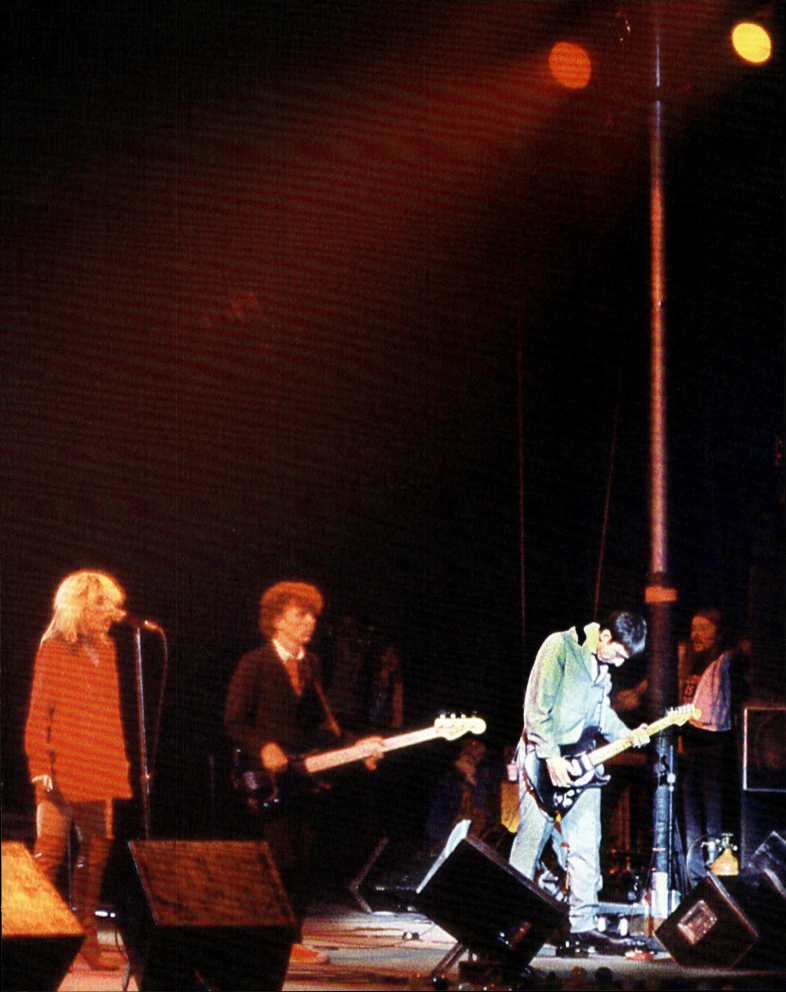

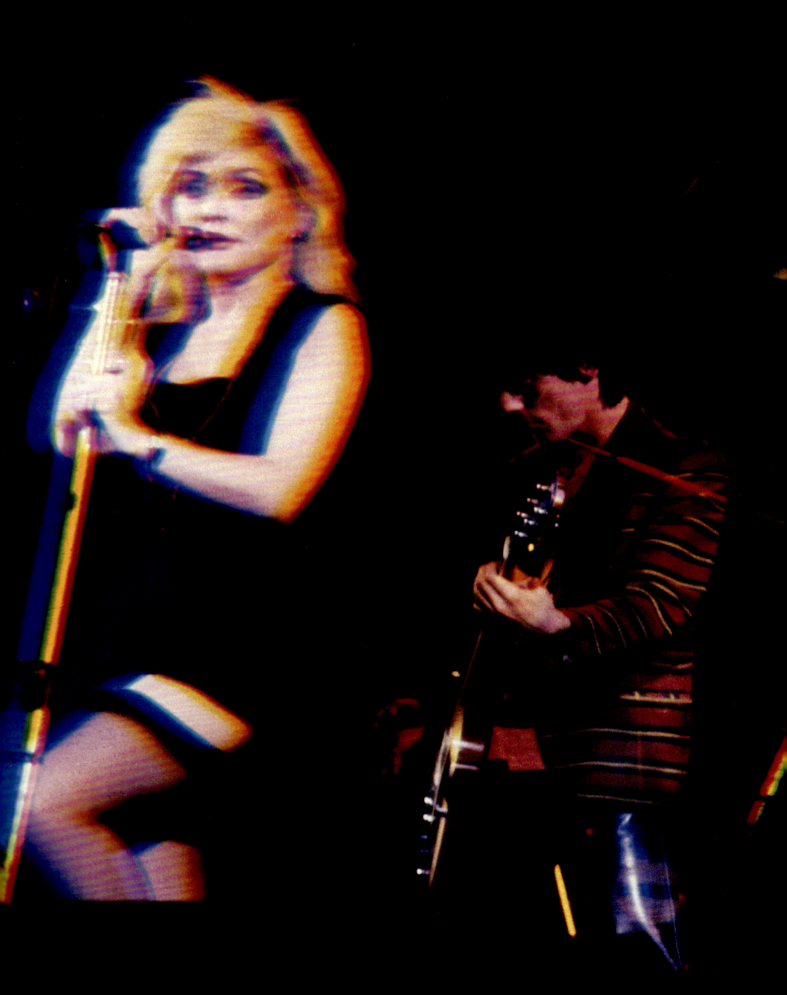

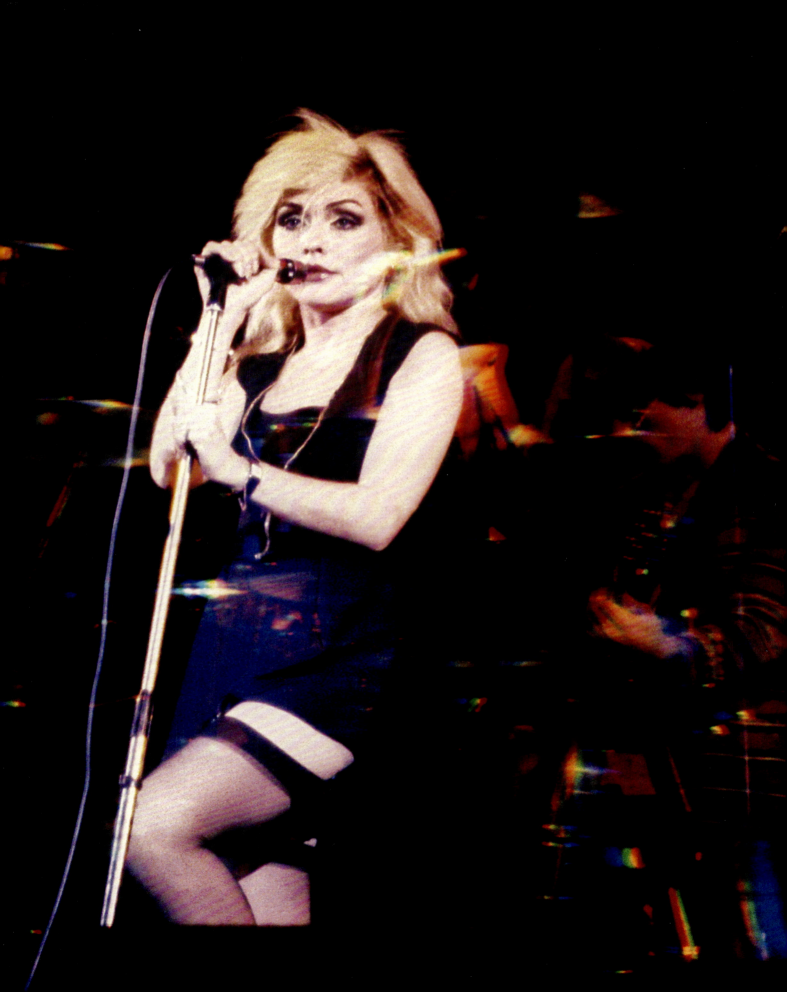

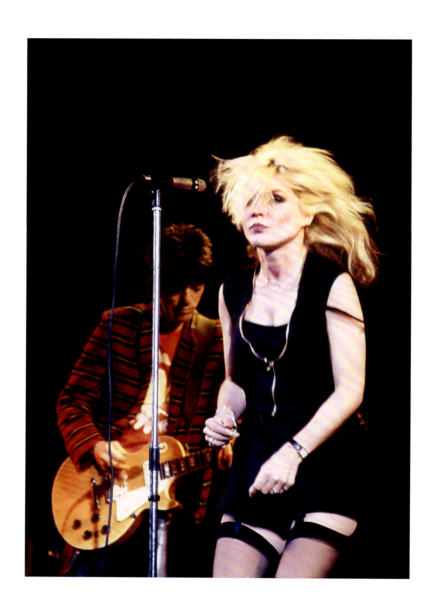

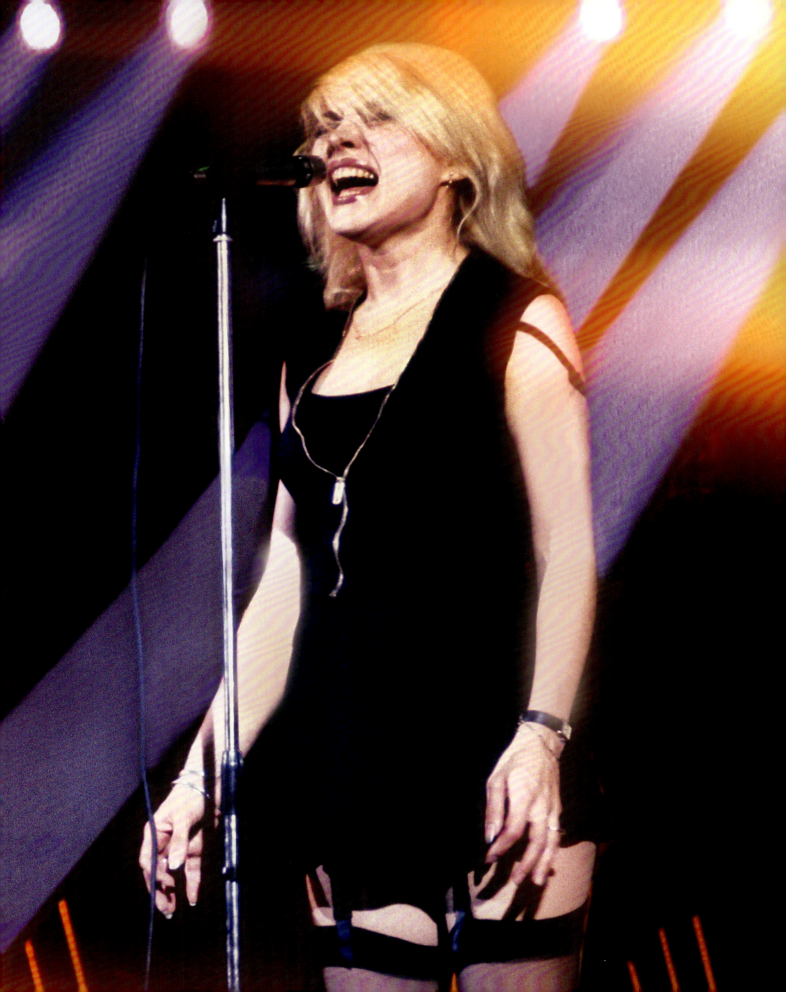

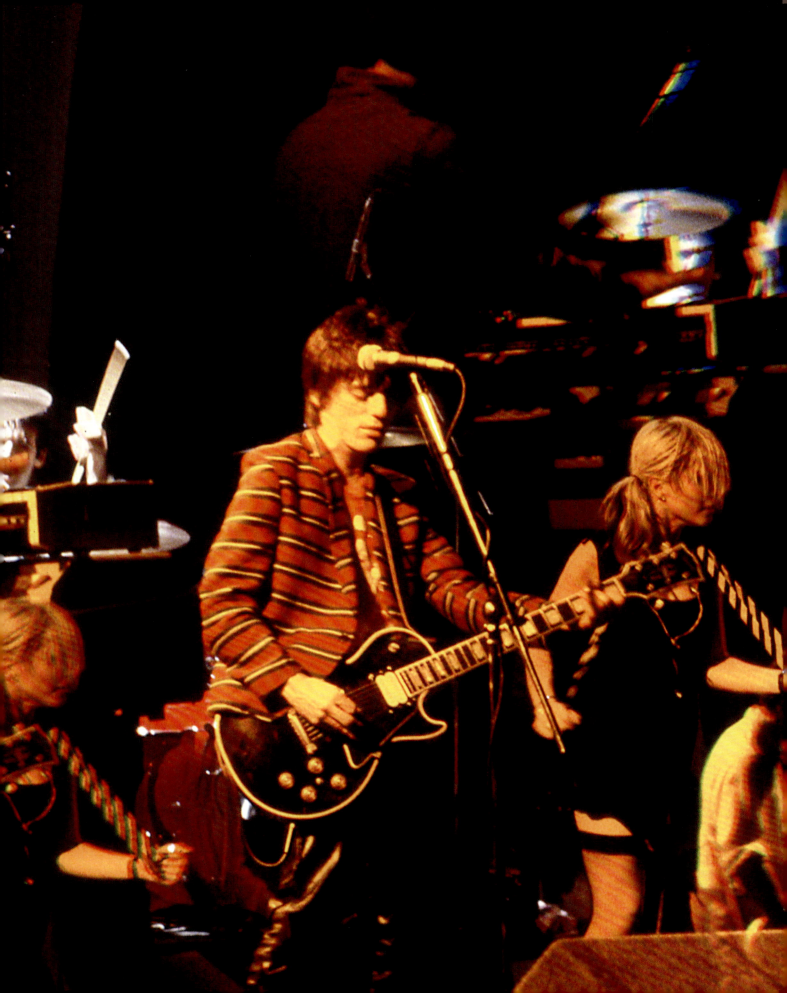

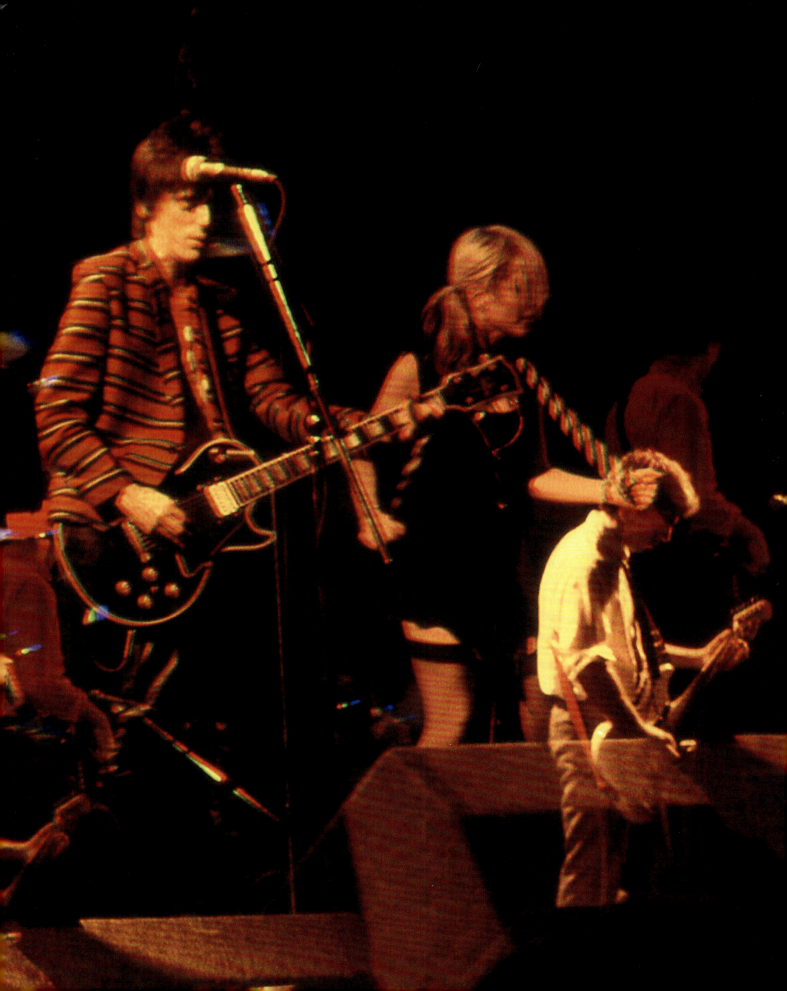

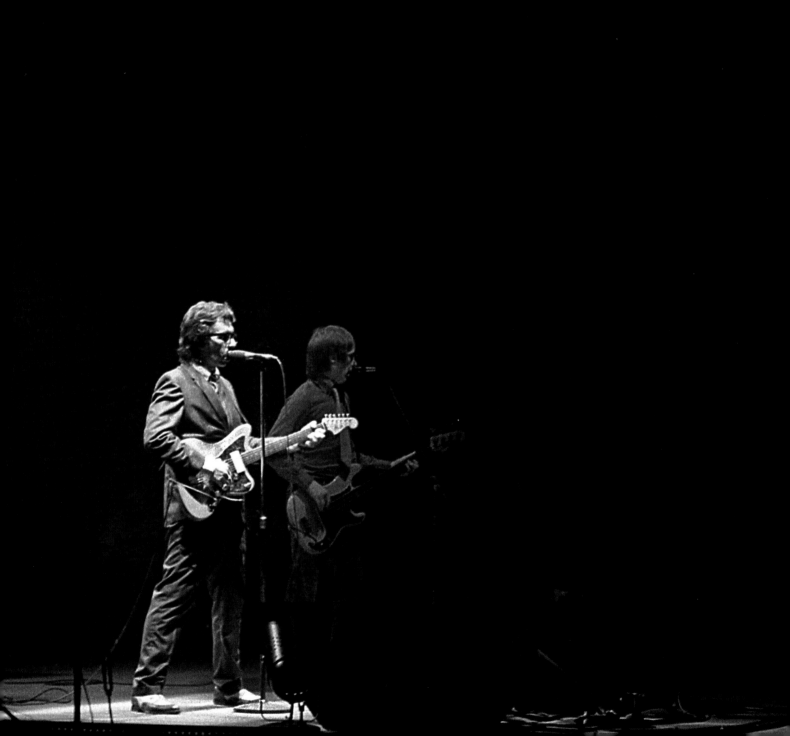

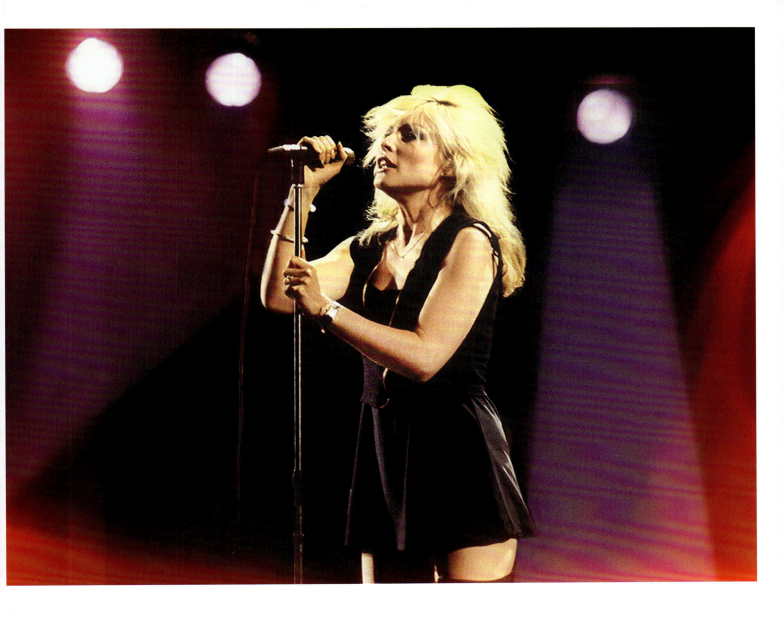

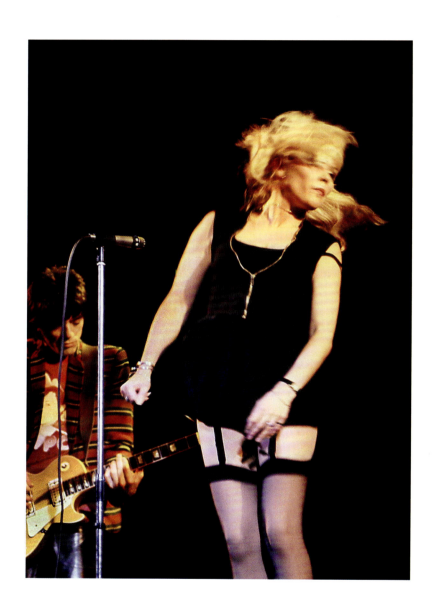

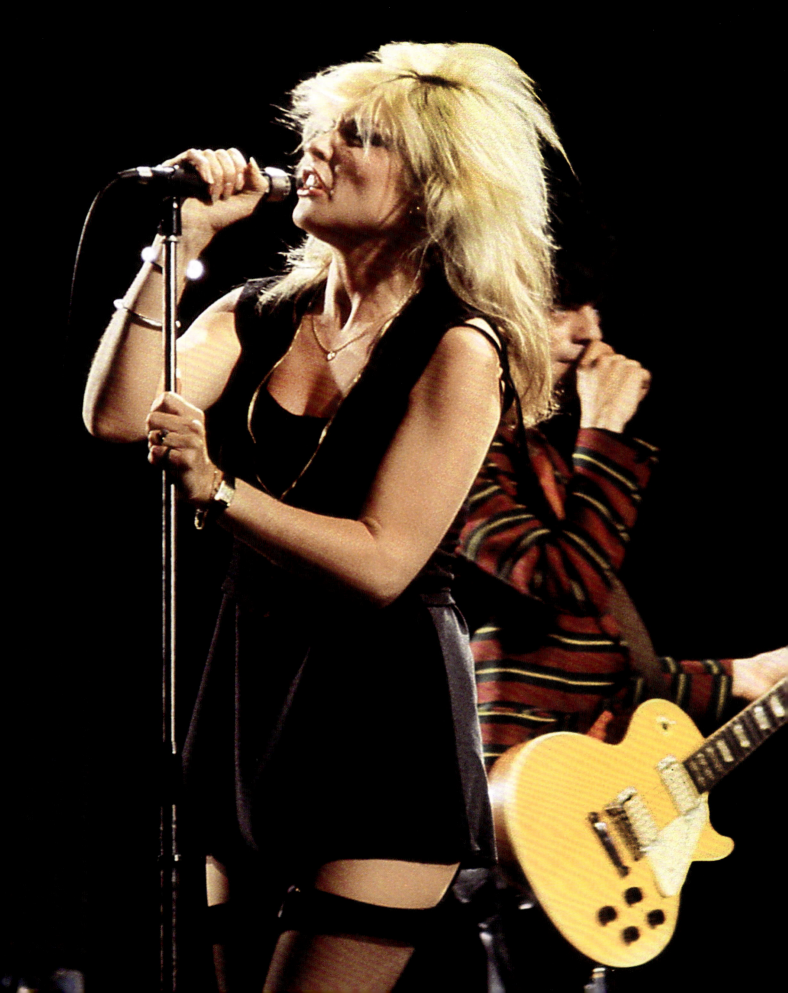

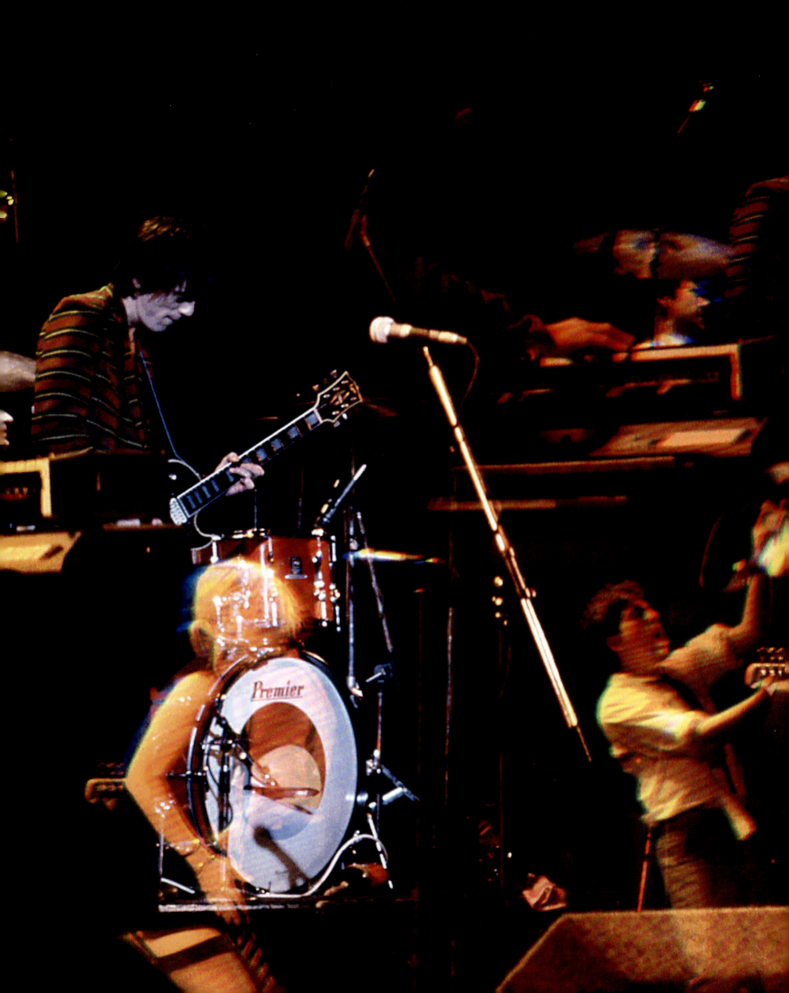

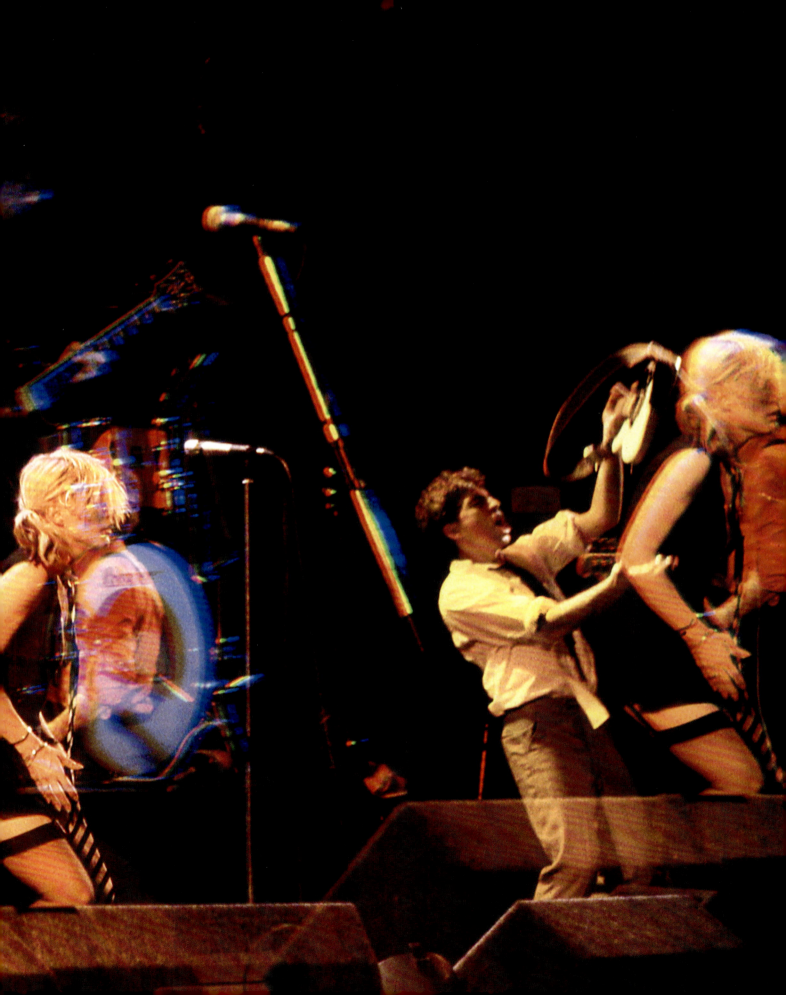

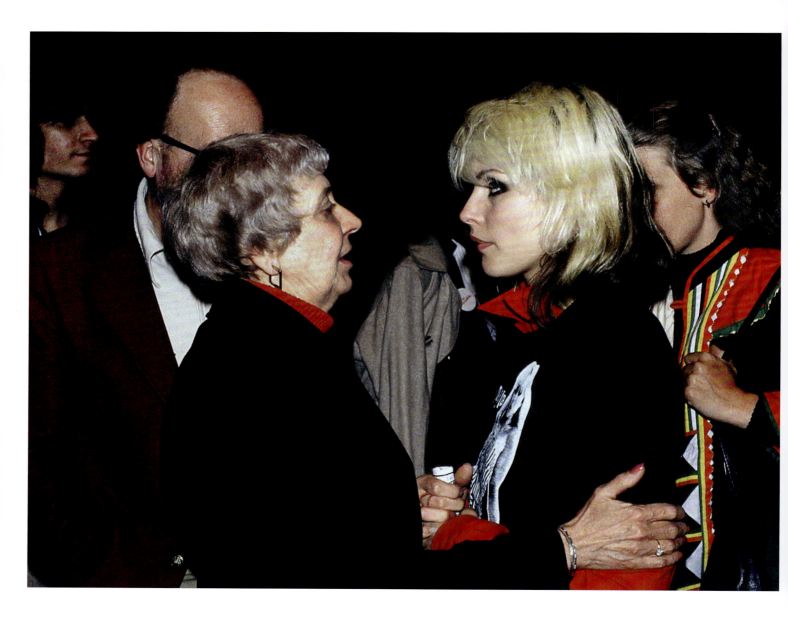

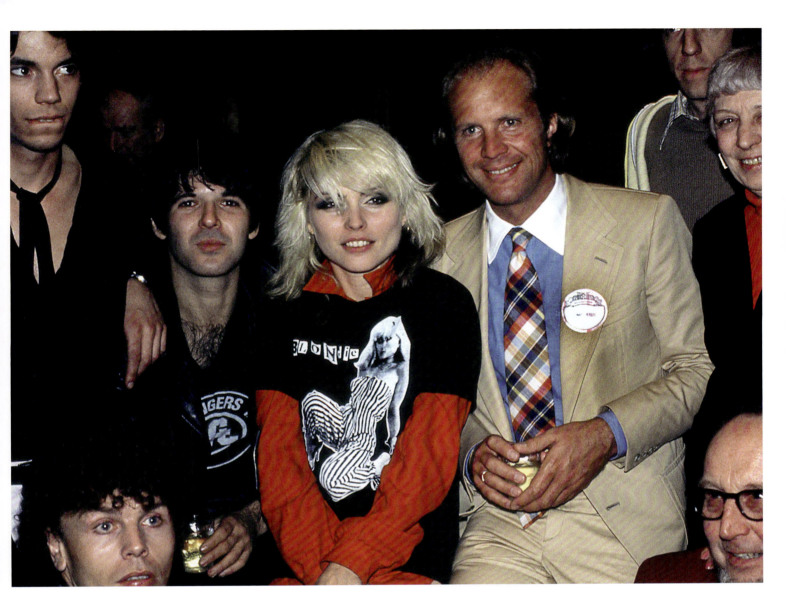

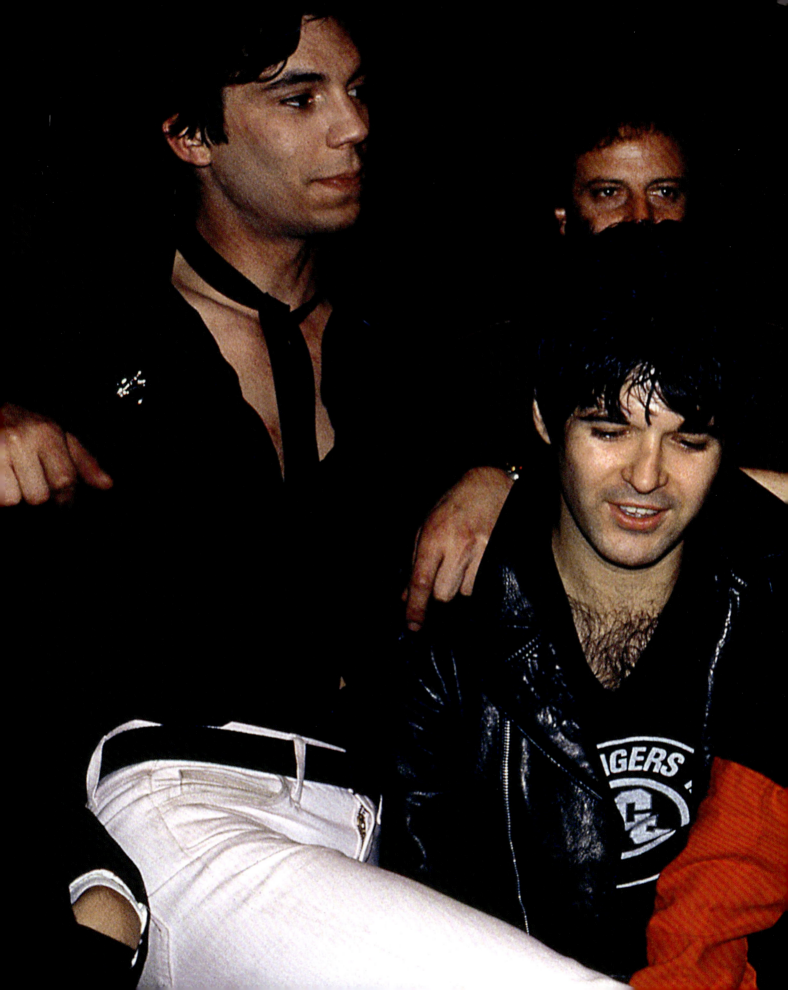

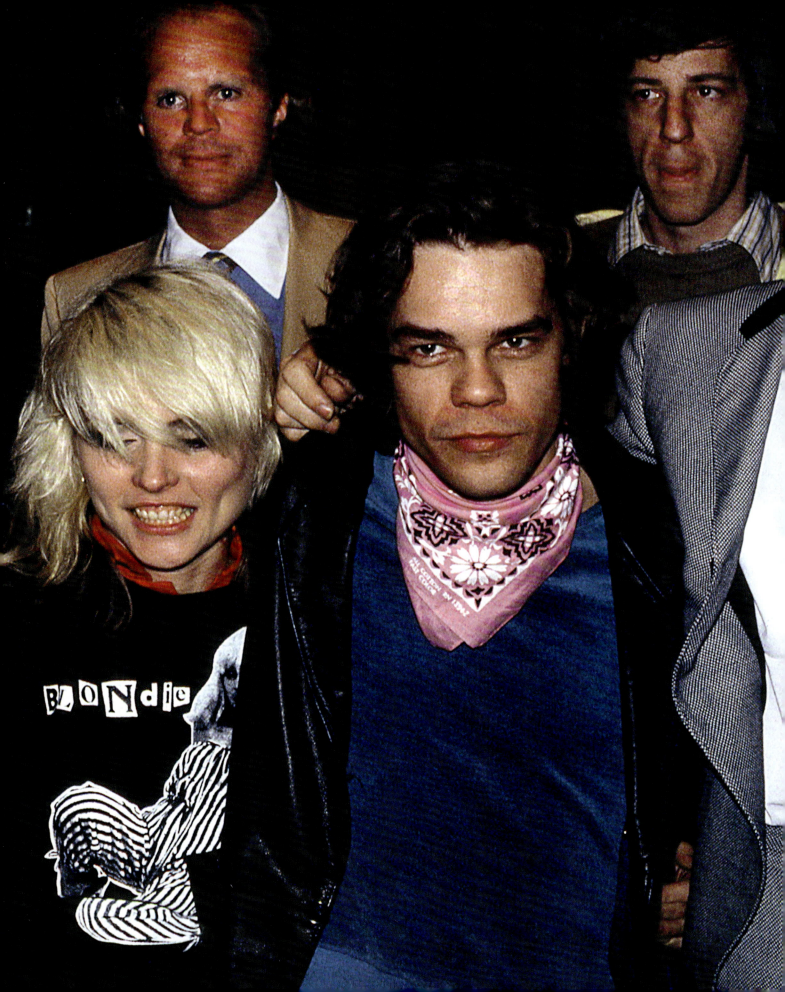

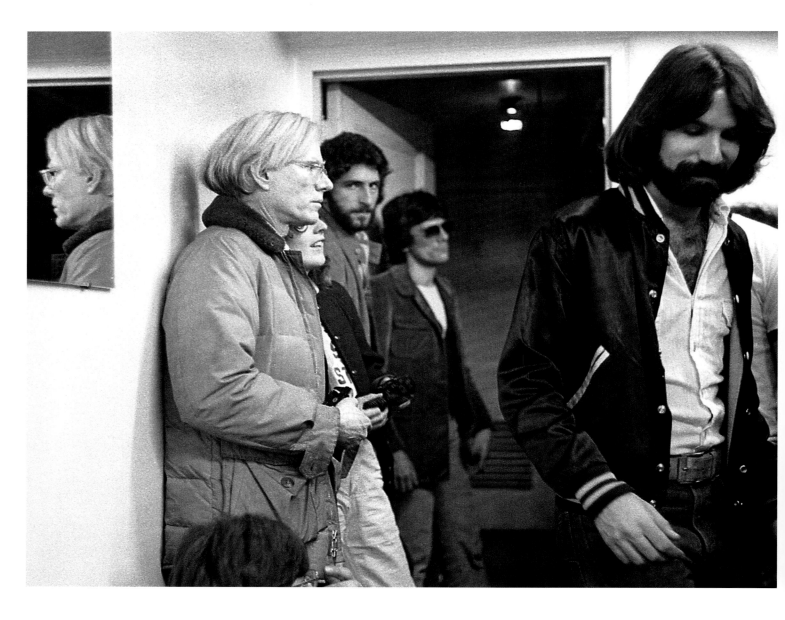

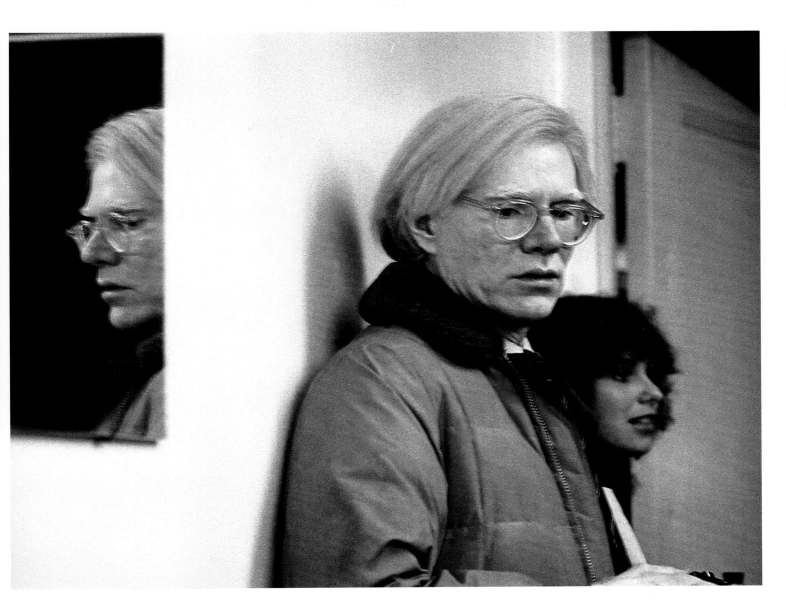

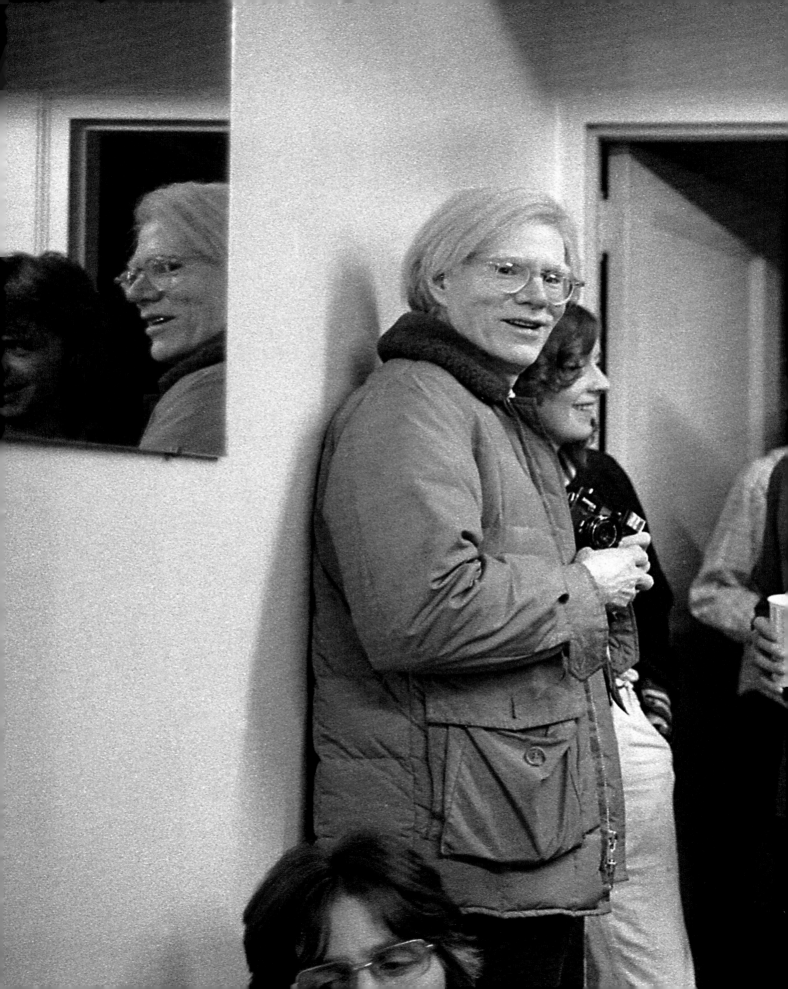

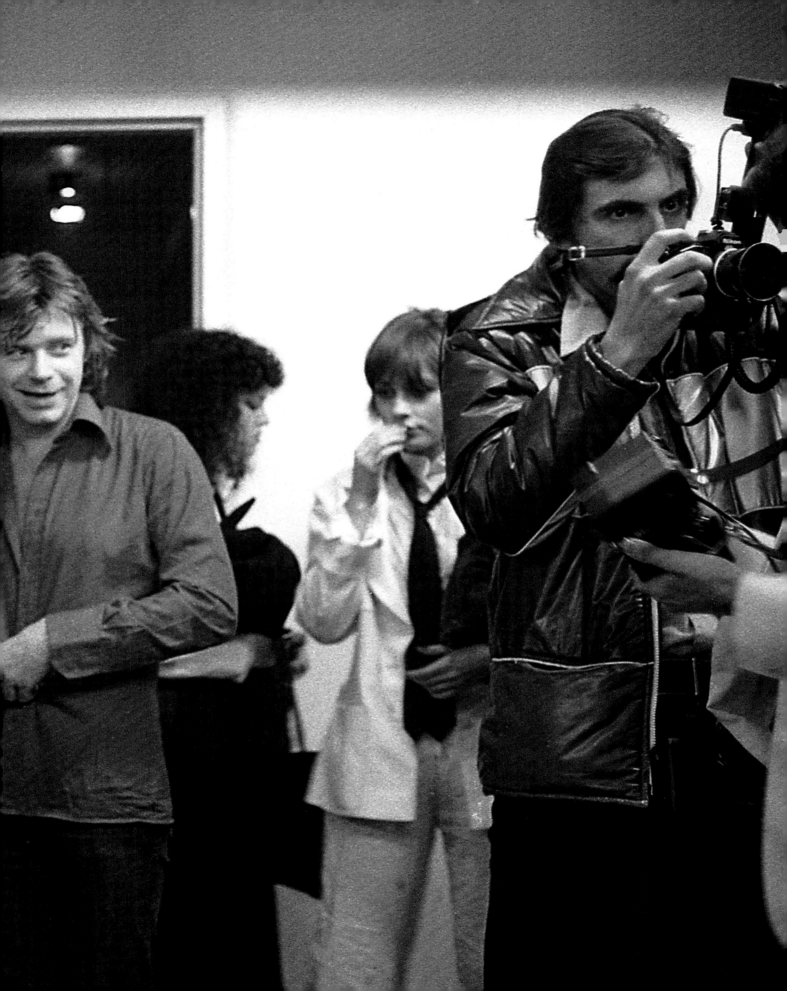

3. POLAROIDS AND GOLD DISCS

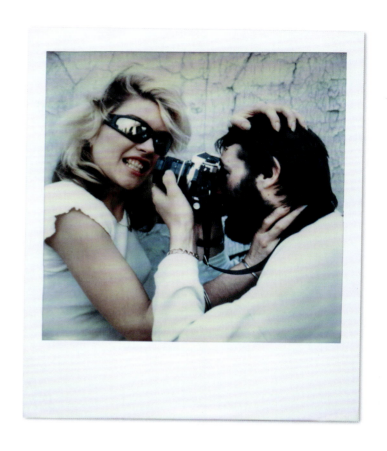

Early Friday morning, I was walking the streets of the Lower East Side, soaking up the street life around Union Square. I knew there was no chance of Chris or Debbie wanting to see this Brit photographer until after midday. I walked miles, block by block, shooting Polaroid SX70 instant prints and looking for locations that might be useful for my *Telegraph* shoot. I always pre-planned shoots with my subjects in order to deliver unique images, so I would research the artist and locations the best I could, as well as delving into magazines and books to spark a visual idea. I had arrived in the USA with a white-label vinyl LP as a prop for the Debbie Harry portrait and a set of flash slave triggers, vital for the roof-top shots. I had also visited the record company offices to look at promo videos of the band as I had missed their notorious Dingwalls gig which had been right on my doorstep in Camden Town in January 1978. I have the ability to see all my photographs in my mind, which I put down to my dyslexia, so I work back from the vision, working out what I need to do to produce the finished image.

Back at the hotel, I had a message to meet Debbie and Chris in their suite. I took my time to look around the hotel for locations and came across a shabby, disused cocktail bar, which had a roof terrace looking towards the Chrysler Building and the New York City skyline.

I had a cluster of locations that were only a two-minute elevator ride from Debbie's hotel suite. On arrival, there was Blondie's entourage watching cable TV and reading reviews of last night's gig. I was able to talk through what I had planned for the shoot and persuade Debbie that the British hairdresser I had asked to style her hair would be okay. My aim was to give Ms Harry the full glam treatment. On reflection, it was playing with fire because it could have gone horribly wrong, and I could have returned home empty-handed. With the shoot set for the next day, Saturday, it was back in the limo en route to the presentation of gold discs for hit single 'Denis' and their album *Plastic Letters*, hosted by Chrysalis Records at the Copacabana club. I manage to squeeze between the local paparazzi to shoot images of the strange mix of punks, corporate suits and the press, before being whisked off with the band to Studio 54. Wow, what a club! It was in an old theatre boasting a light show every bit as good as a Queen concert. Debbie and Chris had hooked up with actor Tony Curtis and friends in his booth, and despite the pulsating disco anthems and troops of revellers on the dance floor, they appeared to be managing a conversation. As for me, my head was spinning with ideas for my big shoot the next day, so I took a cab back to the hotel.

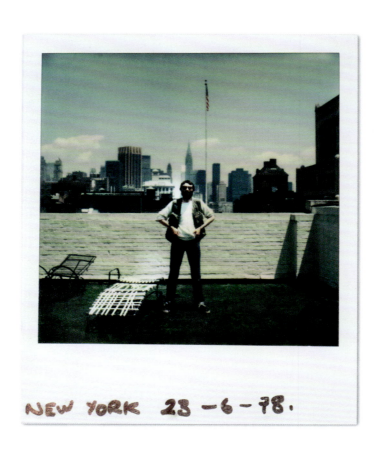

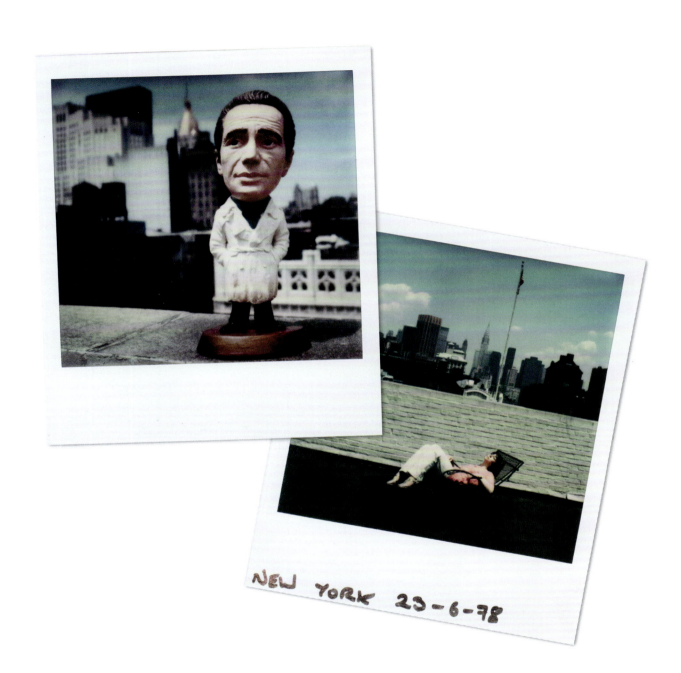

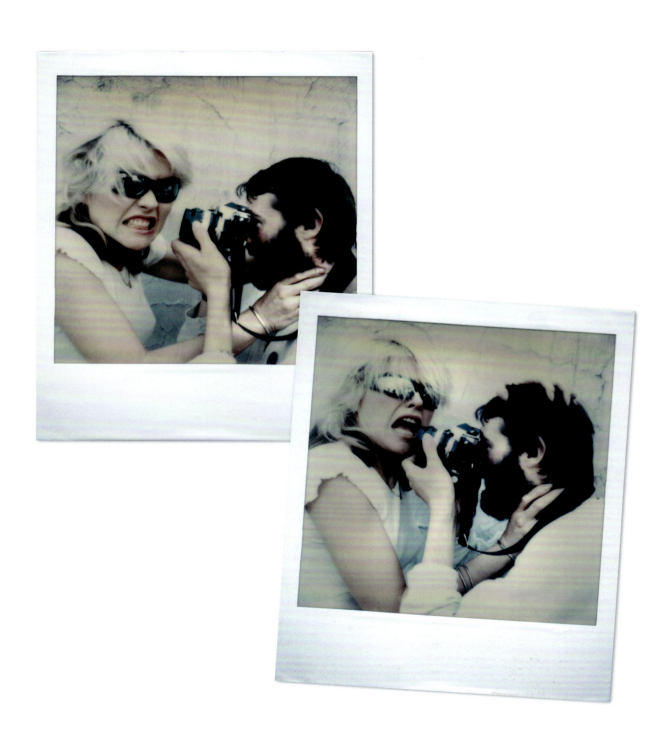

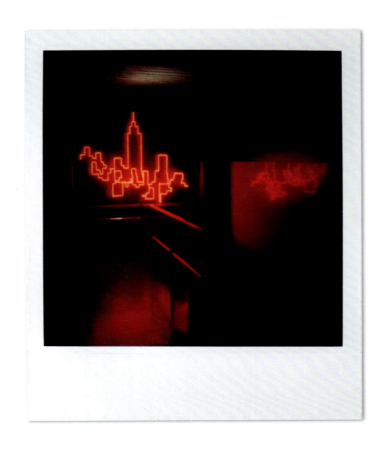

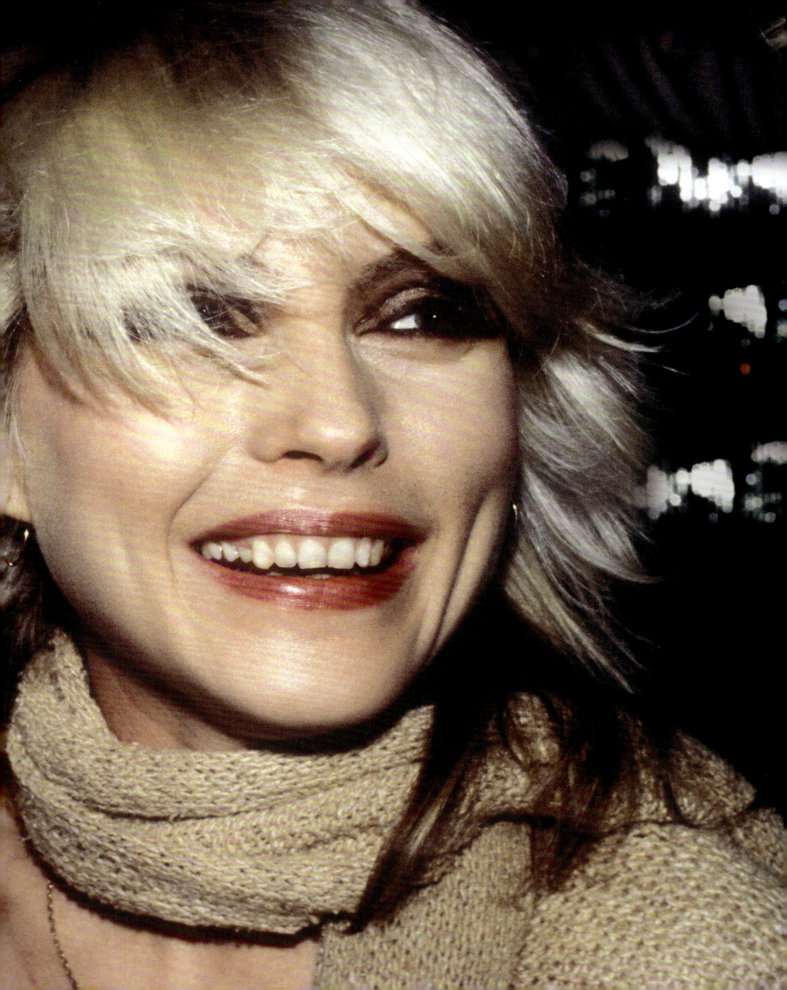

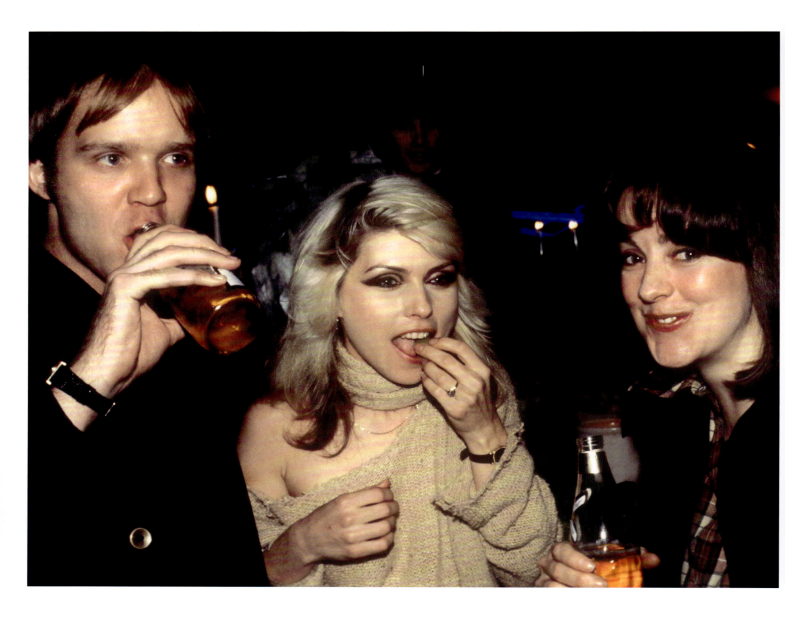

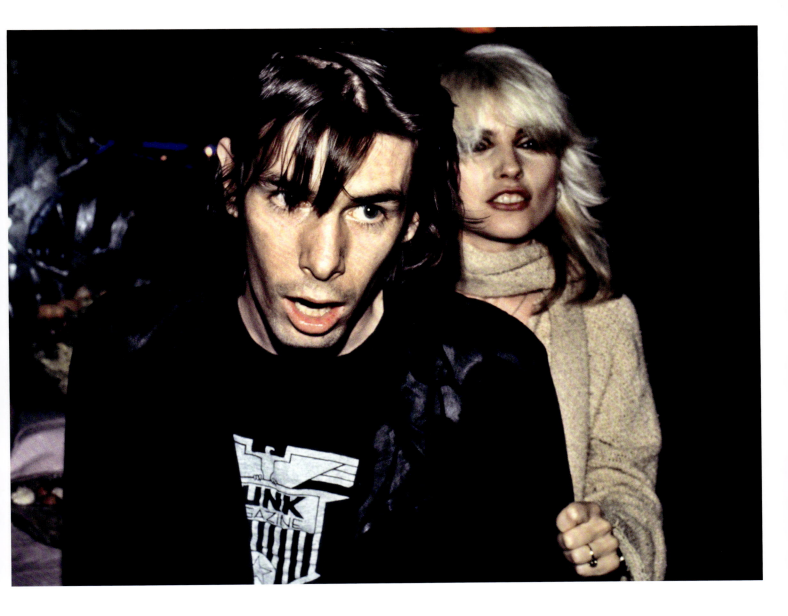

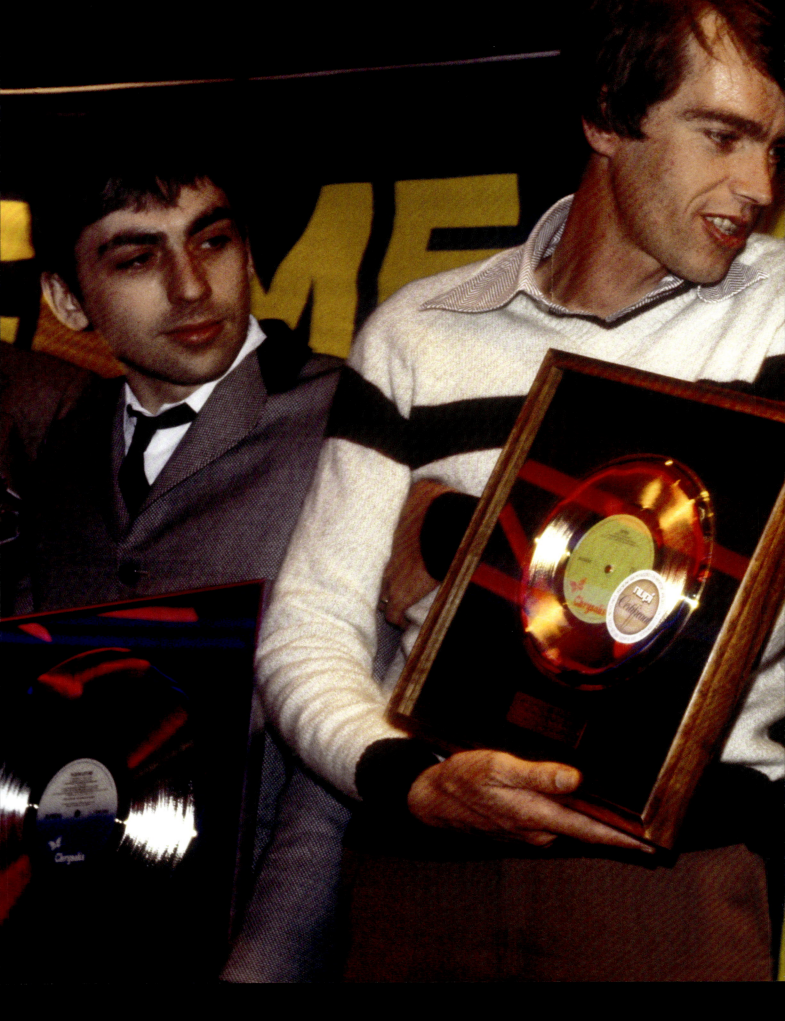

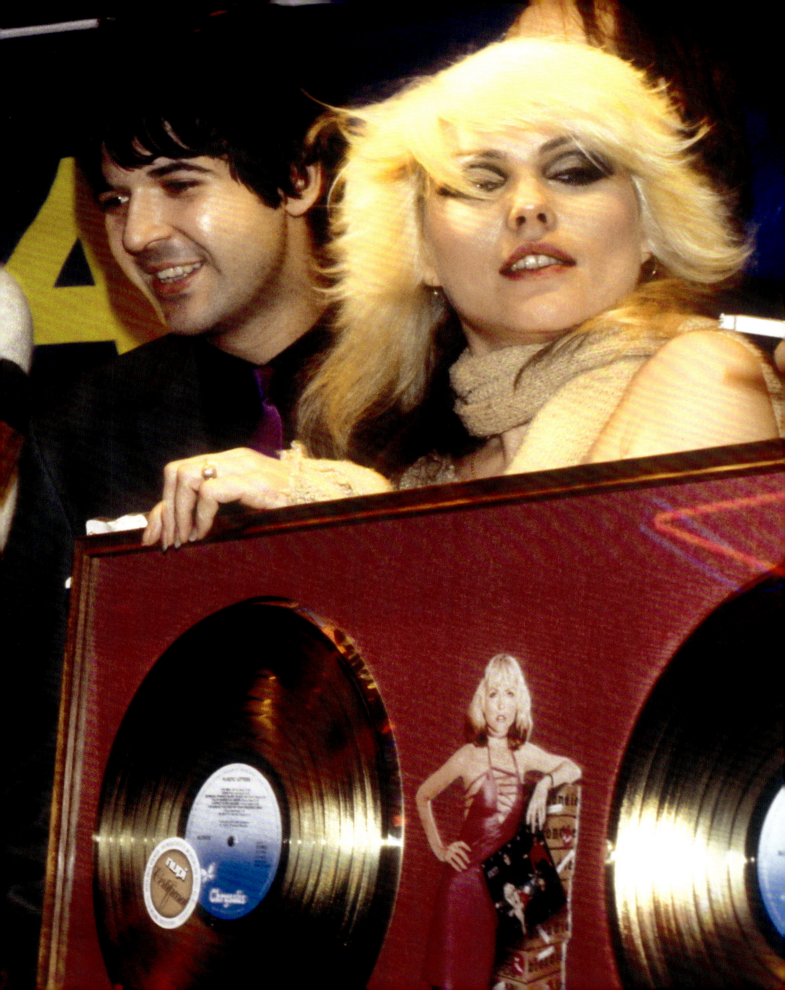

4·SHOOTING AT THE GRAMERCY HOTEL

It was raining on Saturday 6 May. Nevertheless, I spent the morning once again walking around Midtown Manhattan, killing time before the shoot, which was set for 3pm. Before leaving London, I had asked London hairdresser Gregor Schumi, with whom I had worked on The Jam's *In the City* album cover, if he might be able to style Debbie's hair, as I knew he was working at New York Fashion Week. While I was rigging up a makeshift studio in the sitting room, and Stephen Sprouse was in attendance talking over the look with Debbie as she made herself up, Gregor worked his magic. There was a slight hiccup when Debbie began worrying about her split ends, but the smooth-talking hairstylist, who was used to working with top catwalk models, soon persuaded her that all would be fine. He went to town on the hairstyle and, despite some early apprehension, she agreed to the high-fashion look, completed with a Halston designer dress. The studio sitting room was cleared and the four of us – Debbie, Chris, Gregor and I – got to work. Chris is a keen photographer, and I could hear the odd click in the background as I started work. I shot the full-face portraits for *The Telegraph* cover with a 500mm F8 mirror lens attached to my Nikon FE camera, lit with a Metz Reporter flash attached to a studio stand as close to the top of the lens as possible. Shooting in 35mm meant I couldn't use a Polaroid test print, as I would have back in my UK studio, so I had to trust my flash meter to gain the correct exposure.

The extreme telephoto lens meant I was shooting from the bay window, 13 feet away from Debbie posing against the makeshift white paper background. Debbie lit up in front of the camera and produced a series of great cover looks with little or no direction from me behind the camera. Having worked with many bands, I had learnt that you have to know what you want to shoot and make it quick, so after a couple of rolls of 36 exposure film I moved onto the next shot

which used the white-label LP. I asked Debbie to kiss the record, then I set it on a stand and positioned Debbie in profile, looking at the vinyl record. I shot various images and then, just as I wrapped up the set, she poked her tongue out and licked the record; more by luck than photographic skill, I fired the shutter.

The resulting image was to become the cover for the 'Picture This' single and the European *Parallel Lines* photo-disc album. Debbie and Gregor retired to check hair, while Chris and I set off to the rooftop cocktail bar with camera, tripod and flash stand. We started with shots in the Art Deco bar, many of which would be full length. Debbie wore a peach-coloured chiffon mini dress and moved her scarf around like a ballet dancer. I just followed her, shooting as we moved between the abandoned tables. Between bouts of rain, with storm clouds threatening, we grabbed the rooftop for what I thought of as my Statue of Liberty shot. The idea was to have Debbie in a stretched pose with a flashgun firing in her hand against the New York City skyline. This needed to be quick as it was freezing and blowing a gale; if I missed this moment, I don't think my model would have been up for a second attempt.

The damp atmosphere was causing technical problems, along with the flash trigger, which needed to be in direct line with my camera flash. This was not always the case, so sometimes the bloody unit failed to fire. That said, it worked enough times, and with Debbie modelling in a series of sassy poses, I managed to produce a great opening image for the inside magazine story. Mission accomplished, I was totally relieved. I would not see the processed film until my return to London but felt I had managed to shoot a great set of images for the magazine. I returned to the suite to slowly pack up my gear and wind down with the guests.

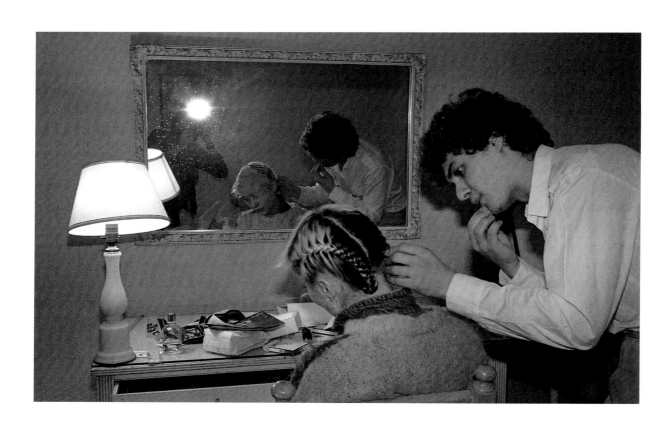

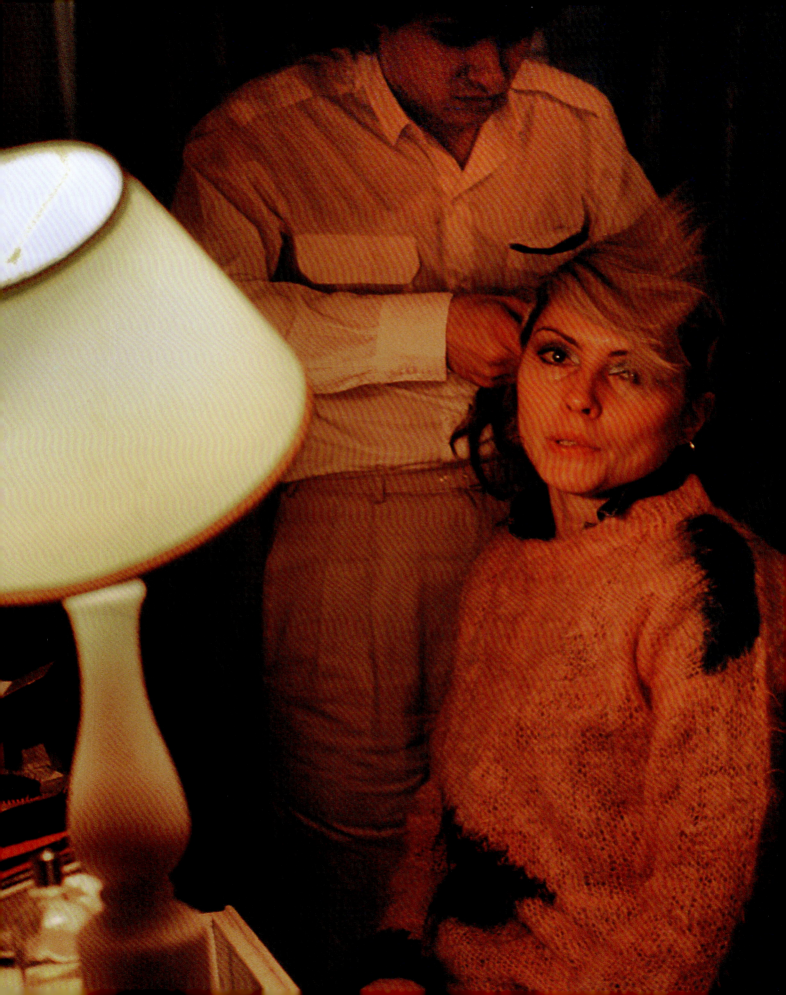

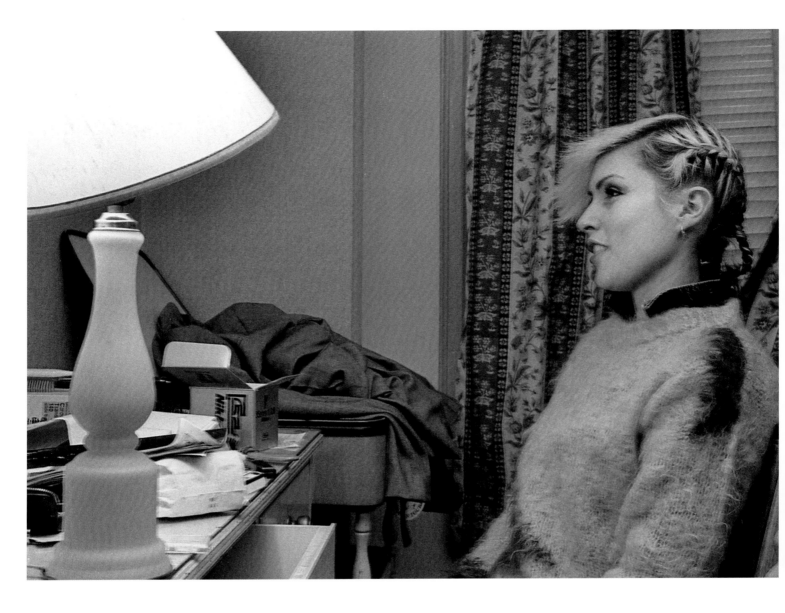

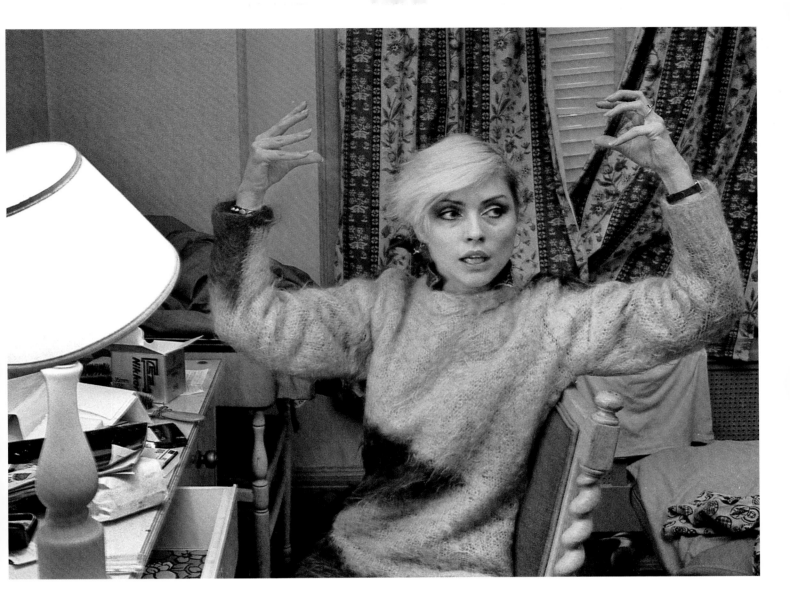

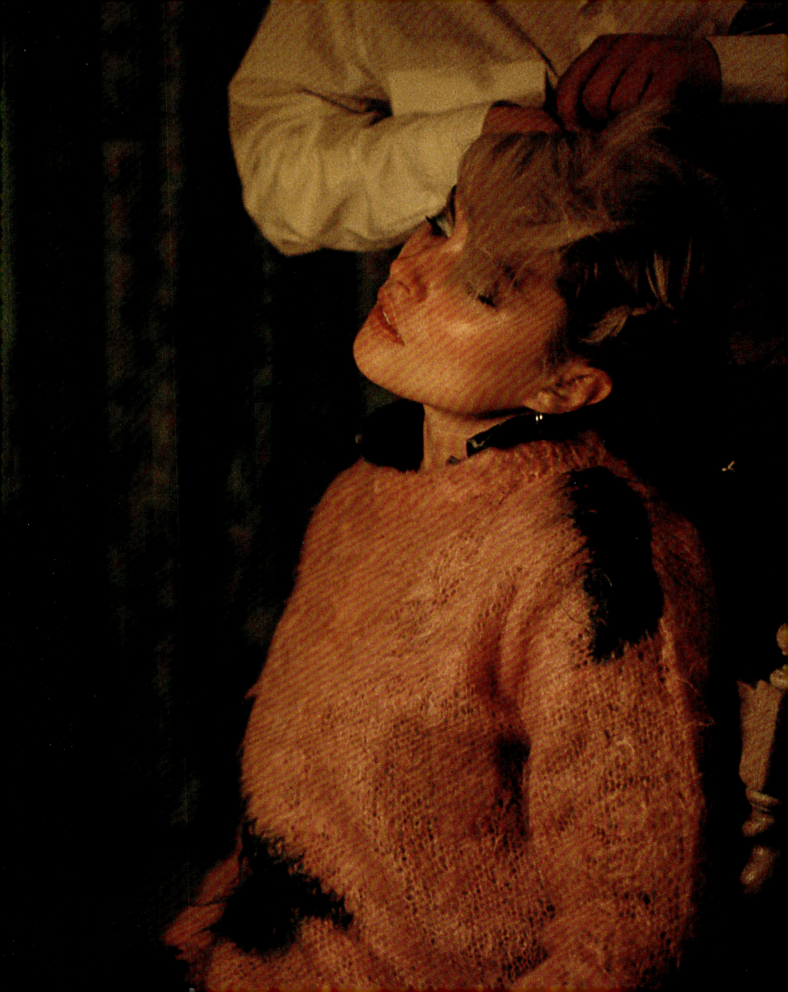

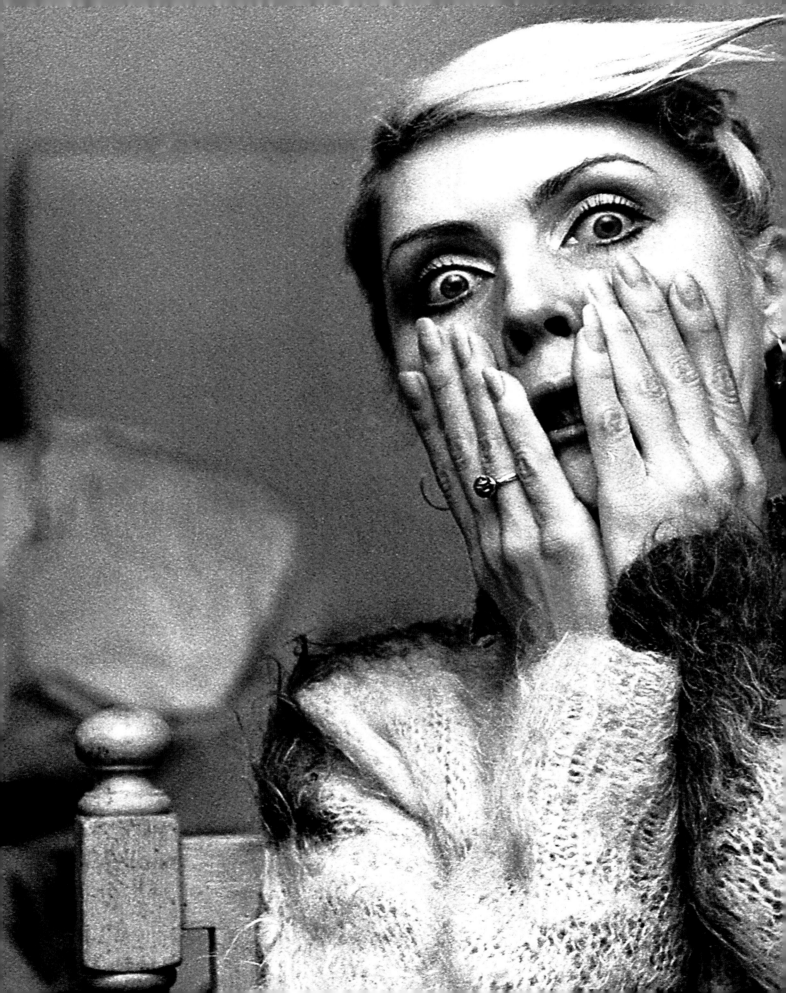

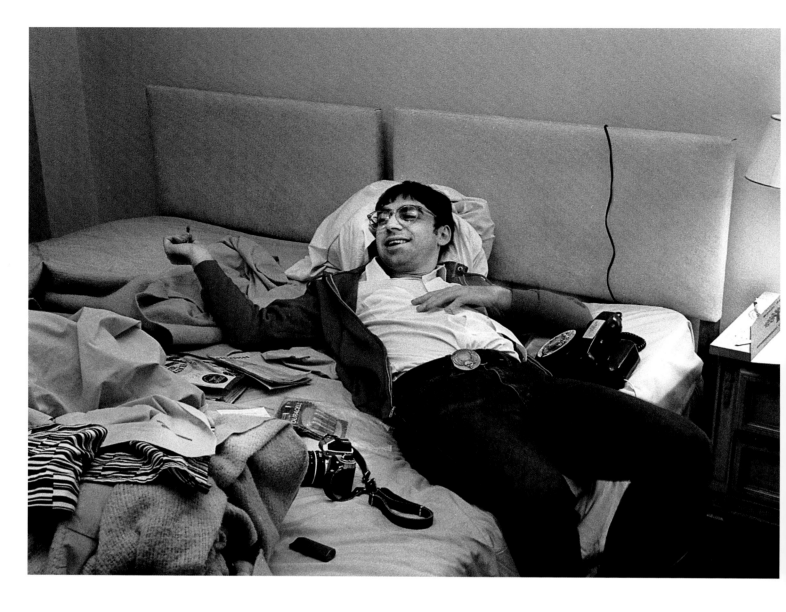

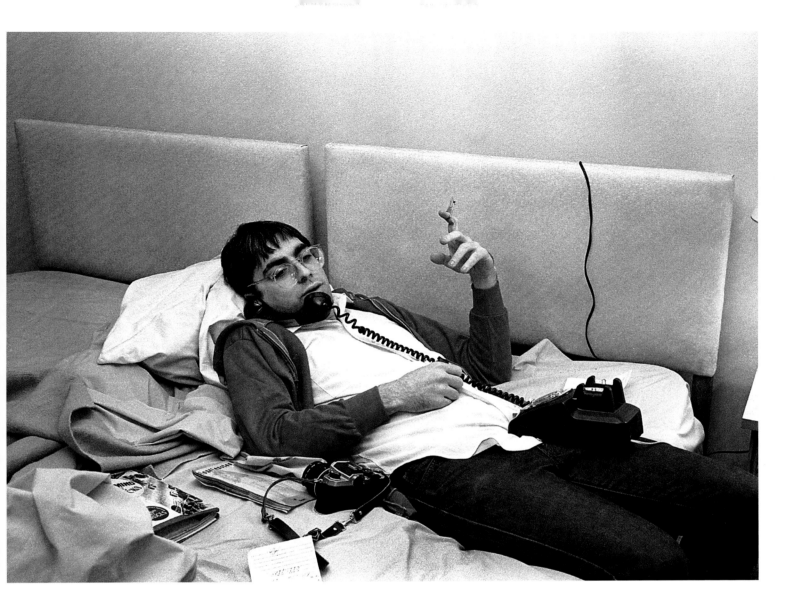

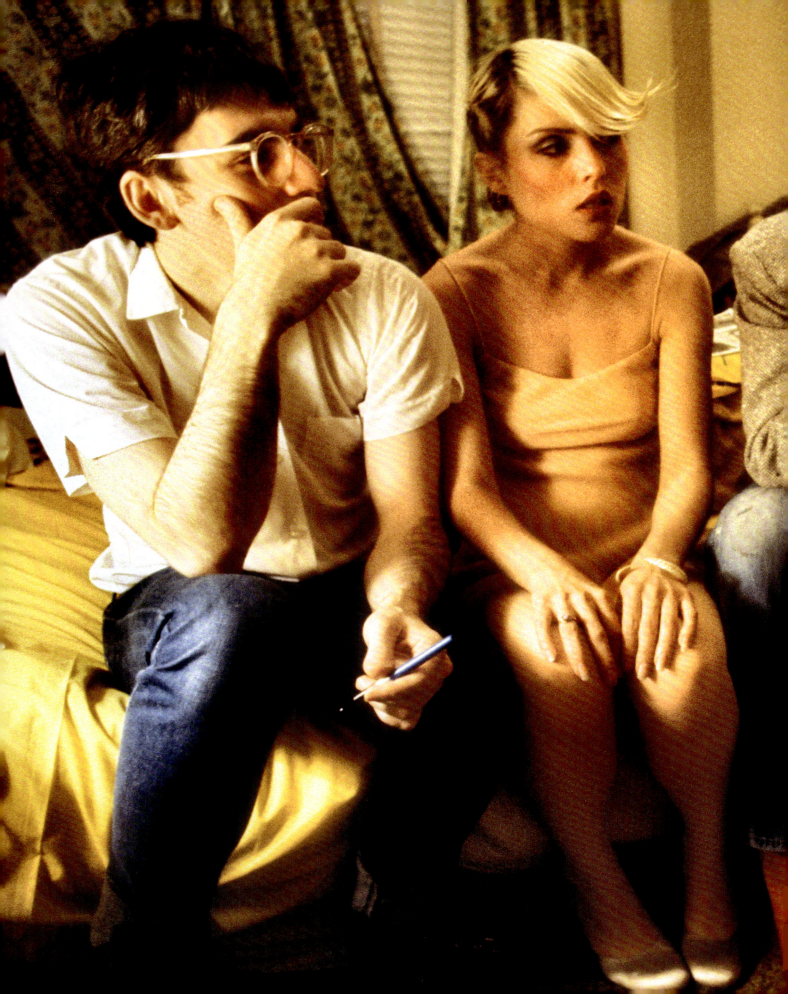

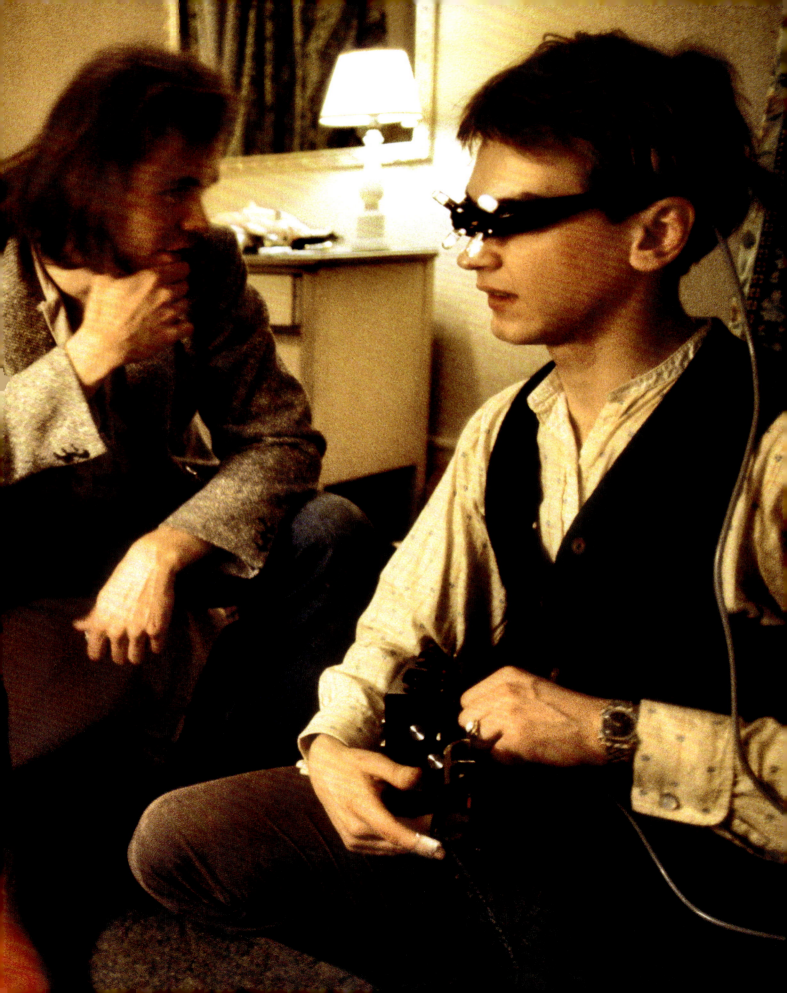

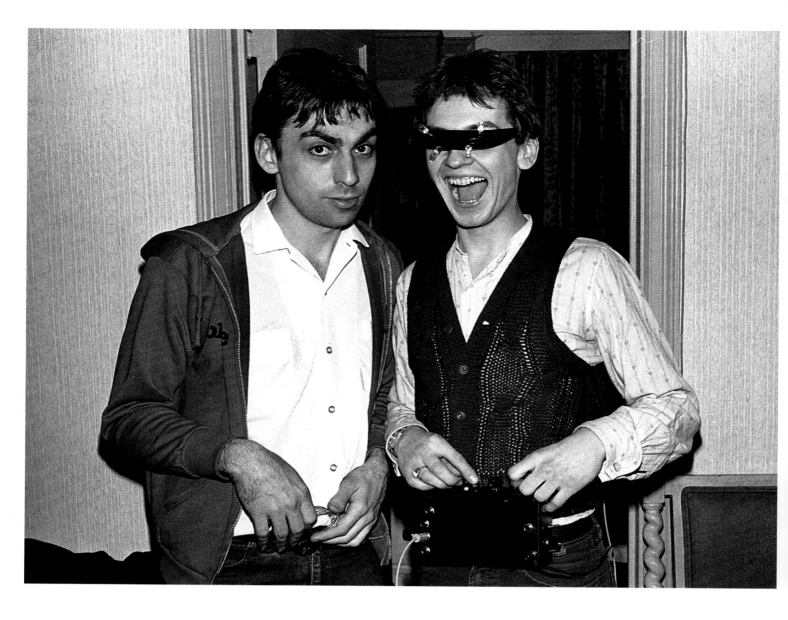

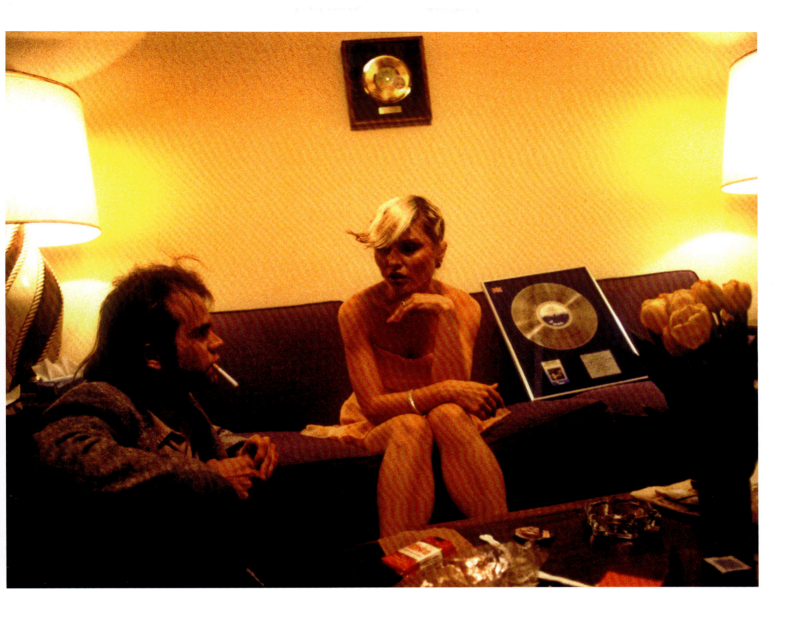

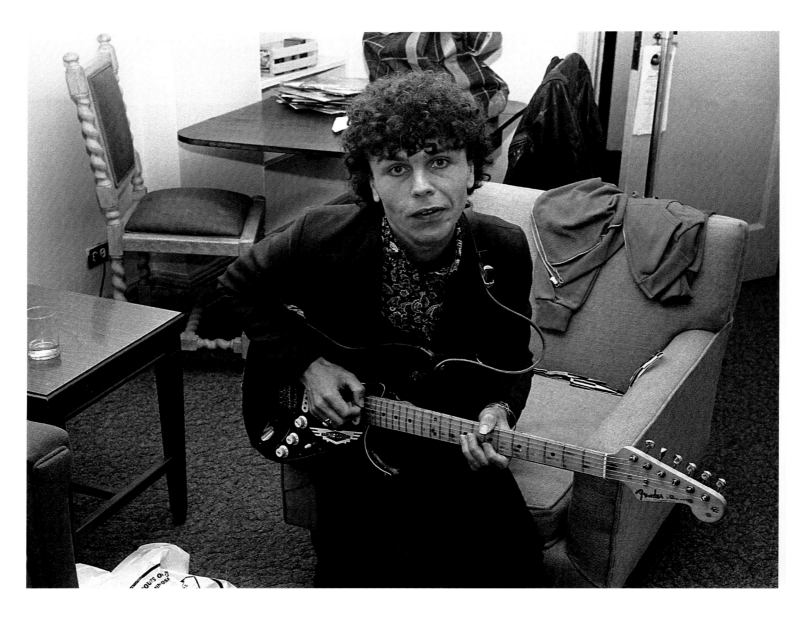

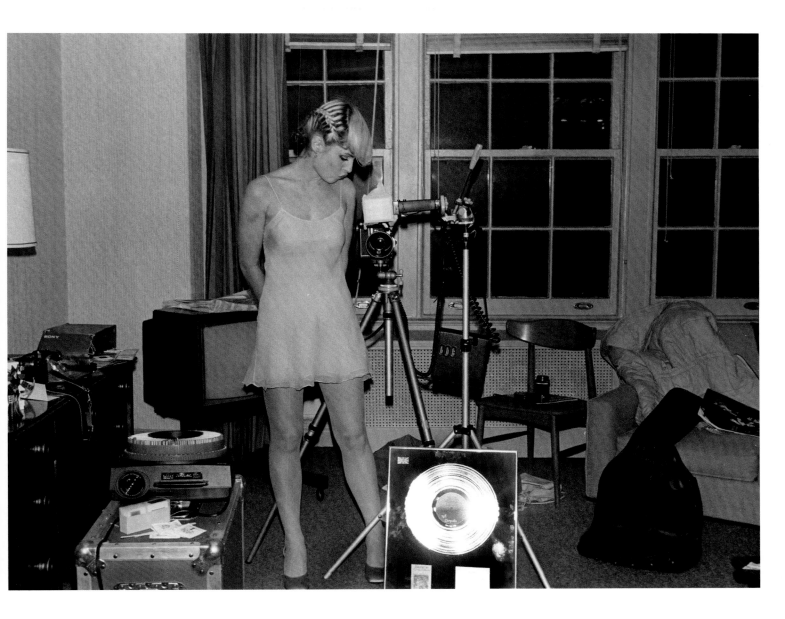

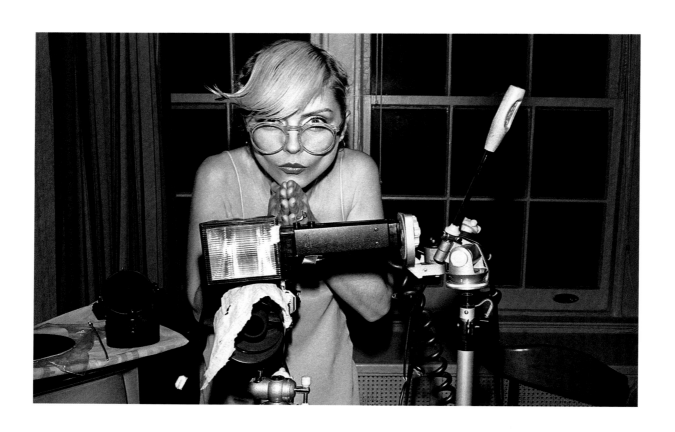

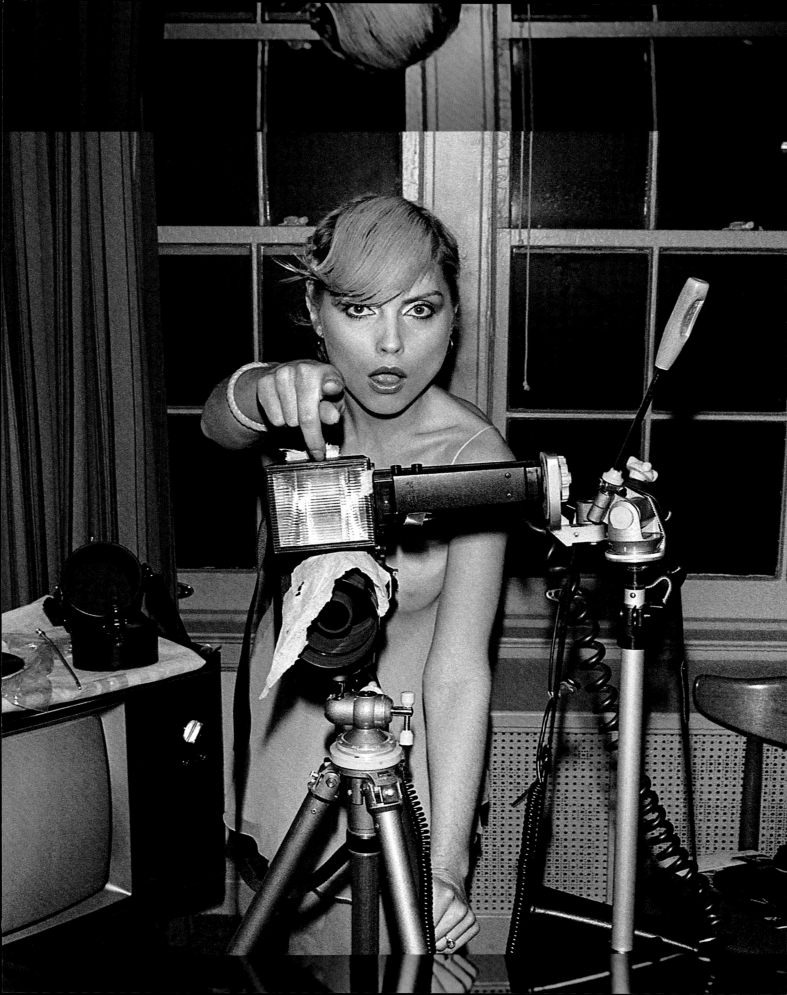

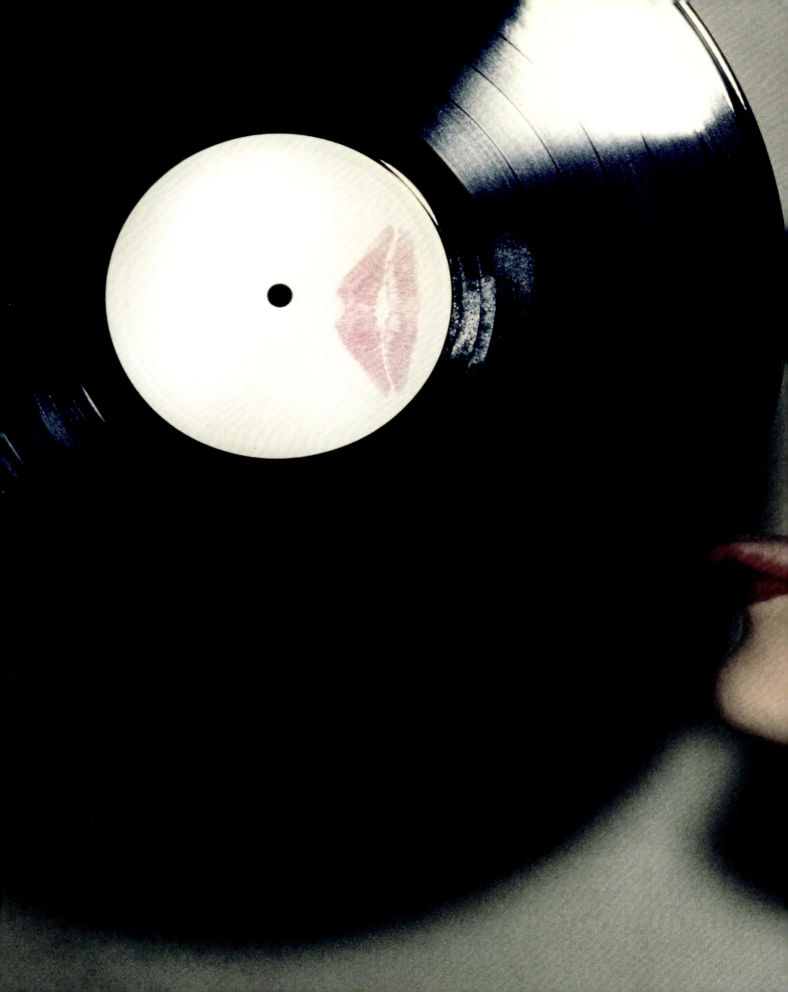

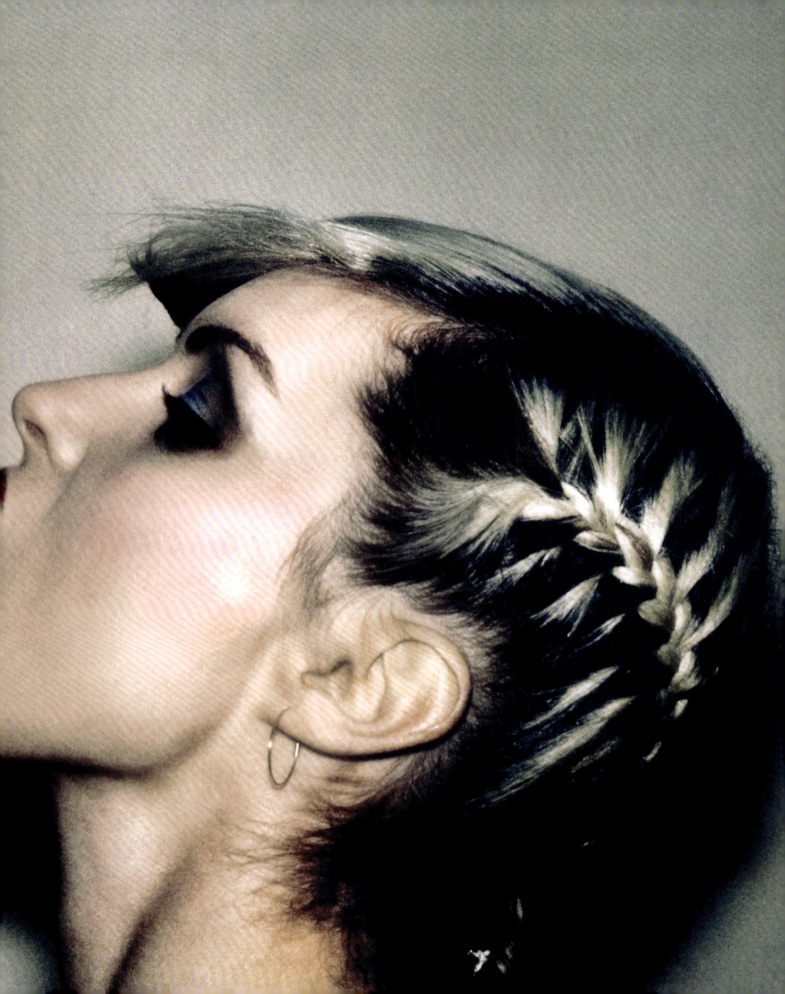

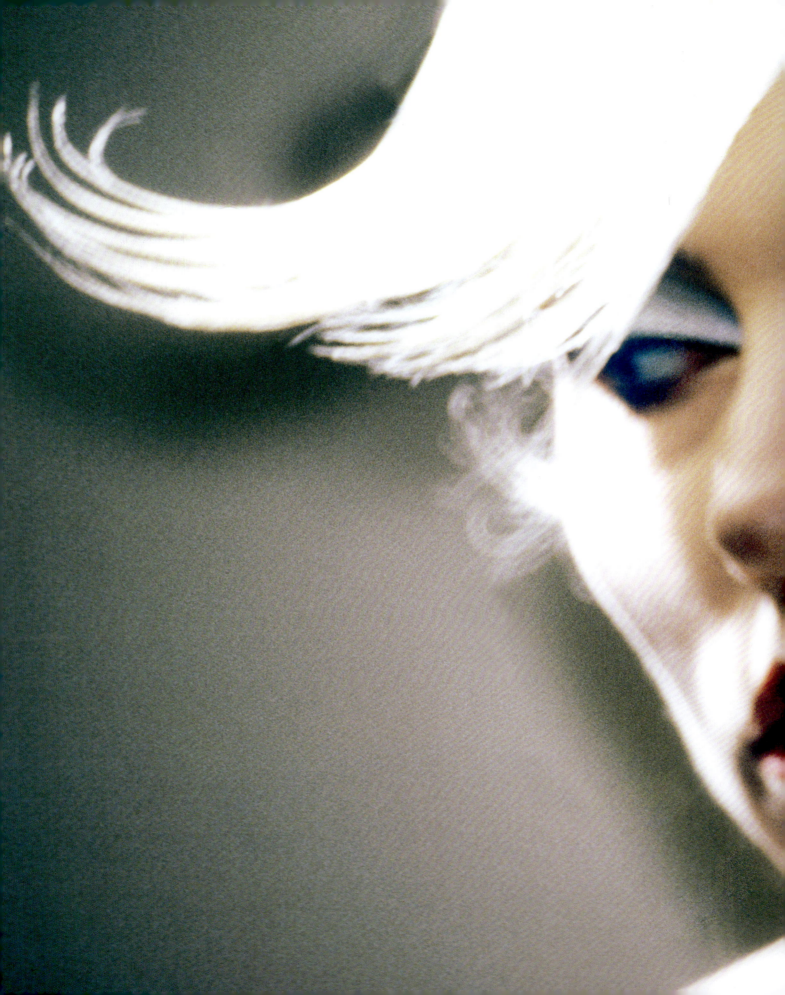

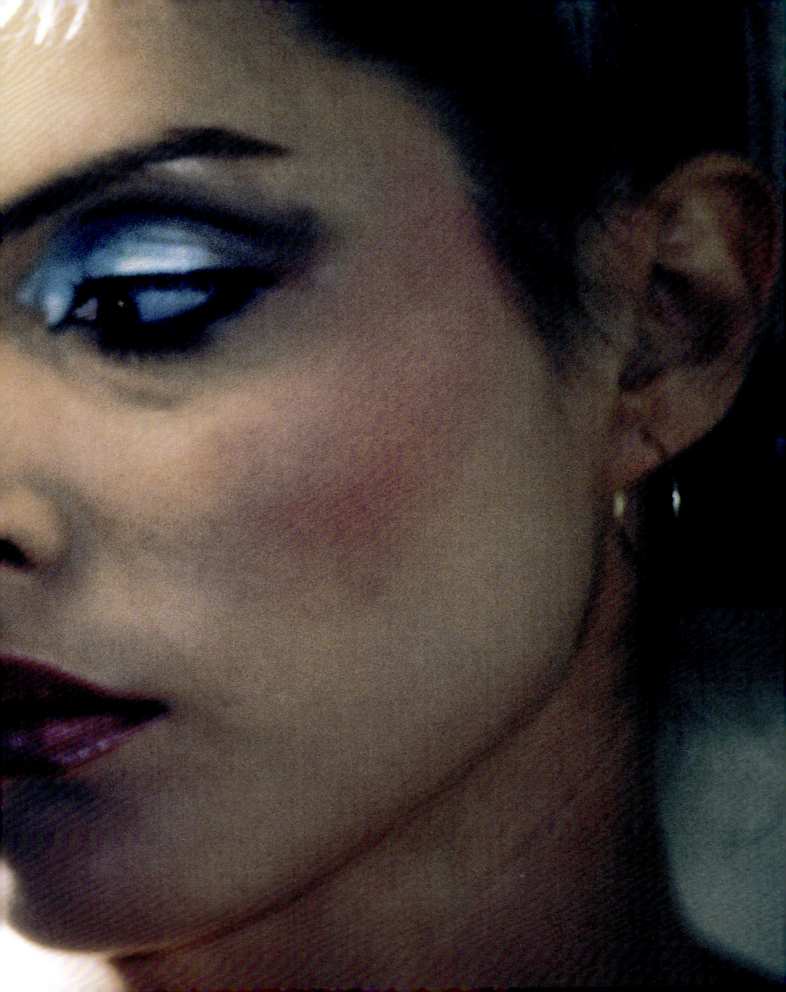

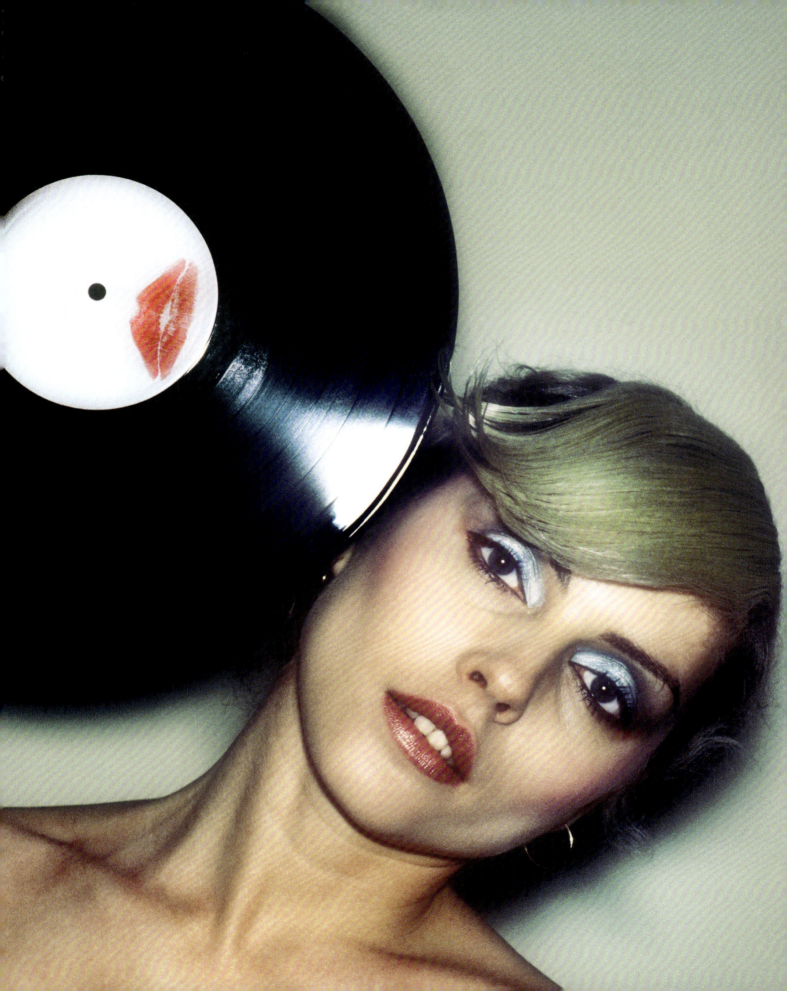

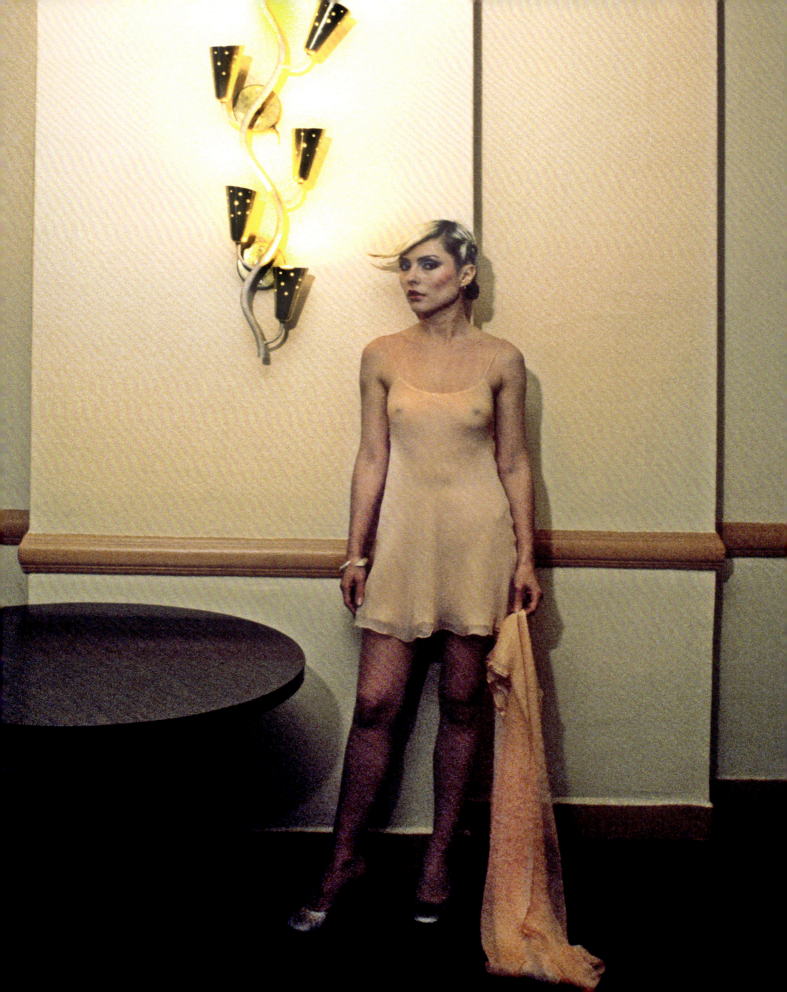

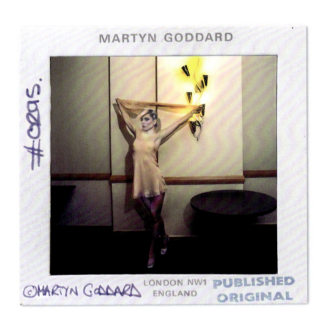

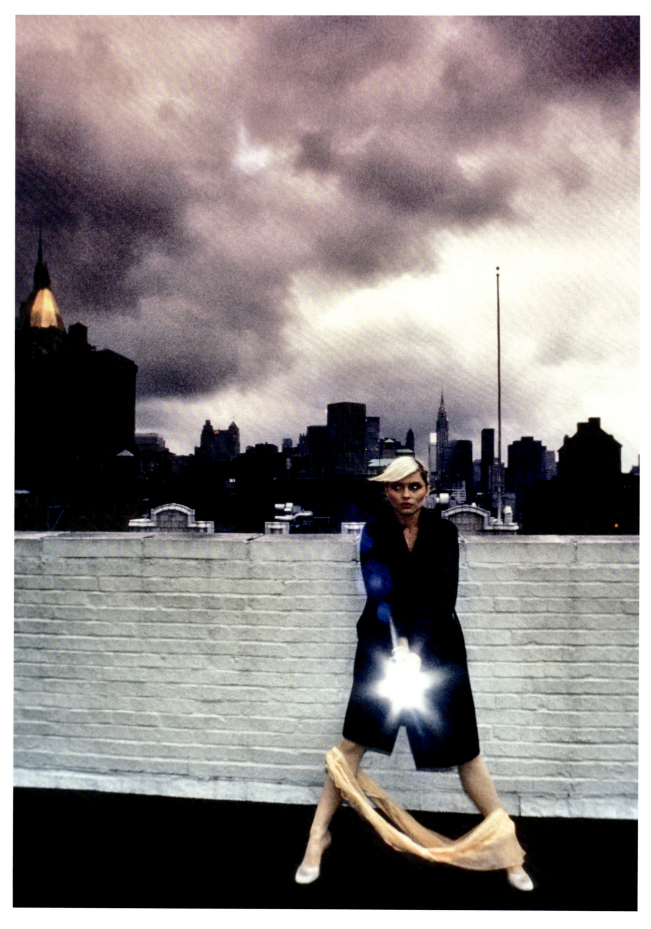

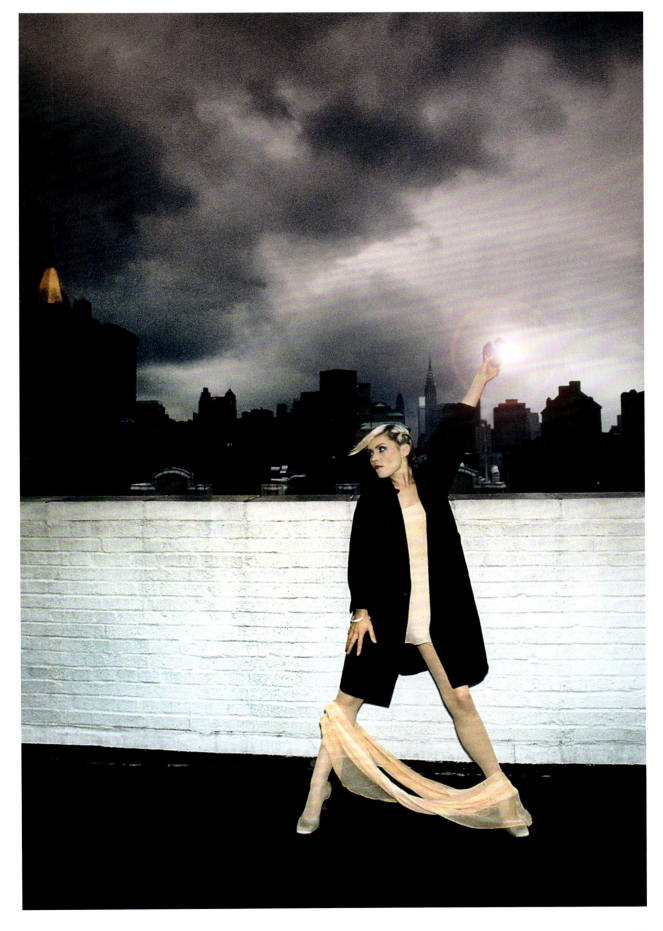

5 · NEW YORK STREETS

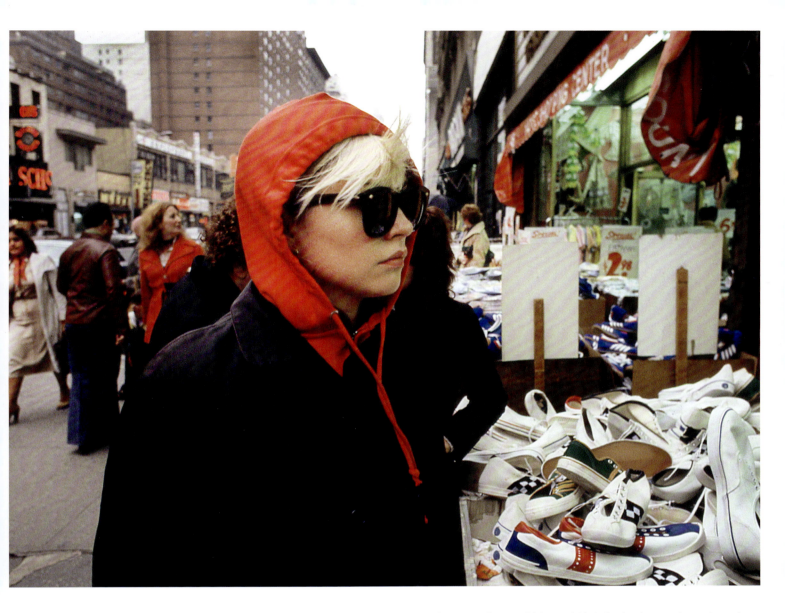

On Sunday morning, Debbie and Chris invited me to brunch and we spent an interesting hour or so wandering around the streets of Lexington Avenue, Union Square and Gramercy Park. Along the way, I shot a set of street reportage images, nothing like the stylised photo session of yesterday. We met Nick Lowe and Clem Burke in the park and walked the streets chatting and shooting. That wrapped up my first shoot with the members of Blondie. I was glowing in what I felt was a shoot well done. I flew home later that day, eager to see the processed film on my light box, ready to edit.

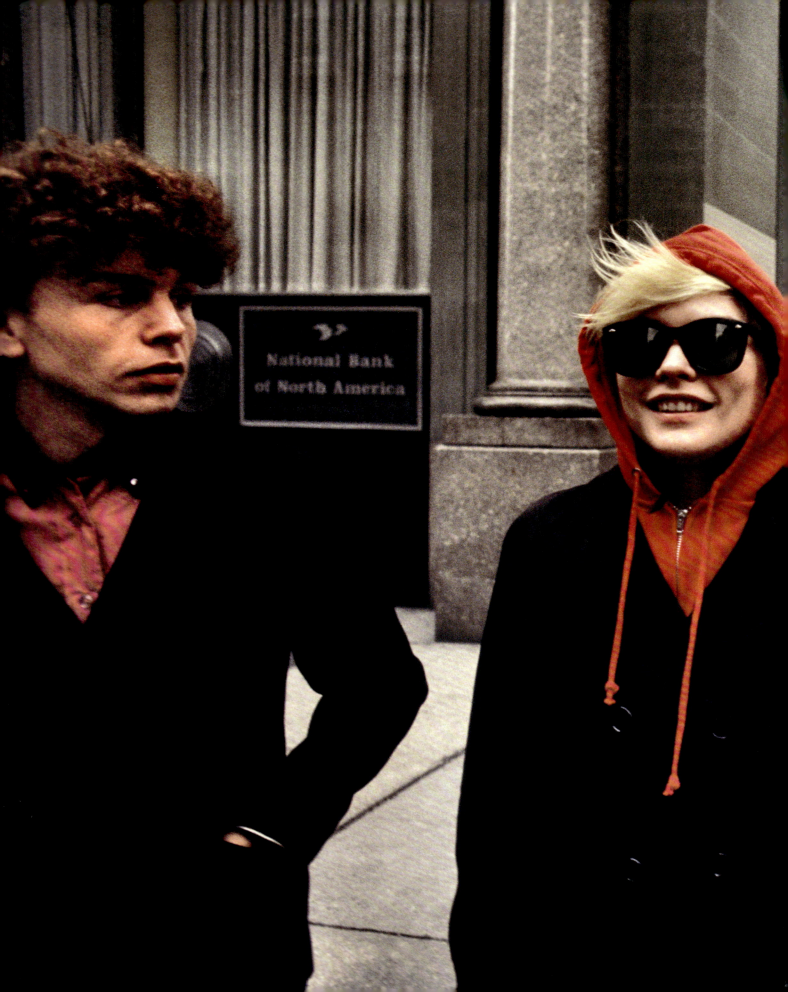

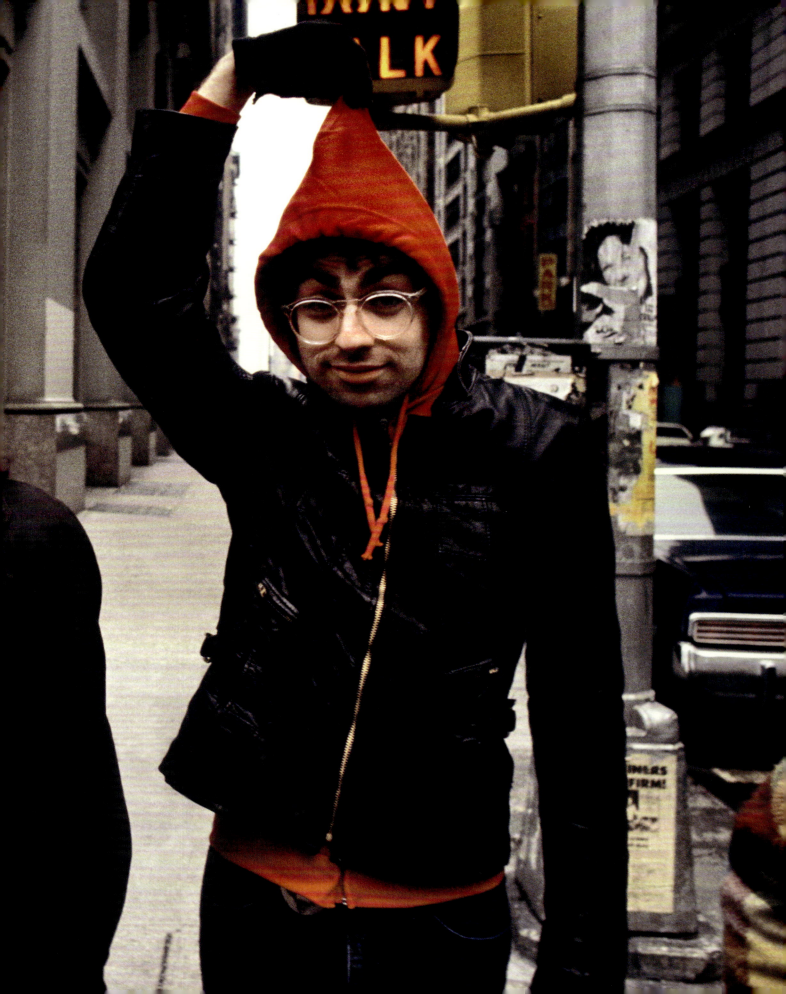

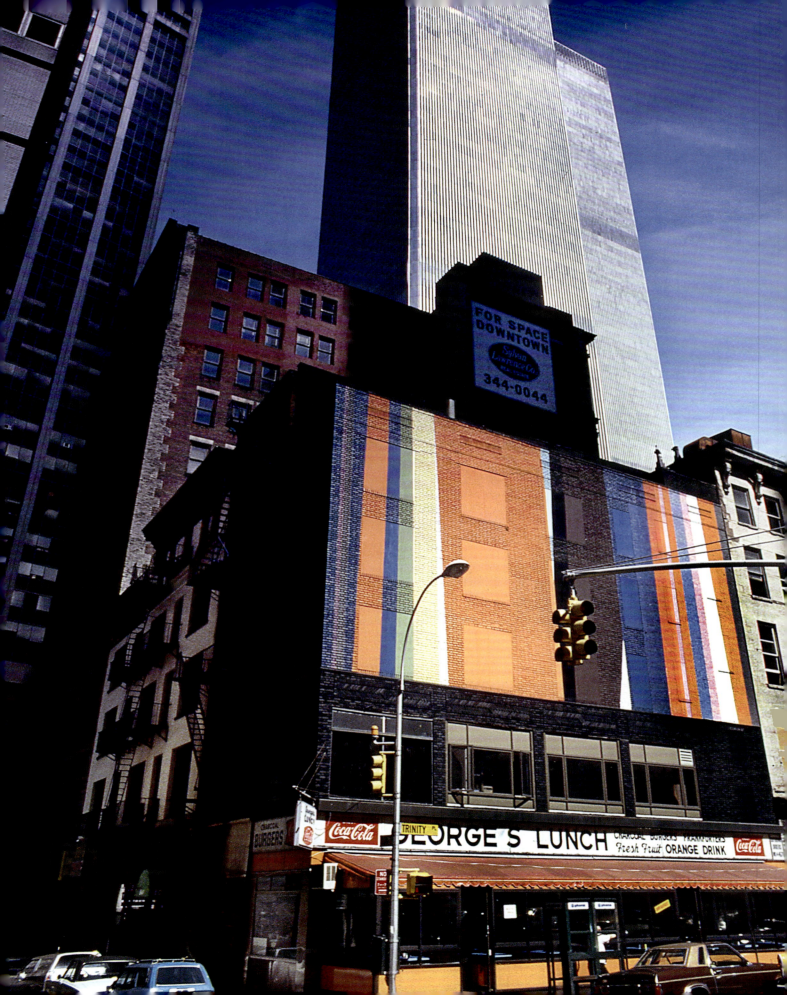

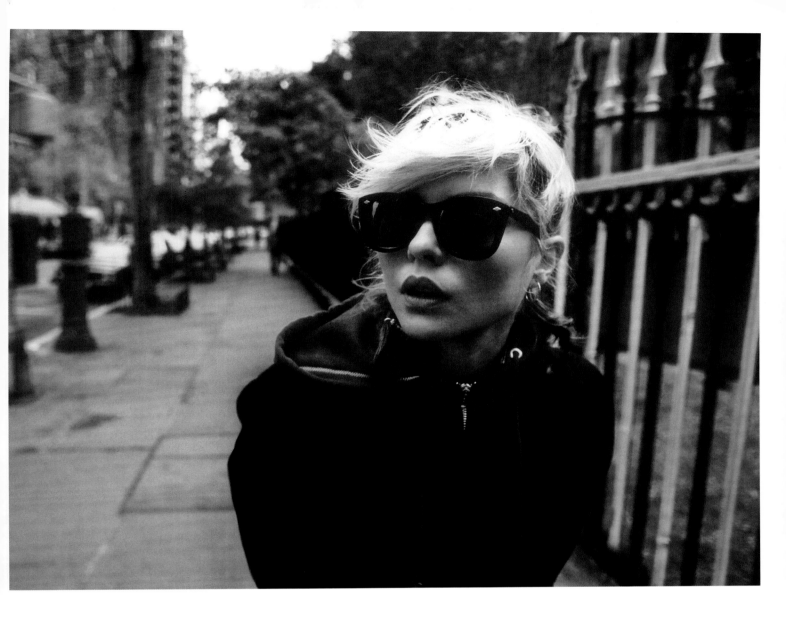

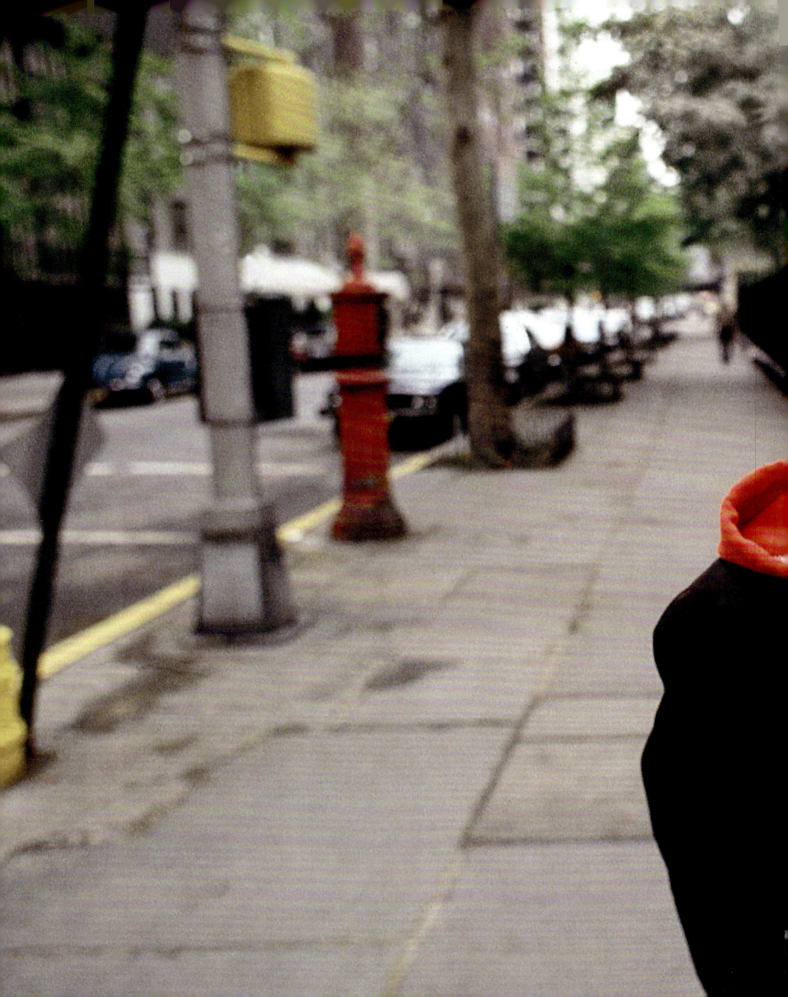

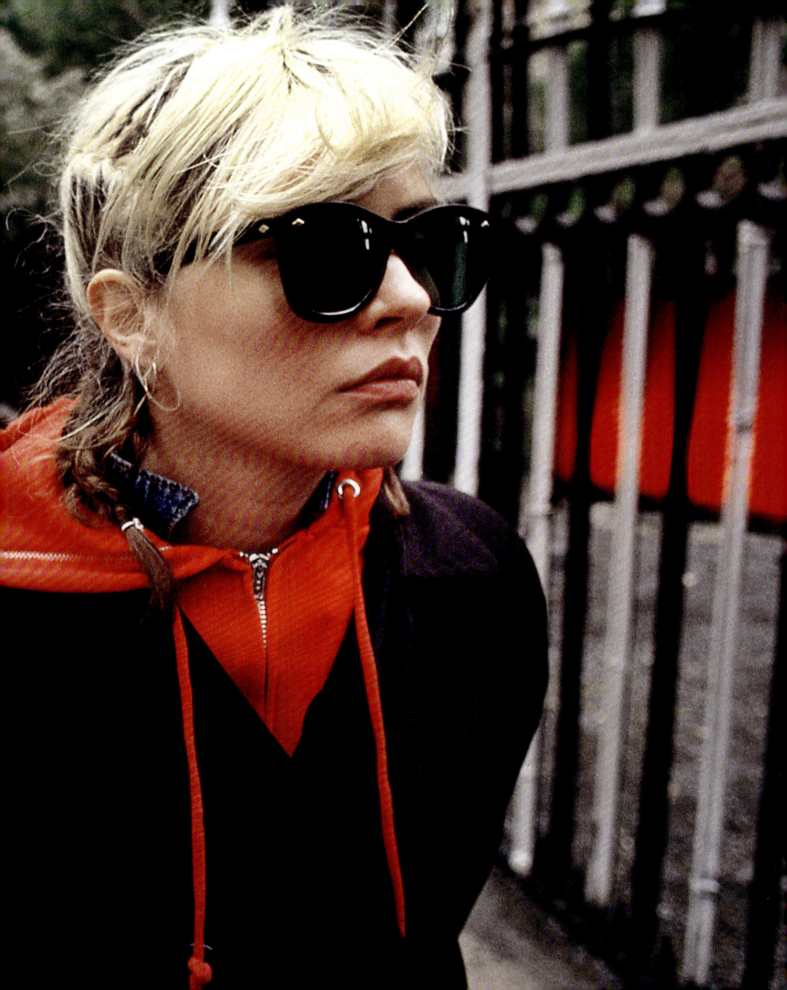

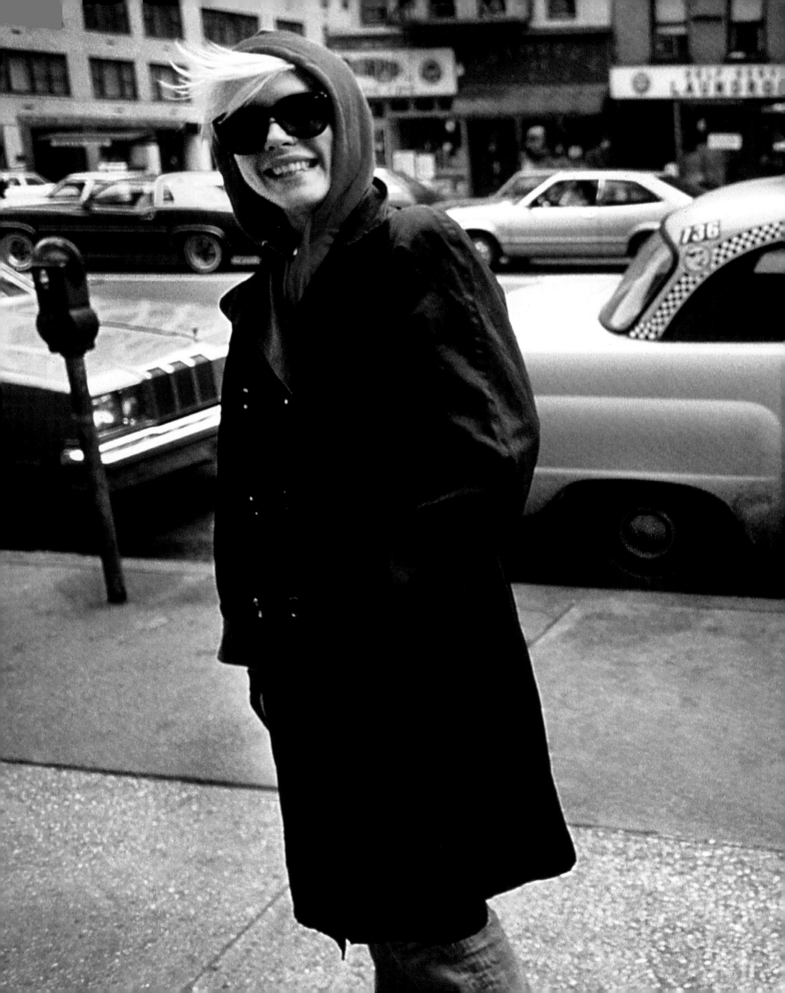

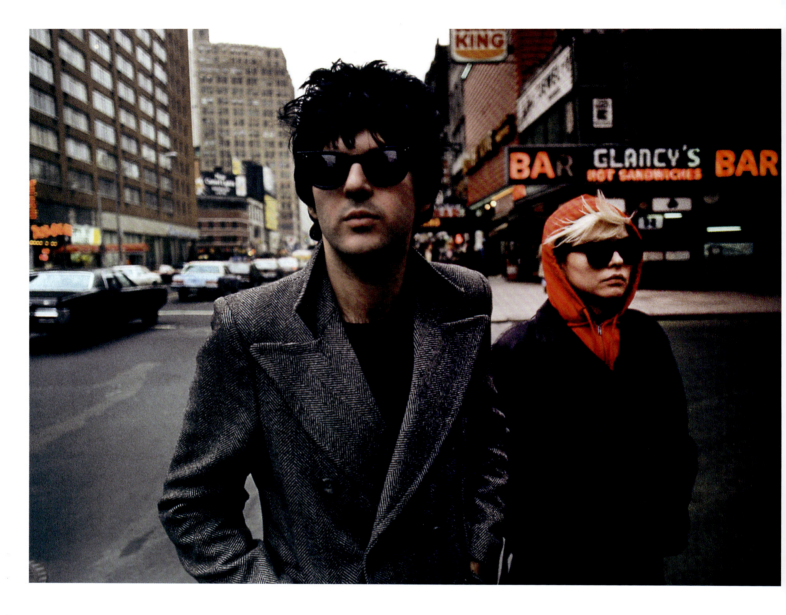

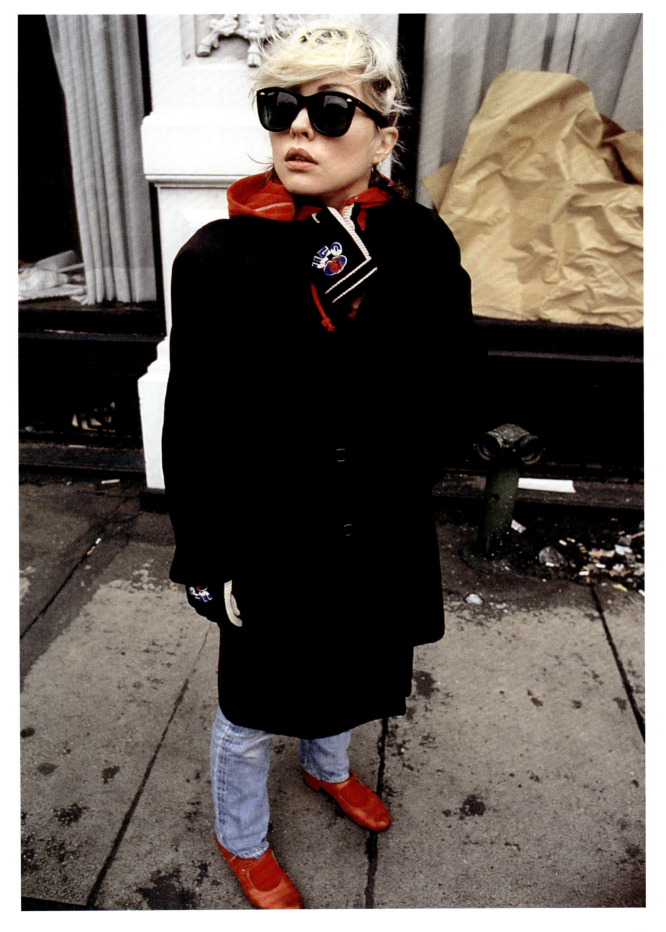

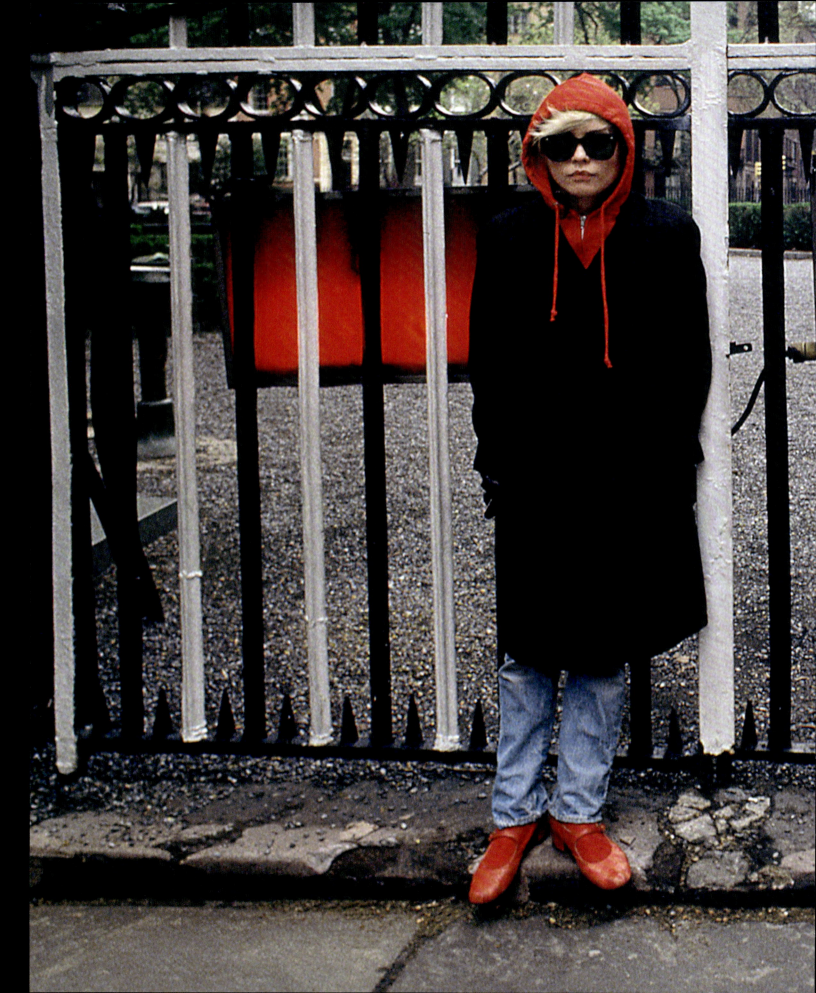

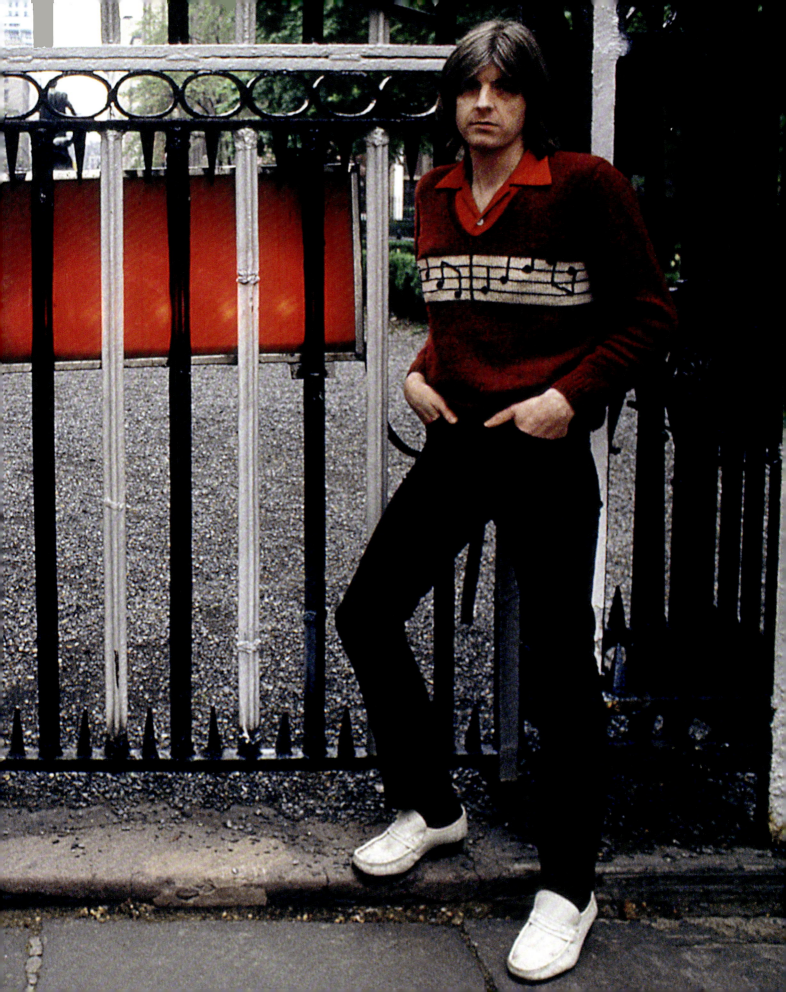

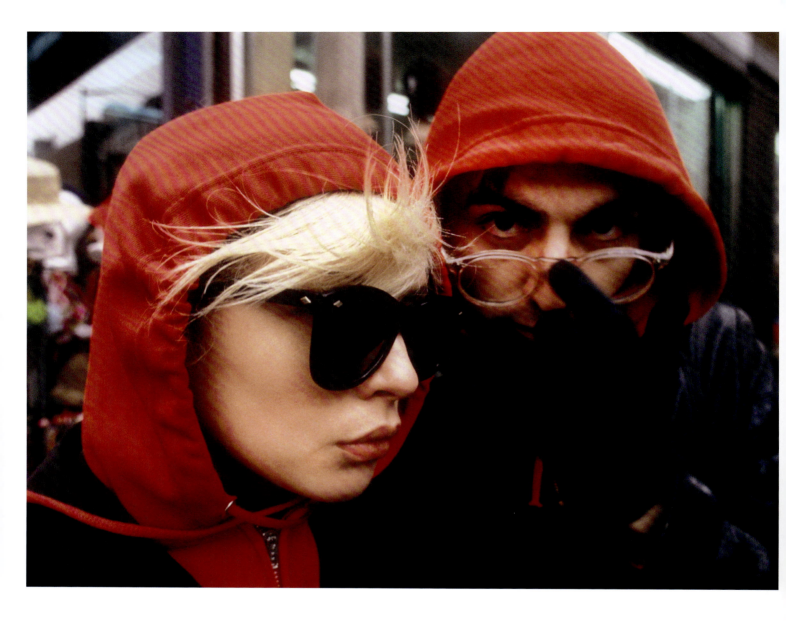

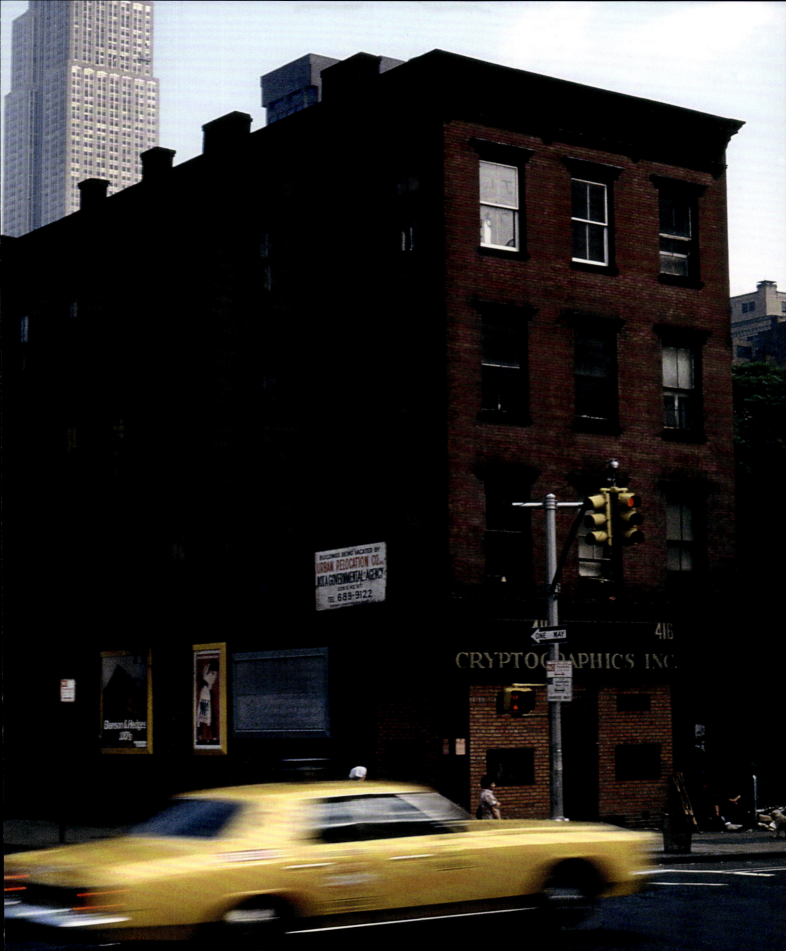

6. 'BLONDIE IS A GROUP!'

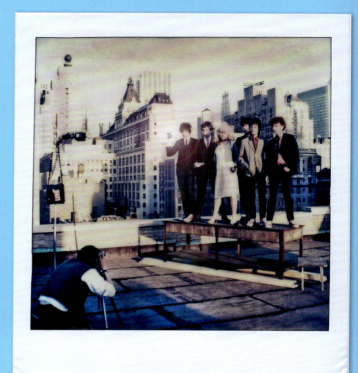

The photos of Debbie Harry had gone down really well with *Telegraph Sunday Magazine* editors, and the features department said the editor was going to hold the story for a 'peg'. I took this to be the new album scheduled for later in 1978. I was on good terms with the picture editor Alex Low, and he let me take a set of transparencies over to the Chrysalis offices in Stratford Place, off Oxford Street, to show the art director Peter Wagg. He looked at the slides through his loupe magnifier, slid the device over the Viewpak, called over his assistant to take a look and then turned to me and smiled, saying 'these are a bit different'. I gathered the folio of images up and returned them to the magazine. A few days later, Mr Wagg called and asked if I was able to return to New York to shoot a new set of images of the band for press, record covers and promotional purposes. After checking my diary, it took a nanosecond to say, 'yes please!'.

Six weeks after my first assignment in New York, I was sitting next to my girlfriend Beverley Ballard, picture editor of *Fab 208*, on a scheduled British Airways 747 flight to the Big Apple to shoot Blondie, all expenses paid. Once again, I was going to rely on the flash slave triggers for the main group photo session. While scouting out the locations for the Debbie Harry portrait on the roof of the Gramercy Park Hotel, I became obsessed with the Art Deco skyscrapers, modernist glass office blocks, wooden water towers and steel bridge structures that made up the New York City landscape. I wanted to shoot this quintessentially New York, New Wave band, with a New York City backdrop. One of the reasons I think the record company art team had sent me back to document the band was that Blondie, although an American band, had a fanbase that was mainly from the UK and Europe. In New York, they were well known in the alternative music and arts community but, once outside the city limits, they were unheard of. Chrysalis was a UK-based record company, and their principal aim was to produce records that would continue to chart in the UK. However, their next objective was to promote Blondie in America. To achieve that, the band would need to cross over and be played on mainstream FM radio. Little did I know that master pop producer Mike Chapman had been brought in to work his magic on the new Blondie album, and that my images of Debbie, taken in May, were a tool to promote the band to a whole new audience that the music press never reached.

We met up with the band at the Gramercy Park Hotel the following morning. It felt strange to be back so soon. The meeting was with the entire band as my assignment was to produce images of the group. At this time, there was a promotional pin badge saying, 'Blondie is a Group!' – a sentiment the entire band promoted in press interviews, particularly Clem Burke. I outlined what images and the type of locations I would like to use and, unanimously, the band suggested that we should use the roof of the Record Plant studios on West 44th Street, situated in the heart of Manhattan. The idea was for me to set up my location studio while the band worked on their album below.

My first objective was to shoot a set of black-and-white portraits taken on the recording-studio roof and local streets. As various members appeared, I tried to find a unique setting for each member: Debbie, Clem, Frank and Chris on the roof; Nigel and Jimmy at street level. The shots were reportage in style, and one of my favourite images is of Debbie leaning on my spare camera and tripod. My next objective was a strong group shot, so I checked out the recording studio roof, which had plenty of potential. With the help of a studio rigger, Beverley and I scoured out a storeroom and found a strong table and some planks of wood on which the band could stand to provide me with a low viewpoint and give the effect that Blondie were standing on the roof parapet, with the New York City landscape as a backdrop.

I rigged my trusty Metz flash unit and tested and retested the remote triggers to work the two flashes Debbie and Clem would be holding. I then loaded the Nikon FE and waited for the band to take a break from their recording session. By mid-afternoon, they arrived dressed for the stage: the guys in black suits and Debbie in her signature *Parallel Lines* white dress. I didn't hang around; with a quick briefing about the shots that I hoped to achieve, and tech talk on how the flash slave triggers work, Blondie lined up on the tabletop. The light was perfect: blue sky that darkened with the use of fill-in flash. I crawled around on the floor, directing the band on when the flash was ready to fire and when to move closer to fill the frame. They worked well together, and the flashes mostly fired, so after a couple of 35mm films, we moved on to the second set, up where the band stood on the roof top with my camera shooting in vertical format. The image would work for a possible magazine or tour-programme cover. The shoot took little more than an hour, before the band returned to the recording studio and we dismantled the set.

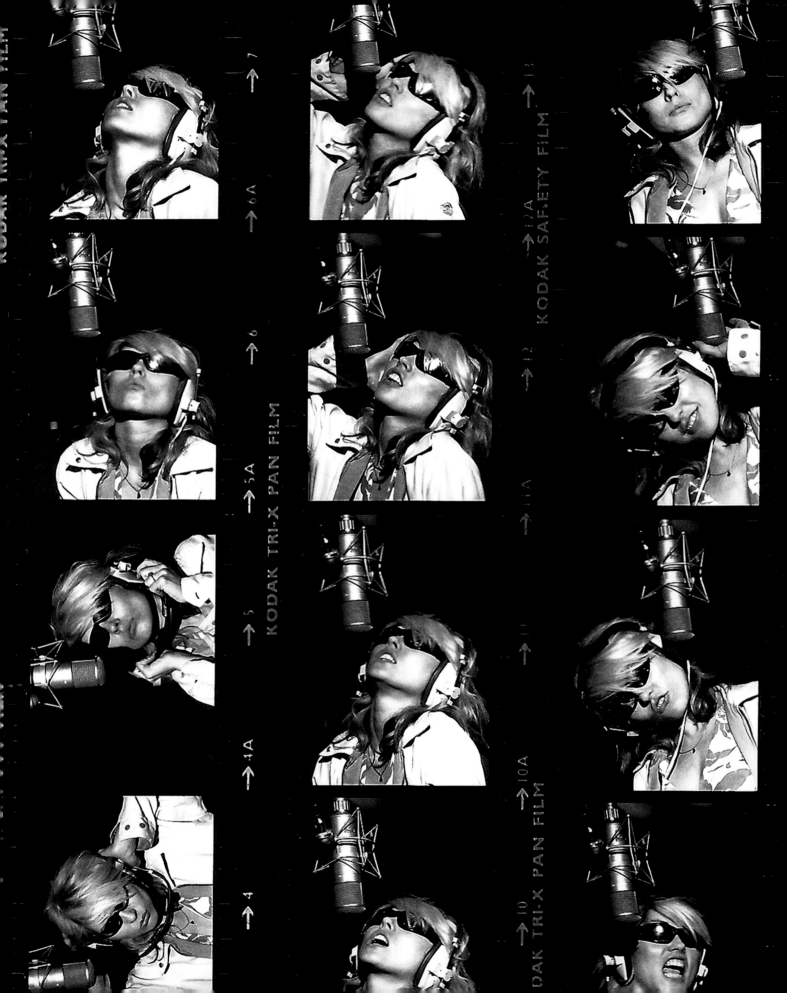

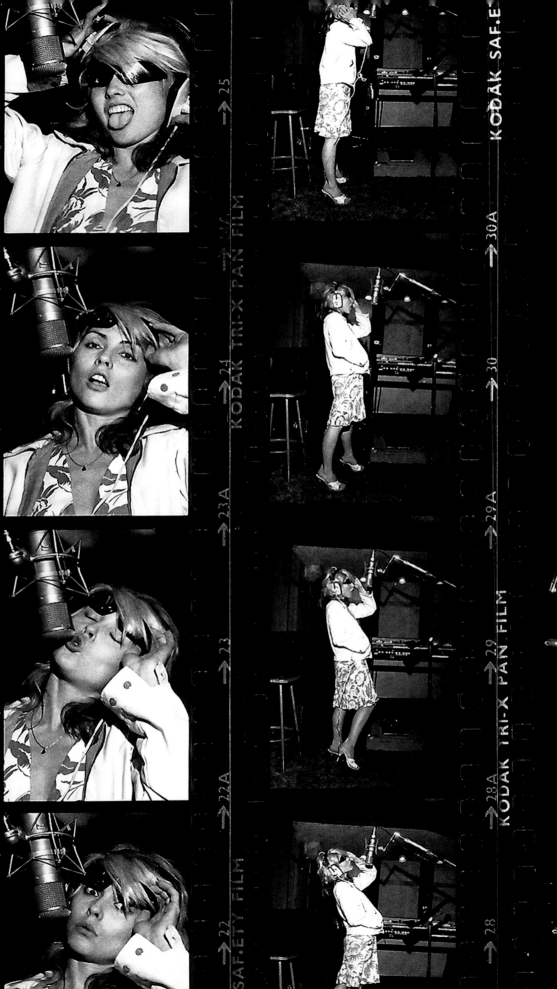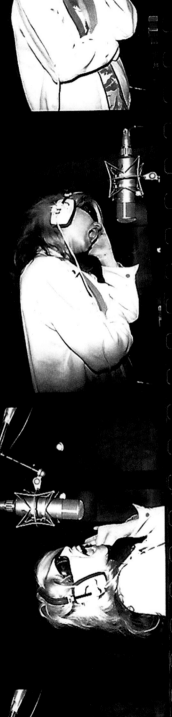

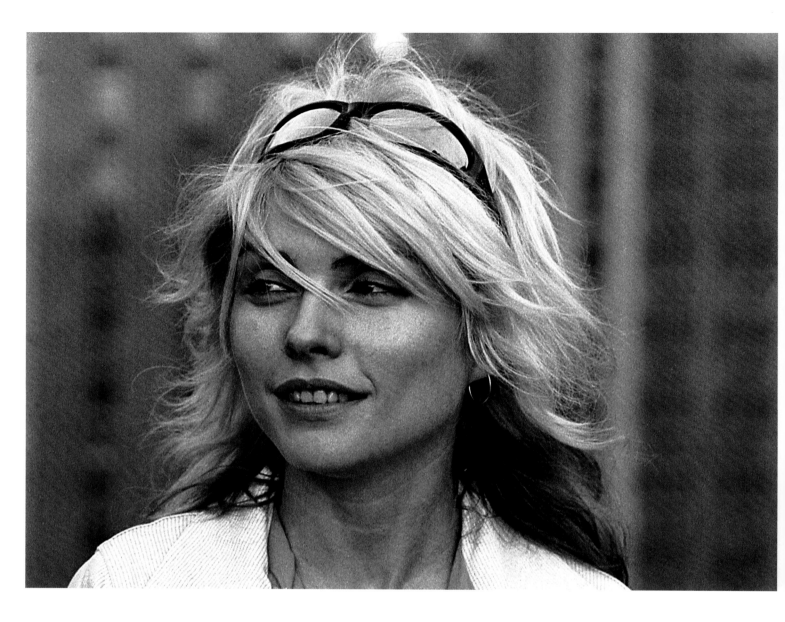

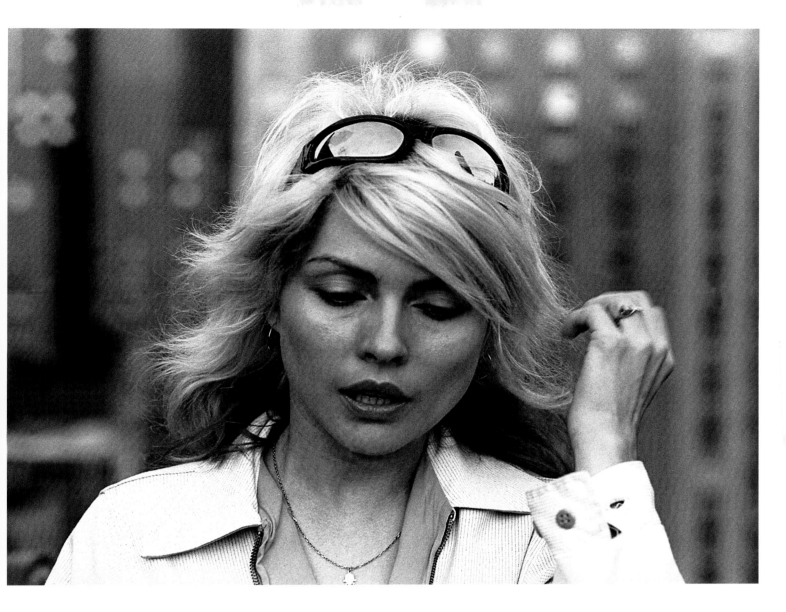

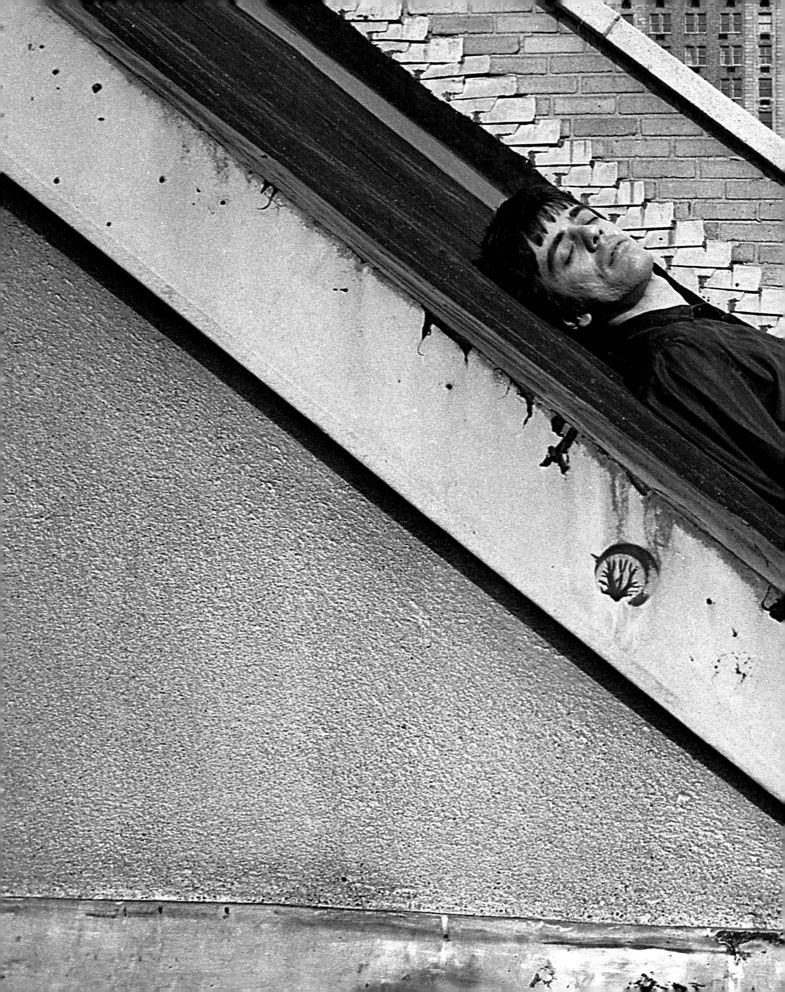

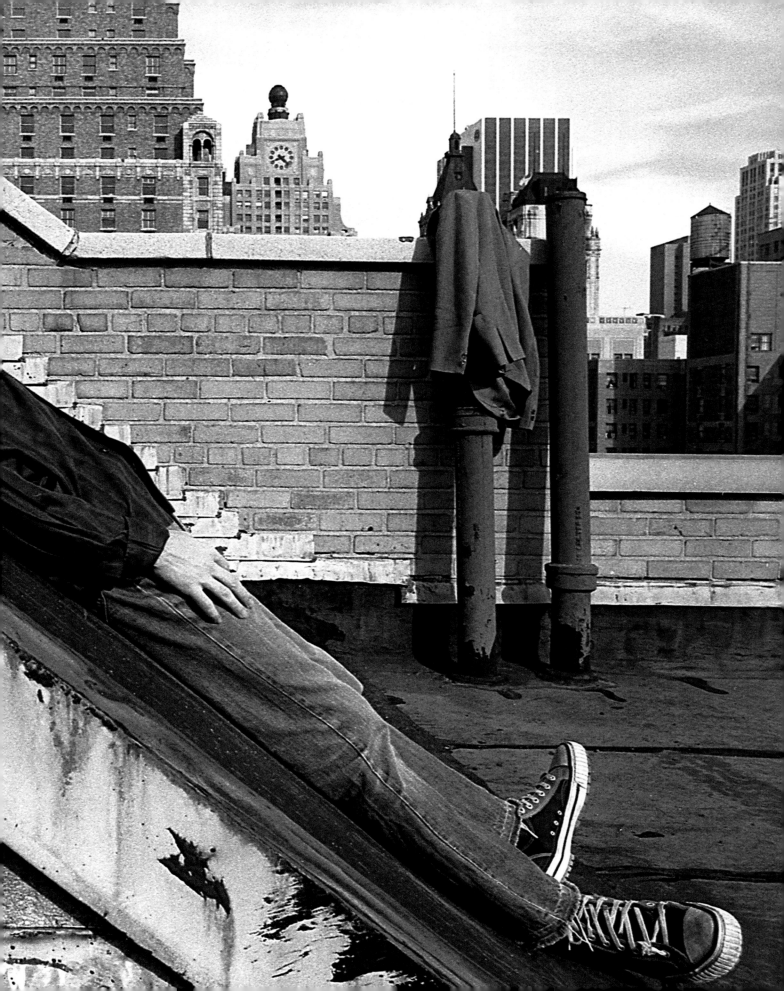

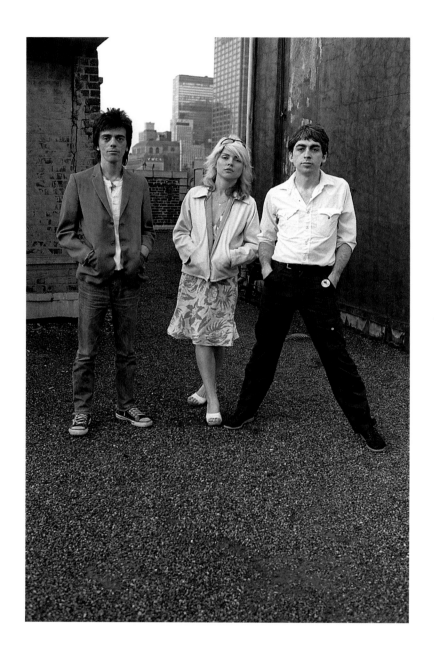

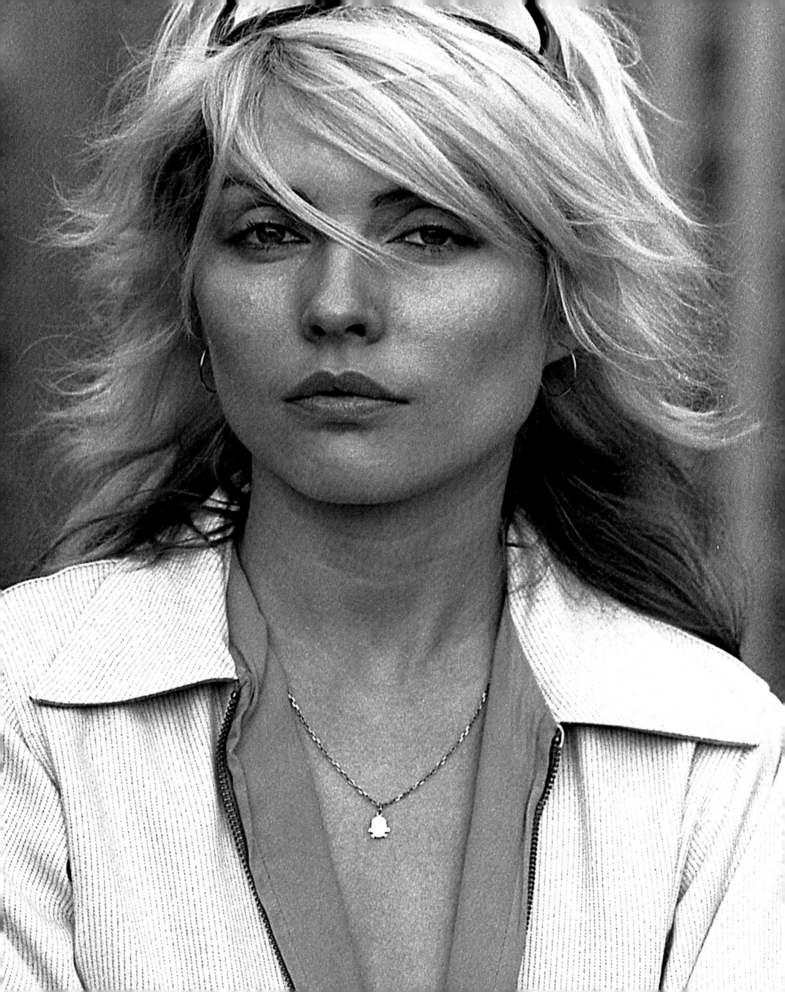

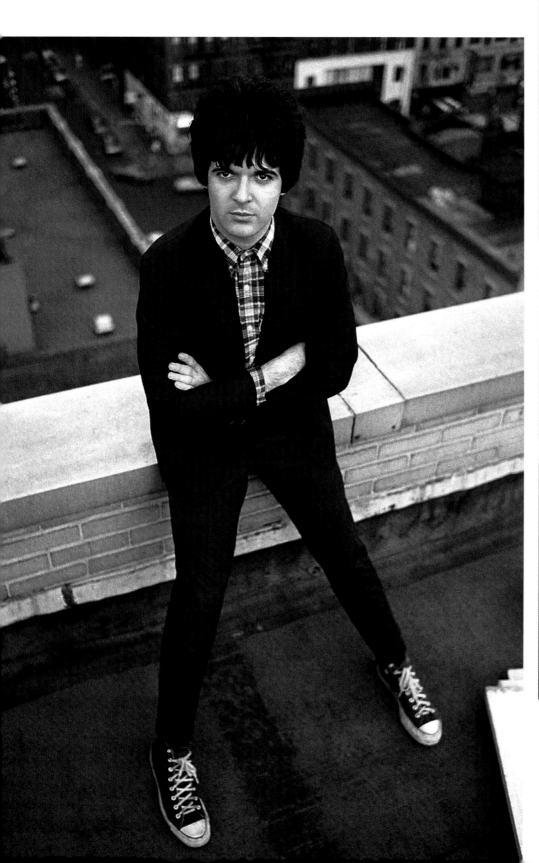
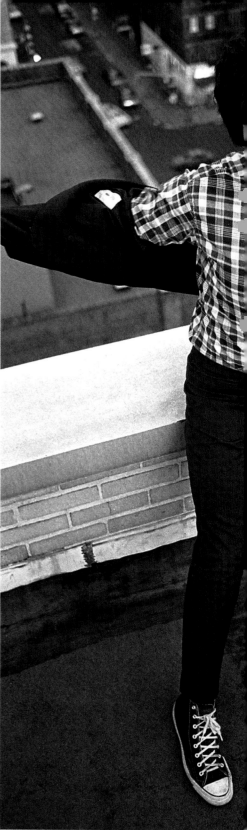

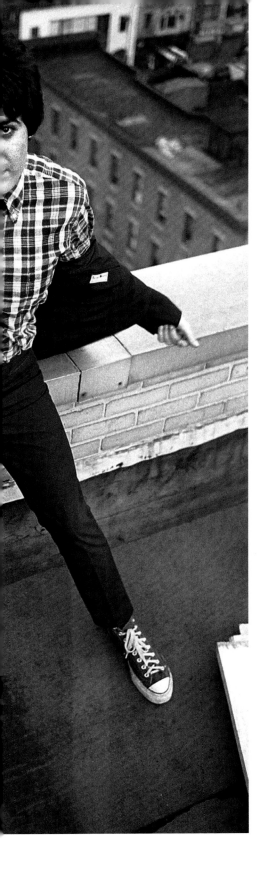
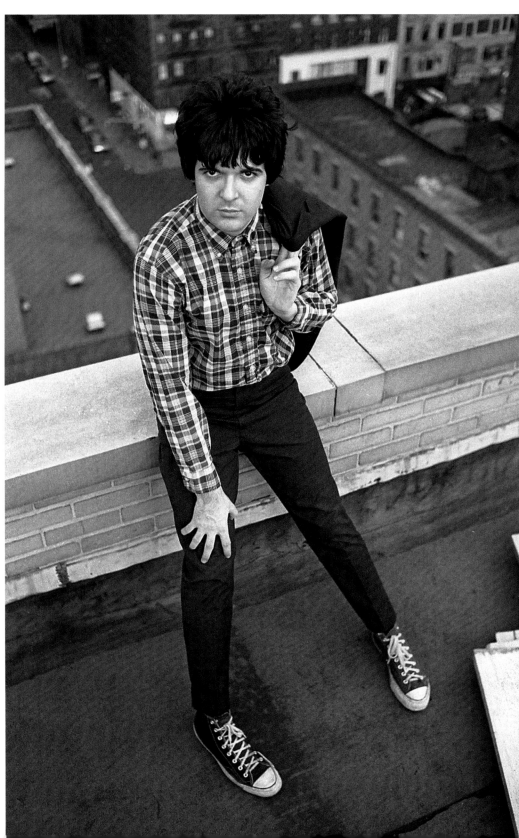

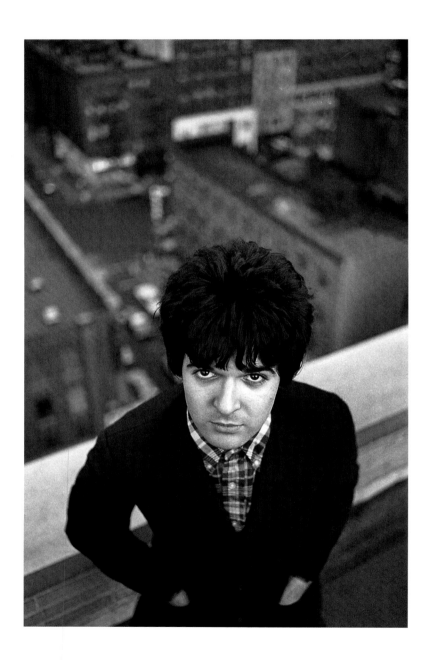

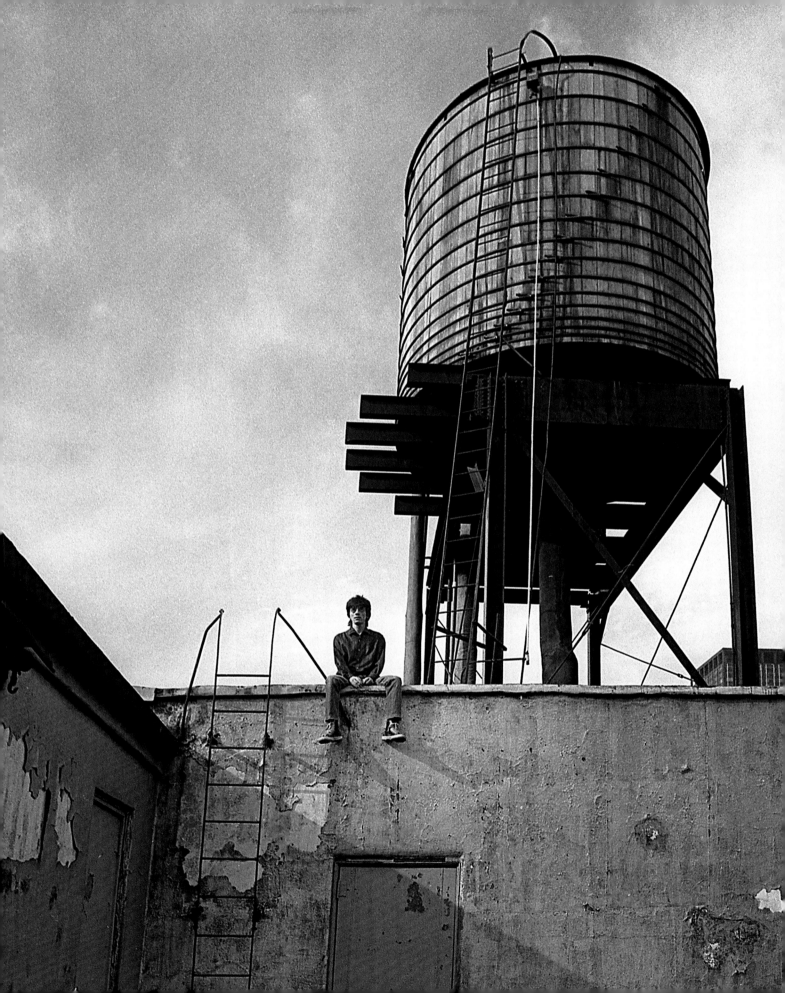

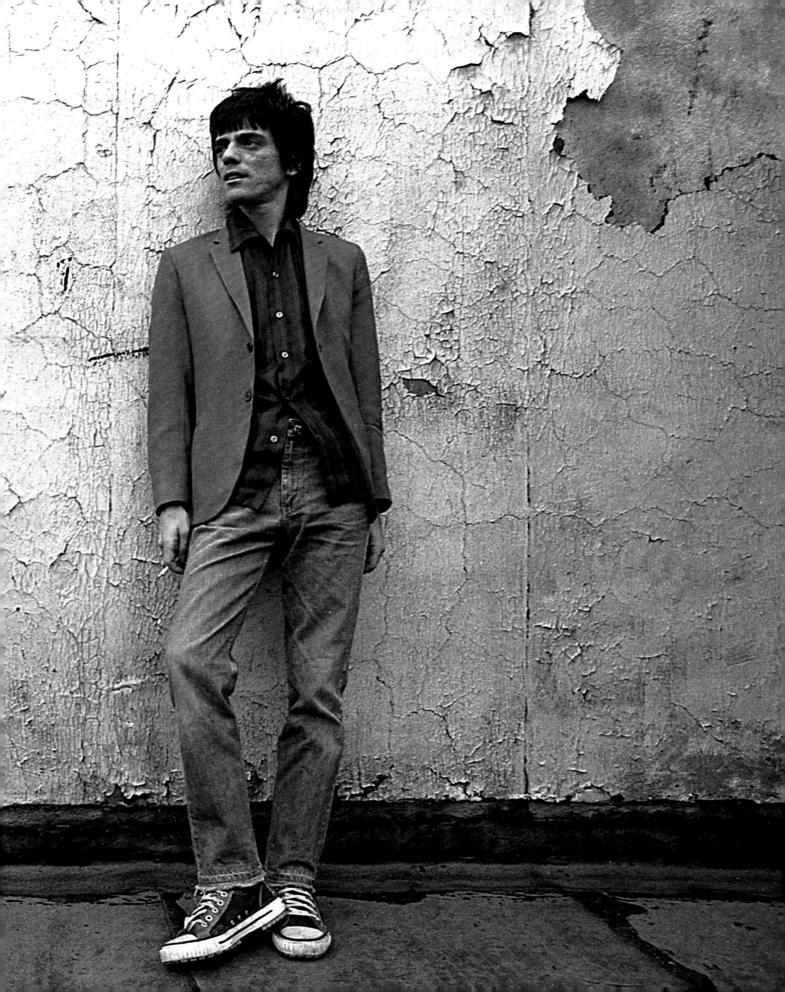

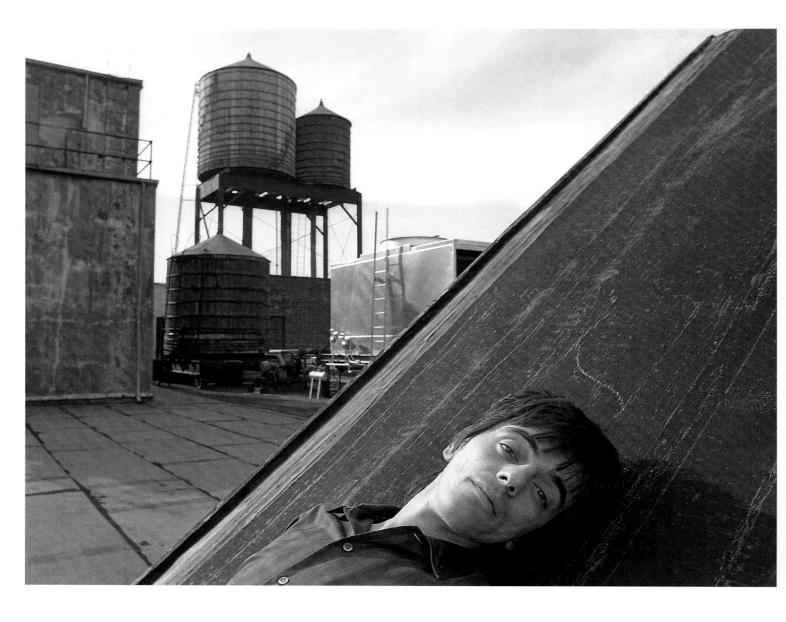

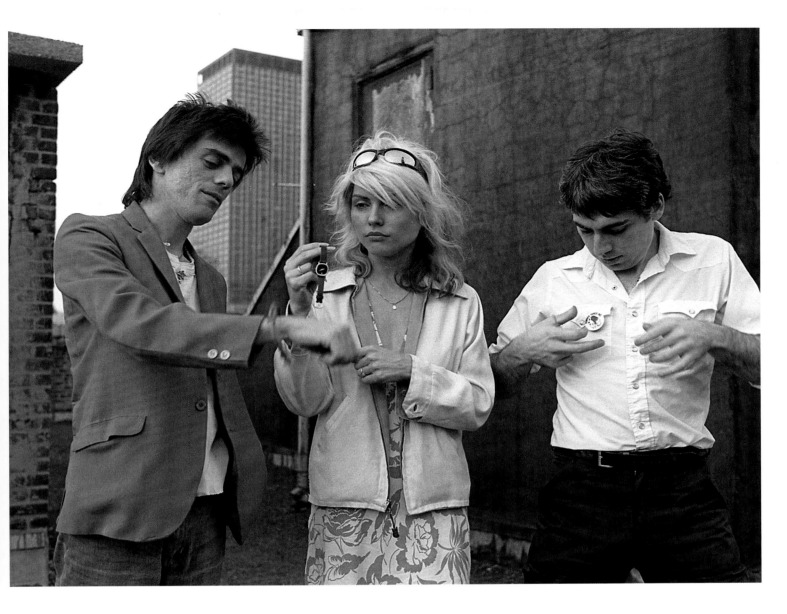

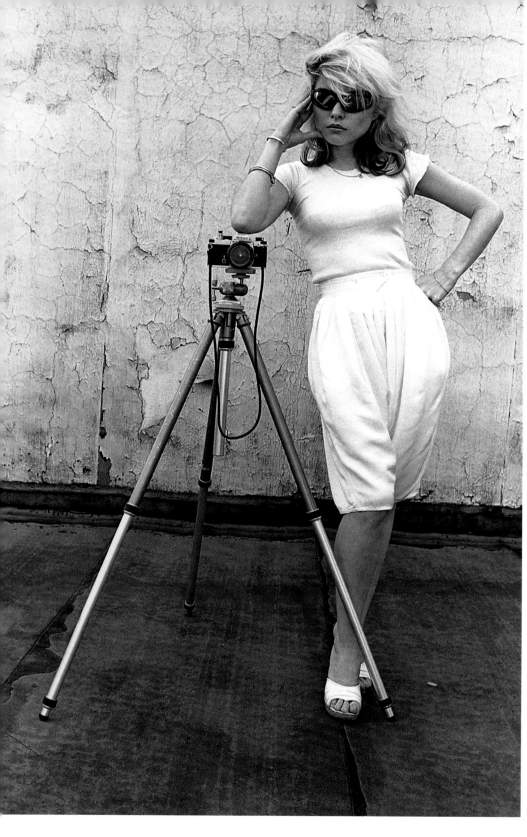

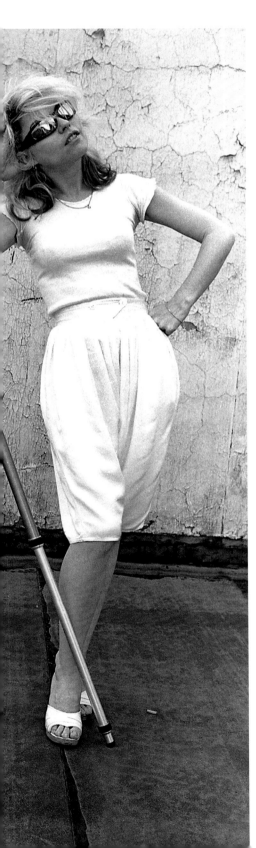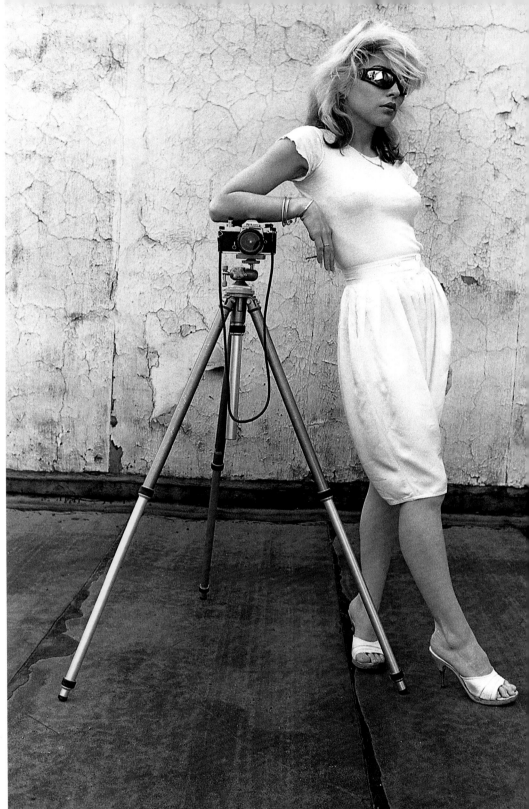

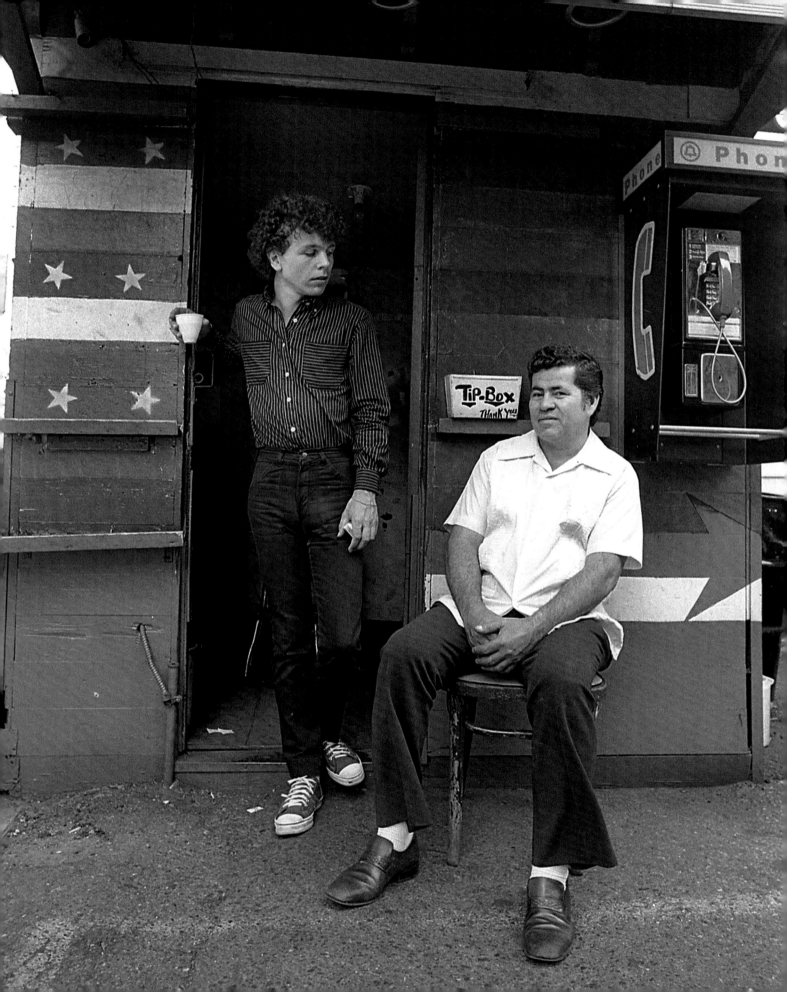

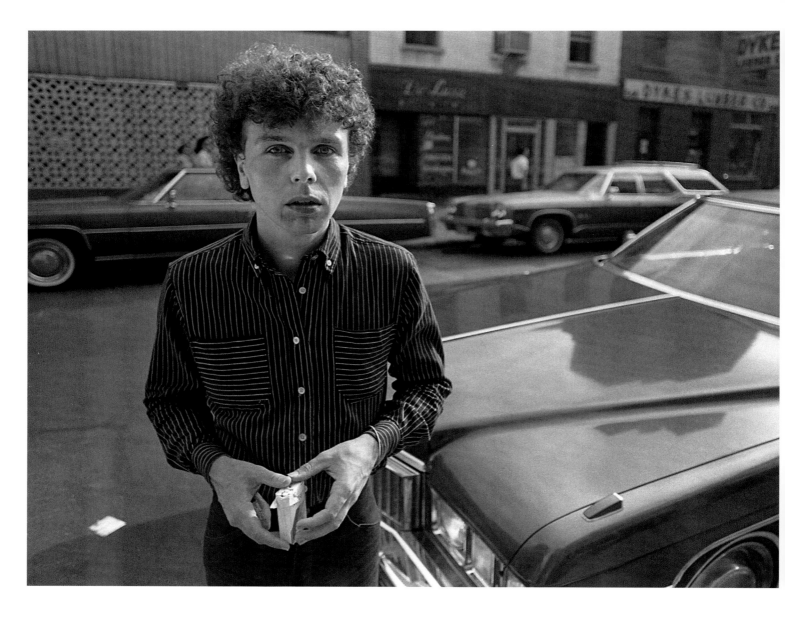

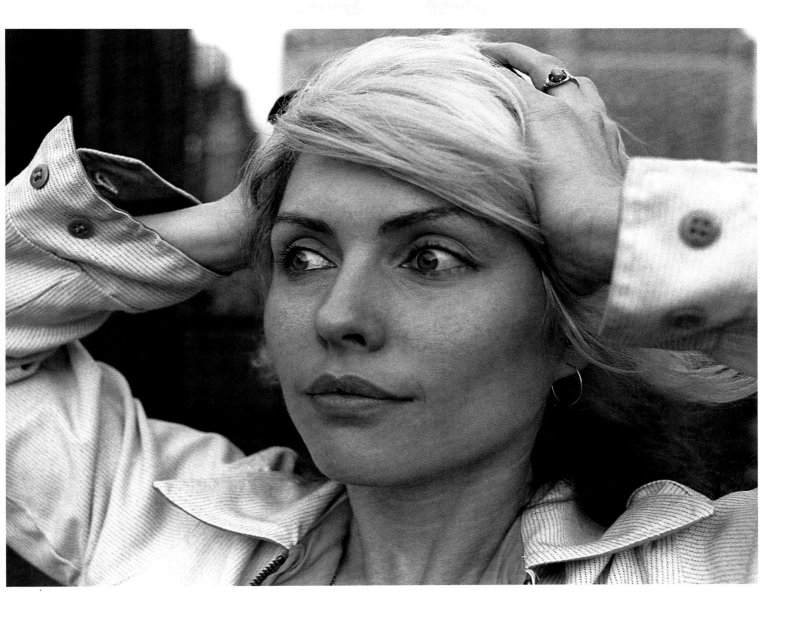

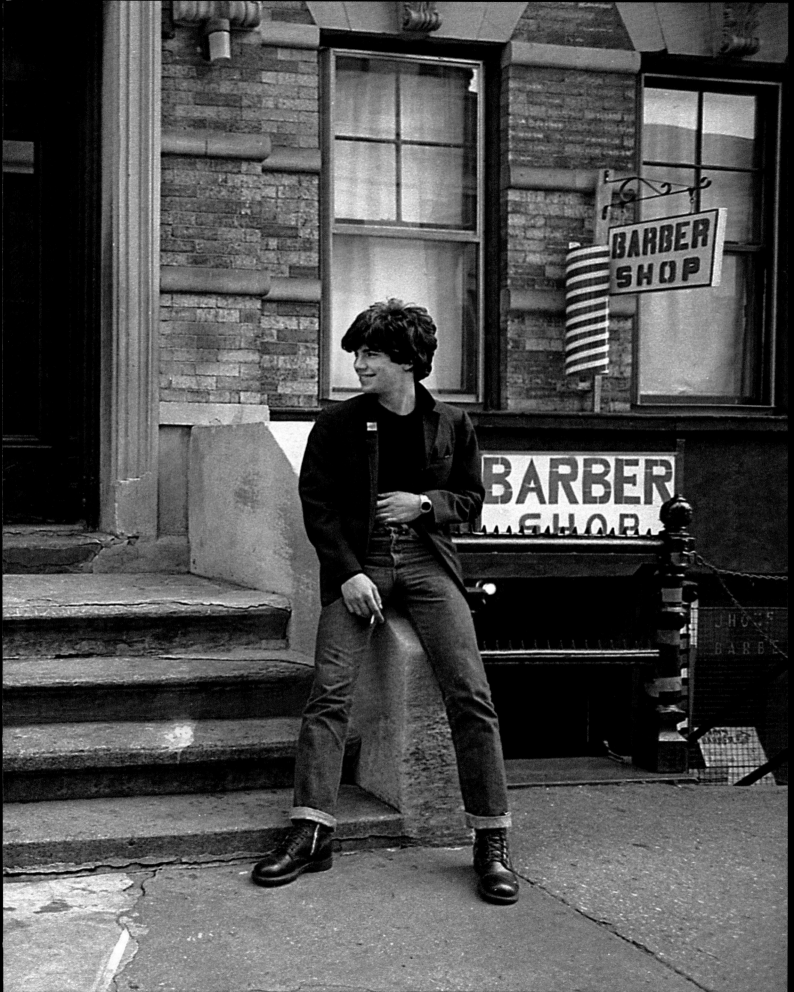

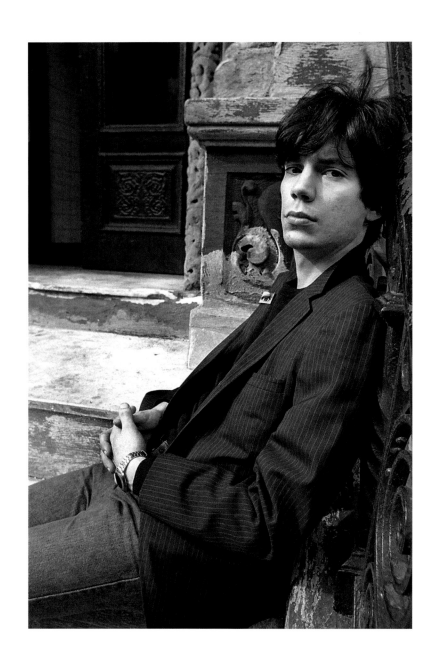

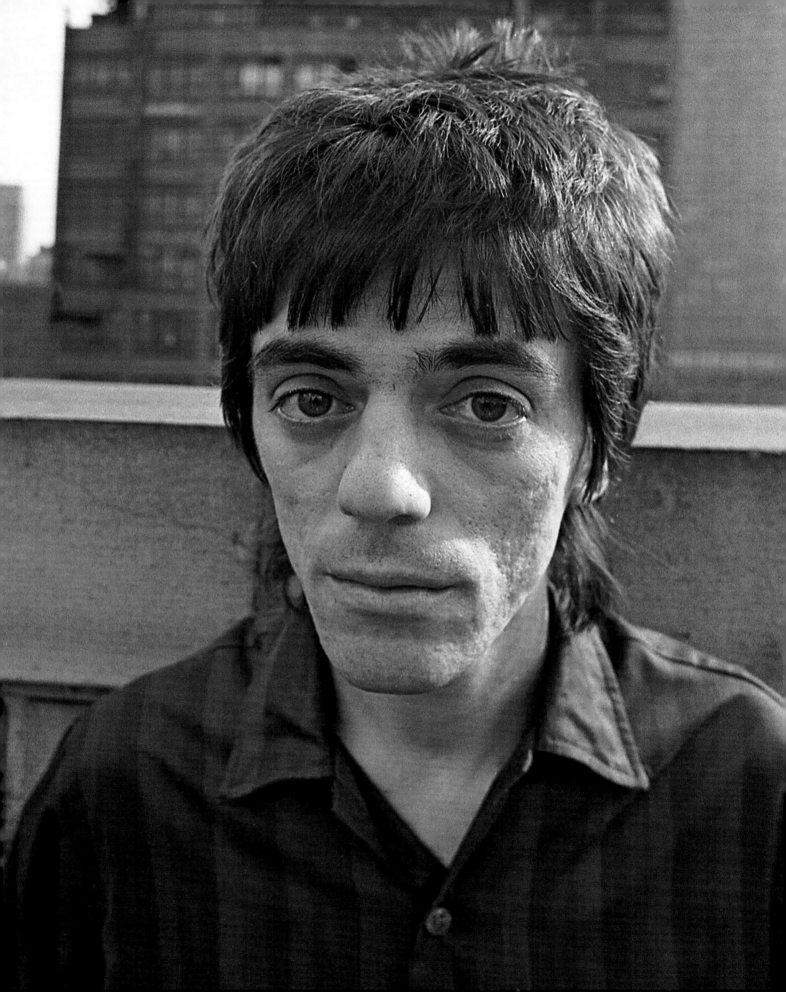

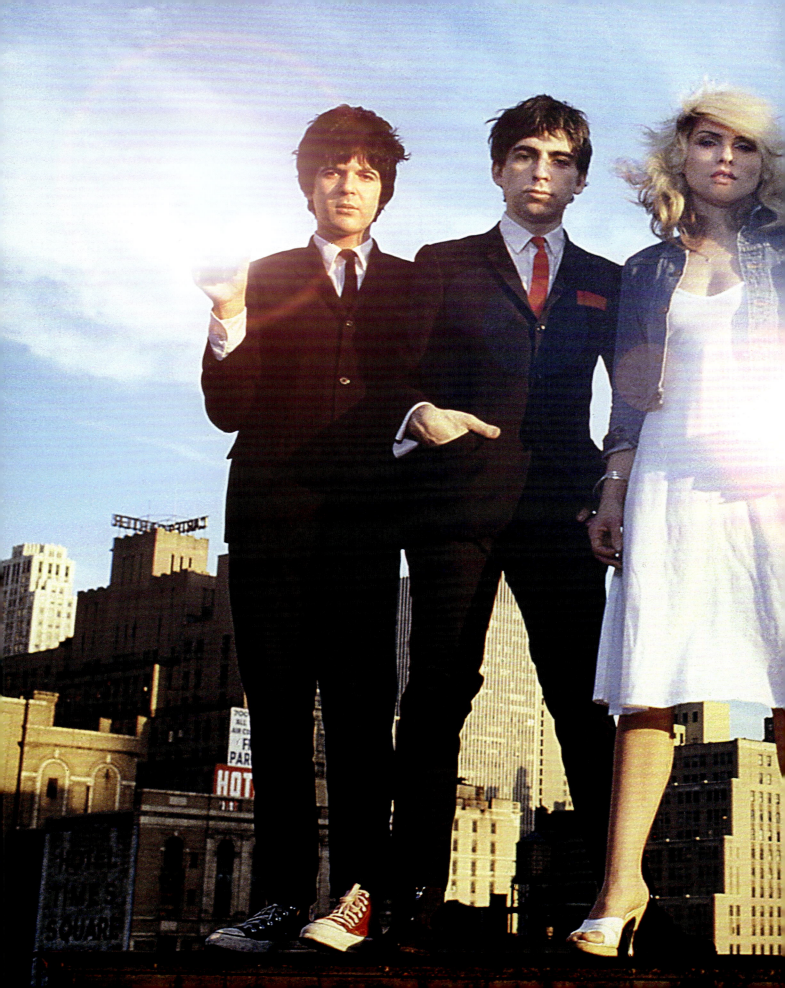

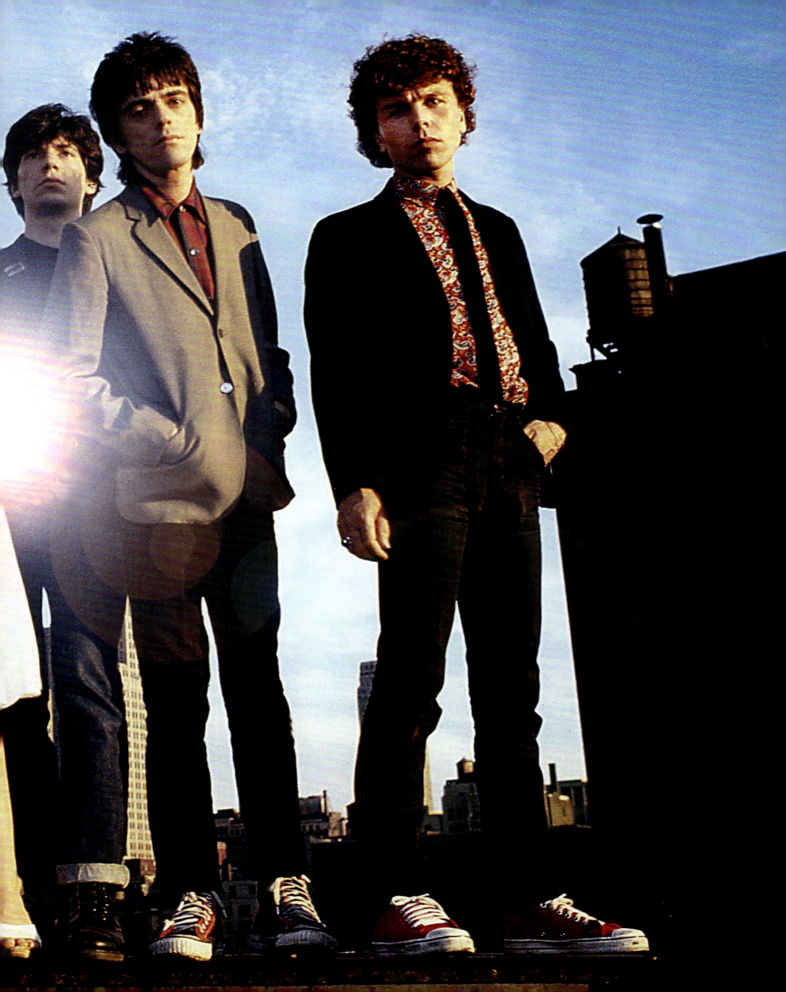

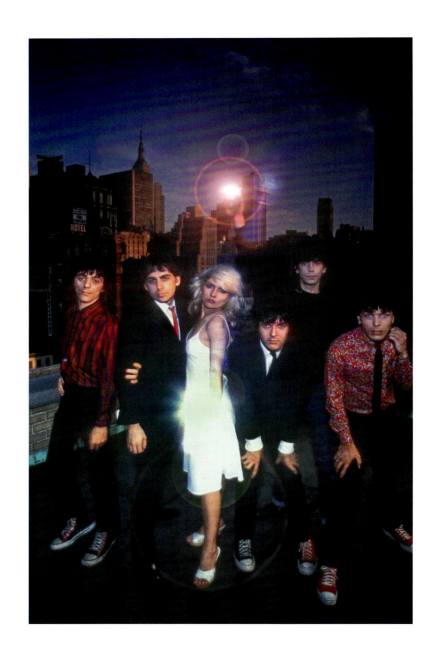

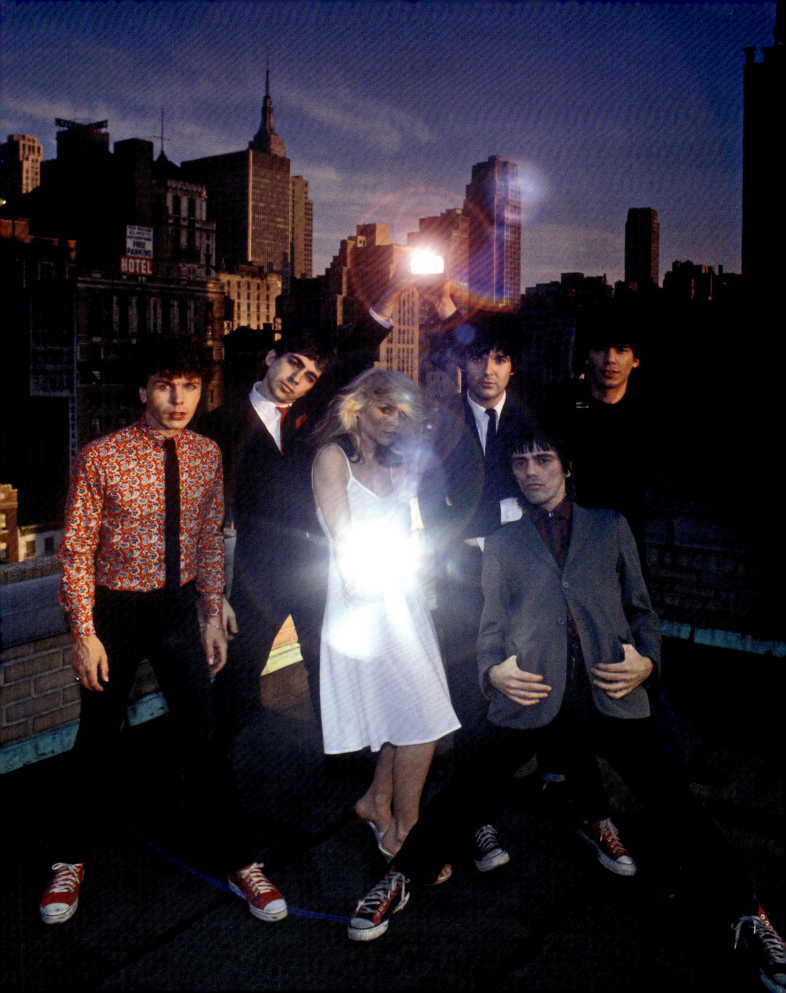

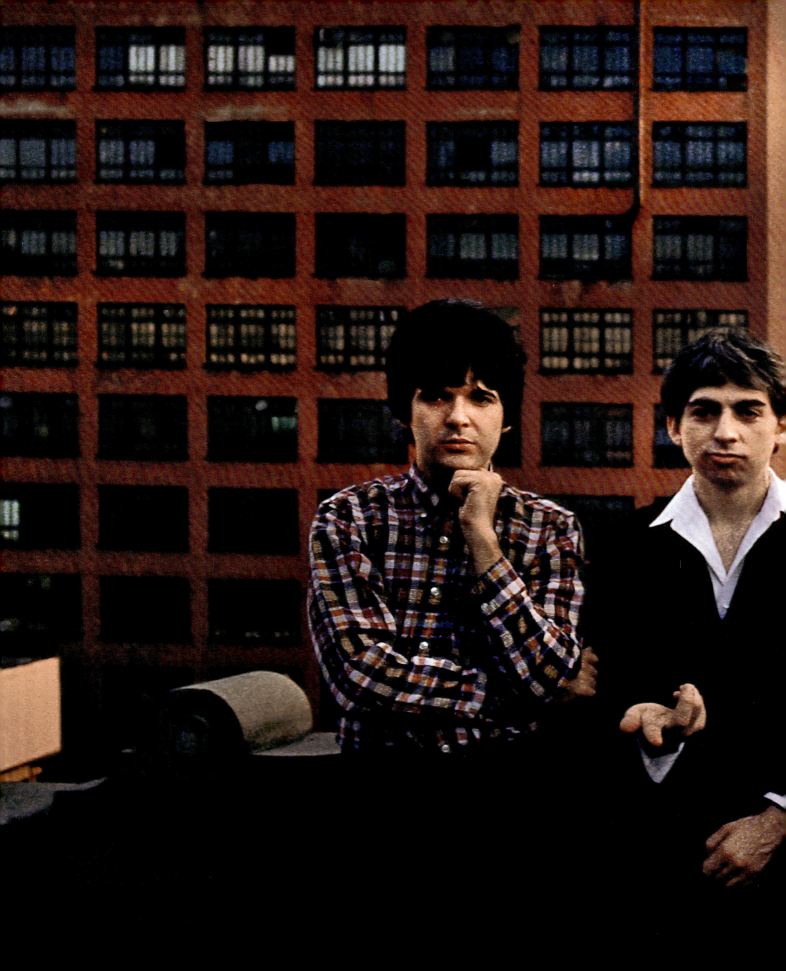

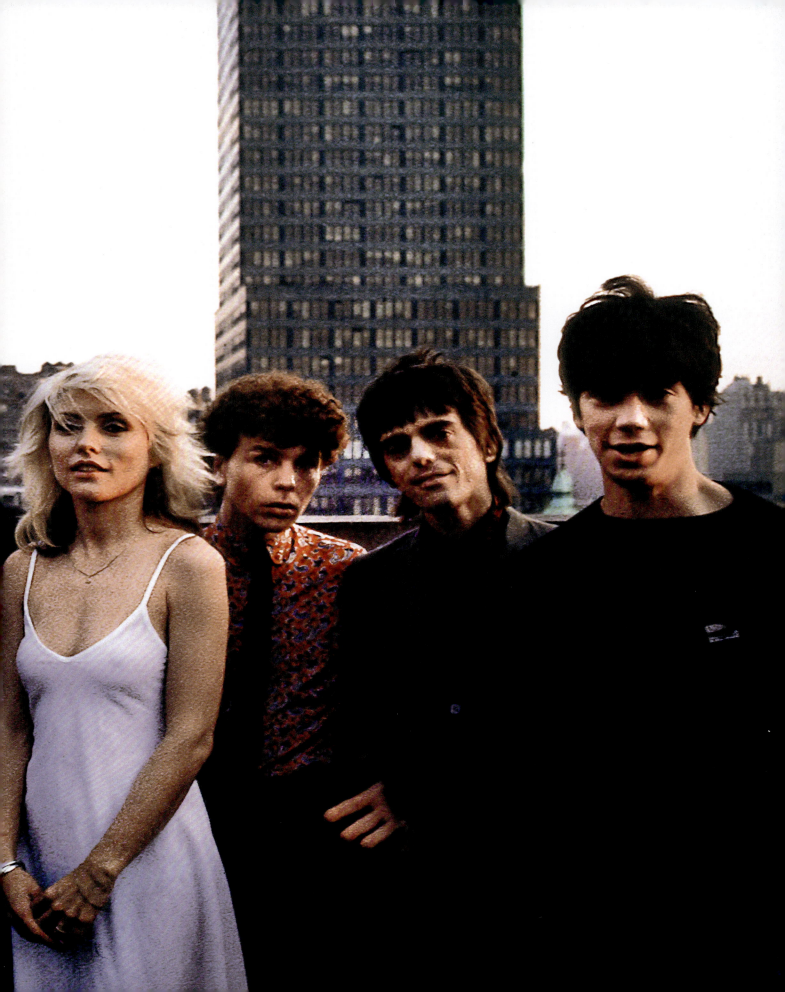

7·RECORDING VOCALS

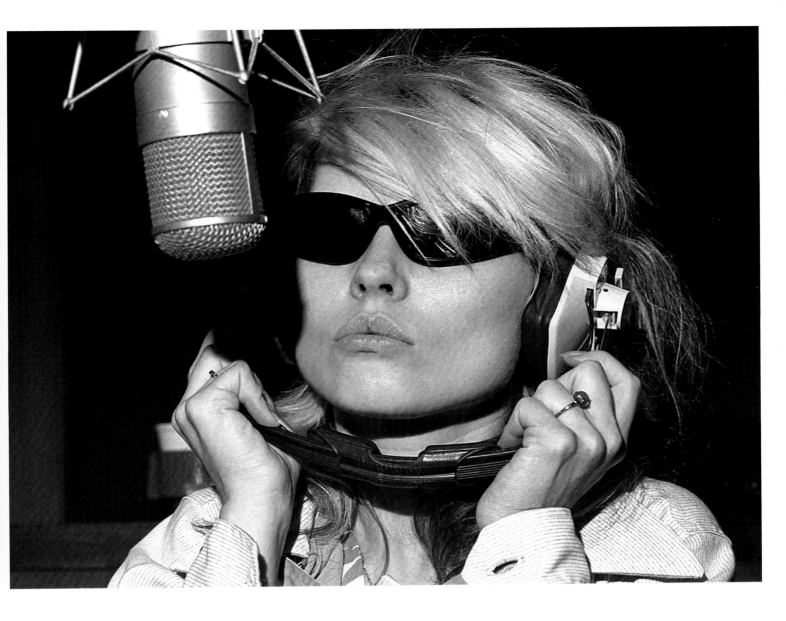

Back in the control room, after our rooftop shoot, I watched the recording process with interest, chatting to members of the band while Debbie was recording vocals in a sound booth. She looked rather frustrated with the painstaking recording of the lyrics line by line. I checked with Mike Chapman, who said it was okay to shoot a couple of rolls of film of Debbie in the studio singing into the microphone. The images were great fun, with her giving a range of tortured facial expressions at having to go over the songs repeatedly. With its punk roots, Blondie the band found the quest for recording perfection mind-blowingly boring. Over-dubs and drop-in notes were not in their DNA. However, the talk on the control room sofas was about crossing over, gaining national radio plays and breaking into the US charts, so the band from the New York scene were taking their medicine from Dr Chapman. The resulting album *Parallel Lines* catapulted the band into nationwide recognition and mainstream American pop culture.

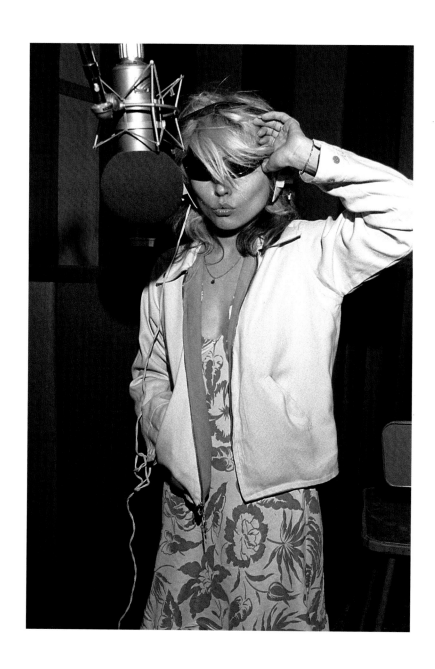

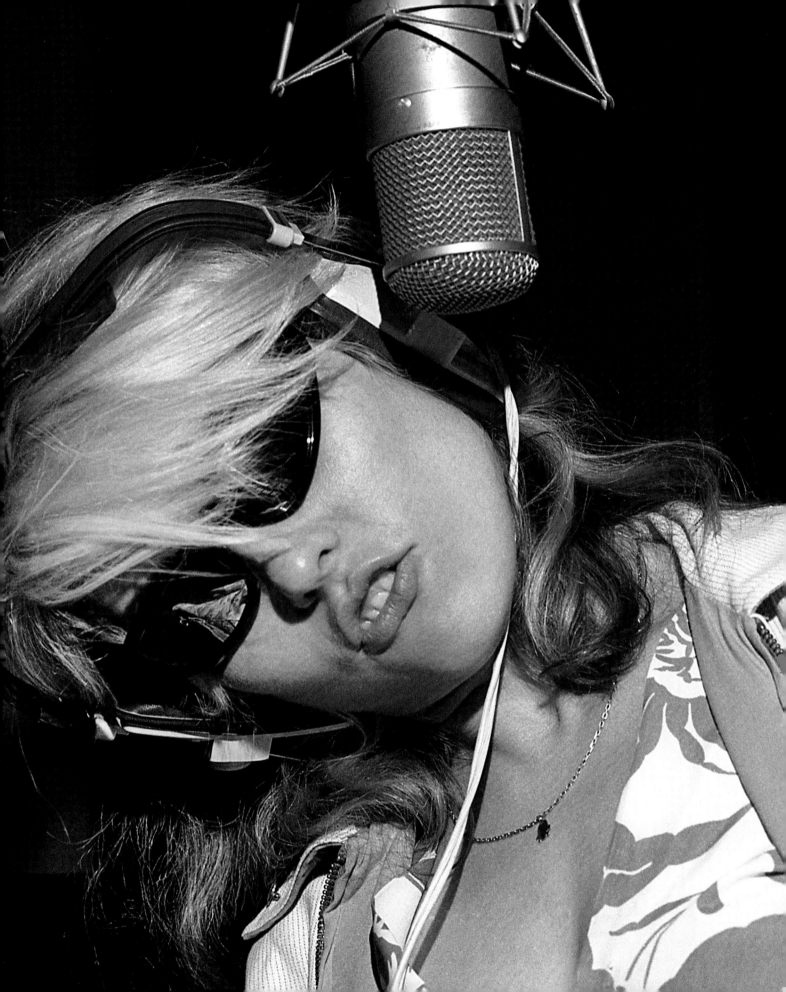

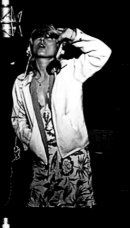
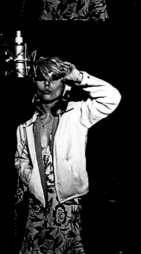
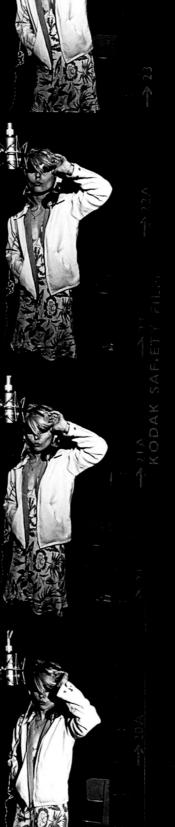
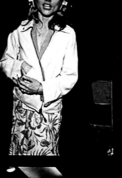
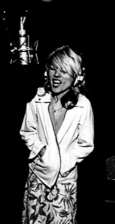
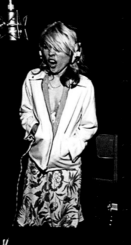
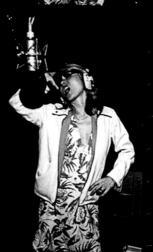
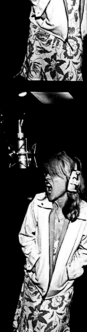
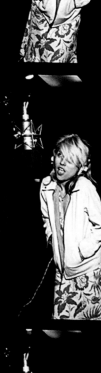

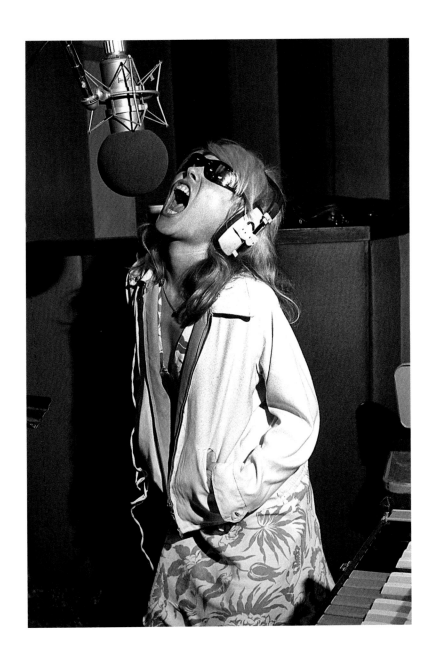

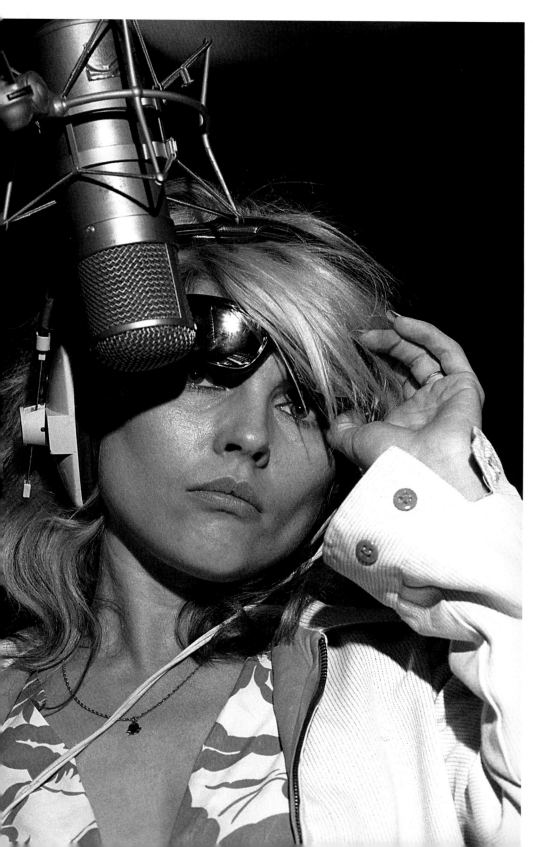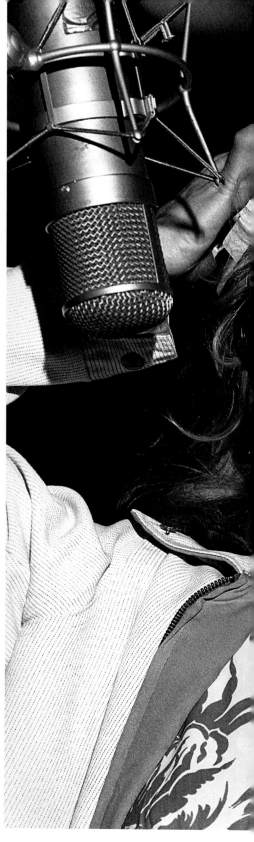

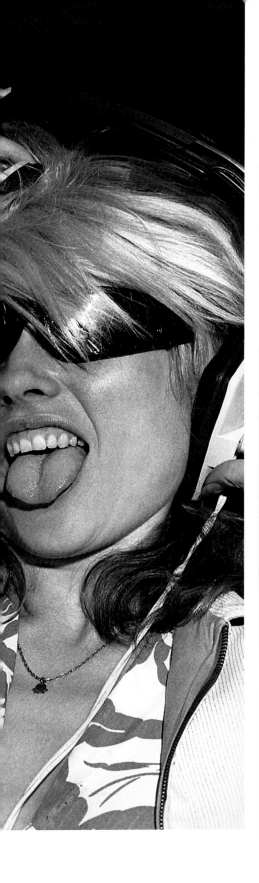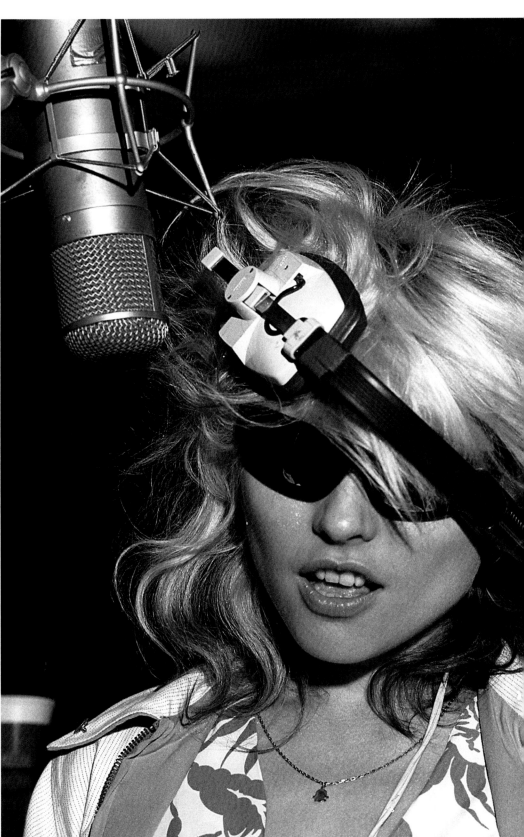

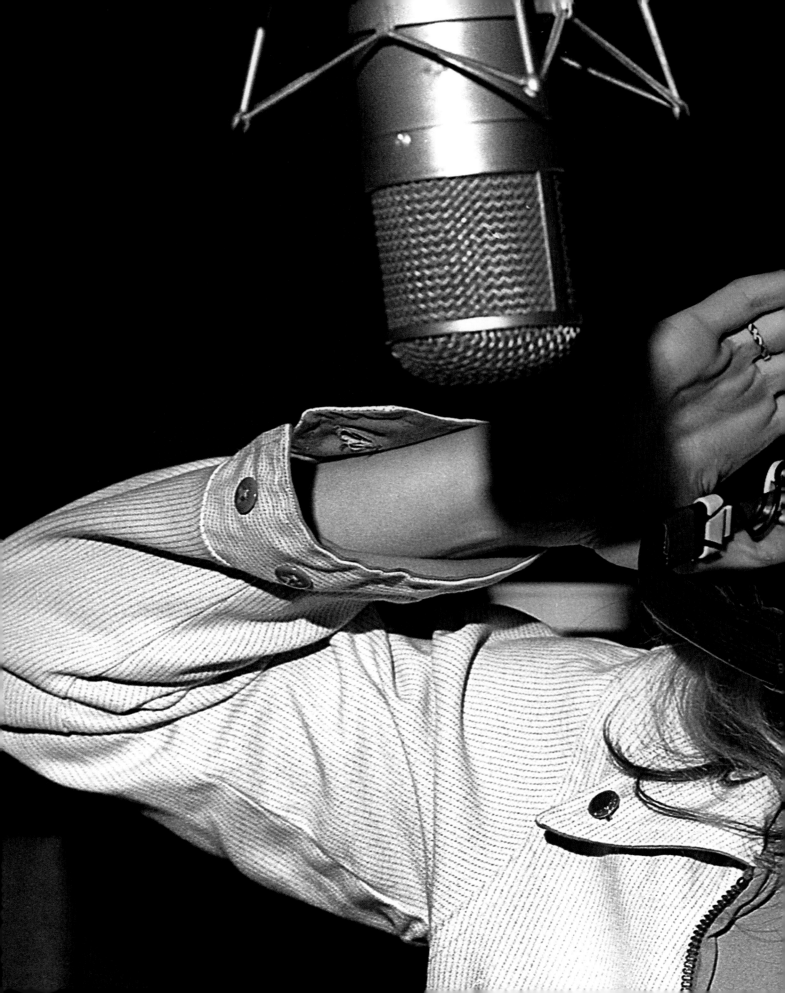

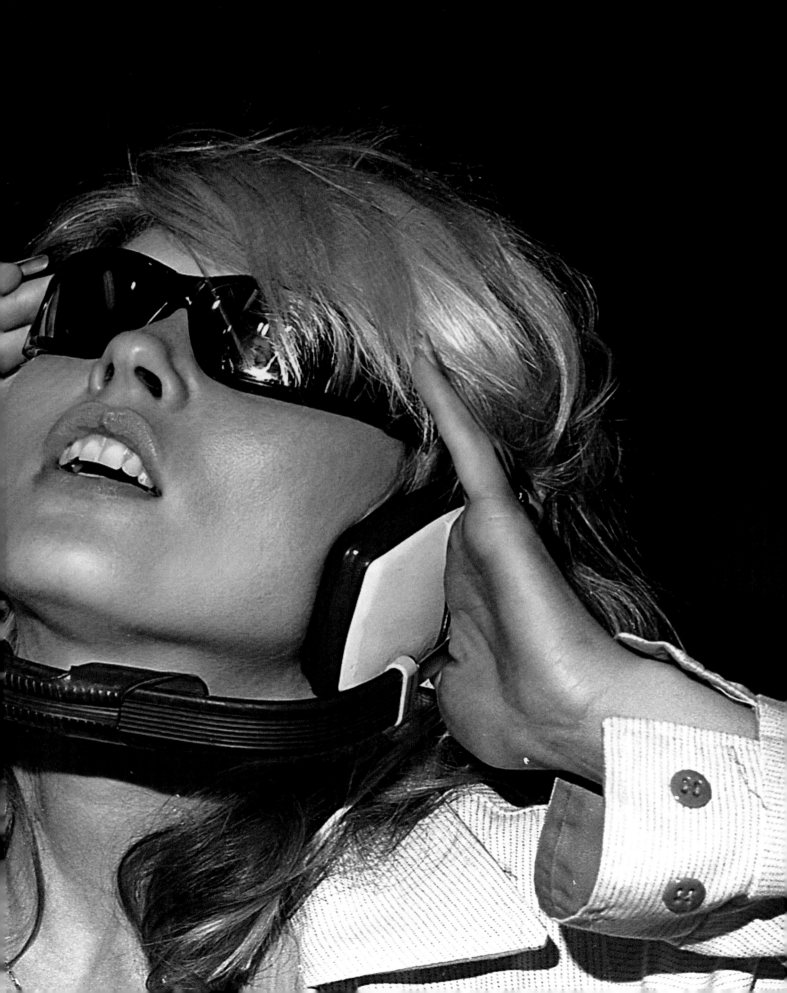

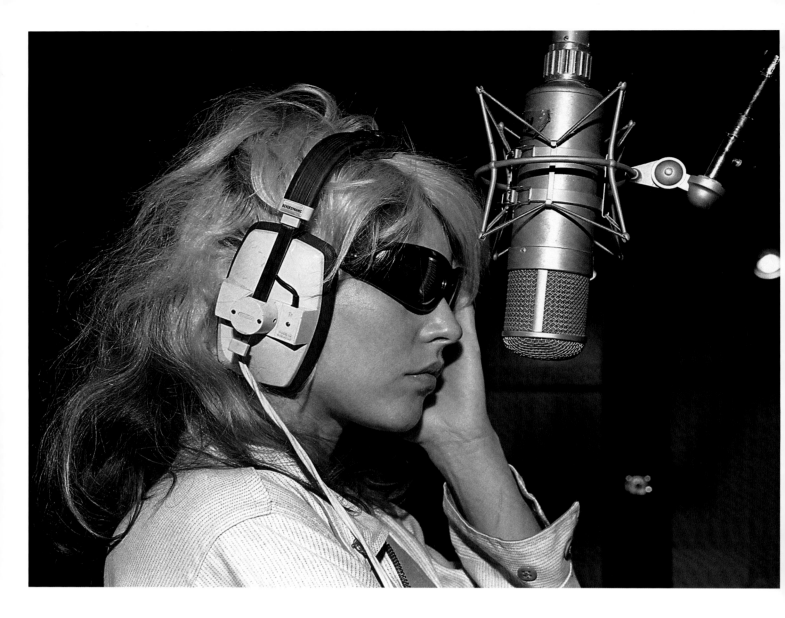

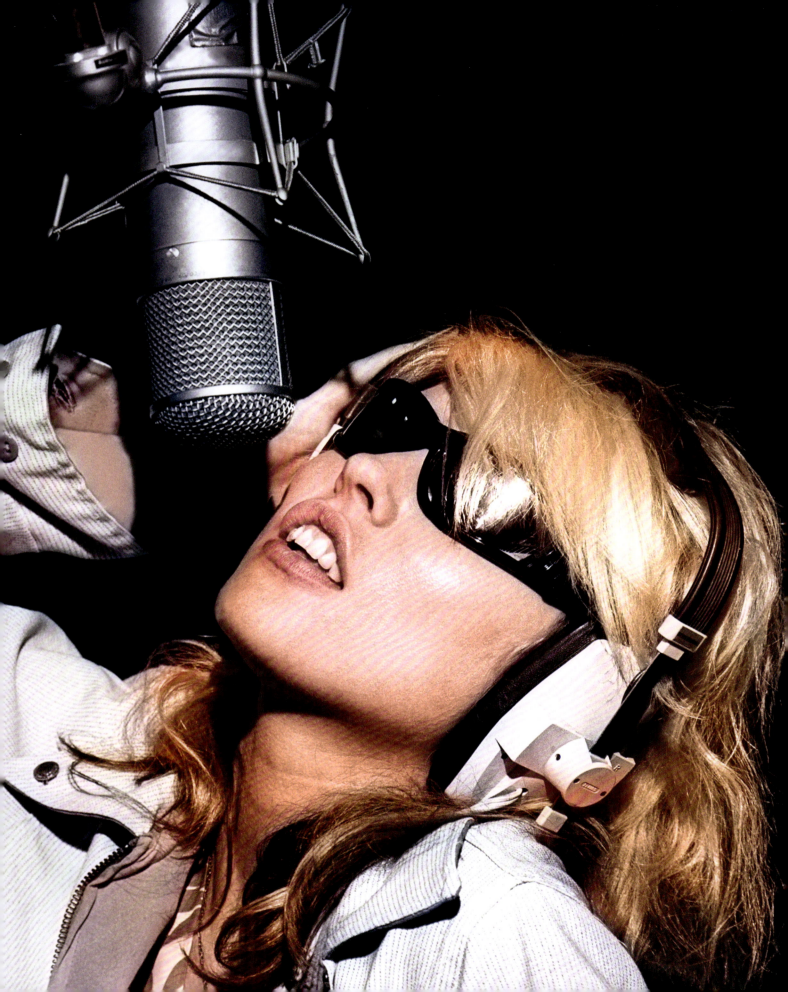

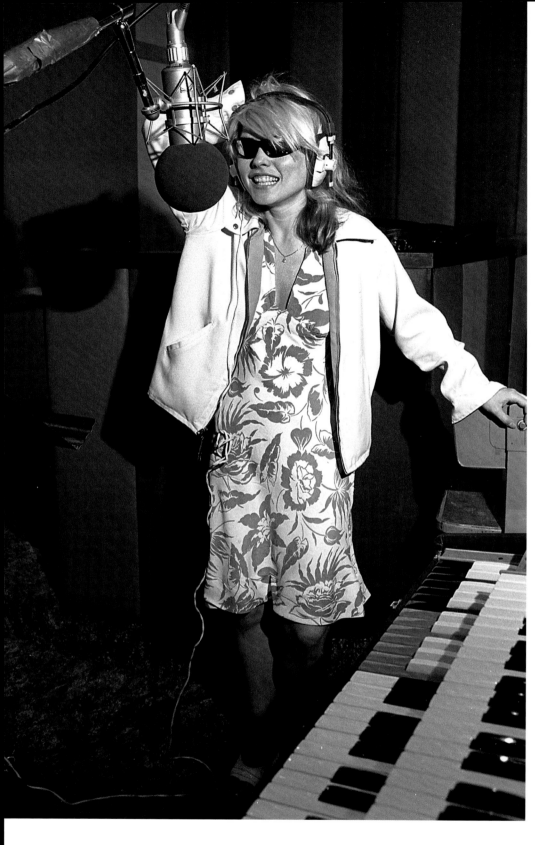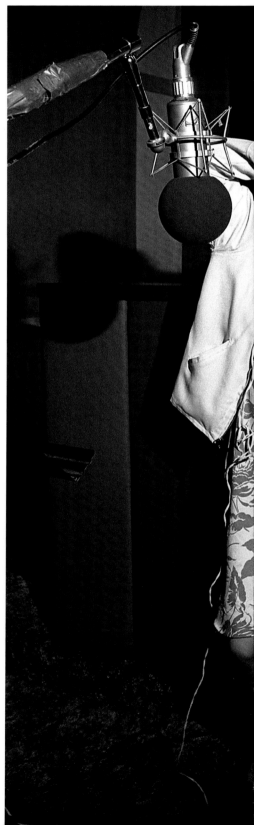

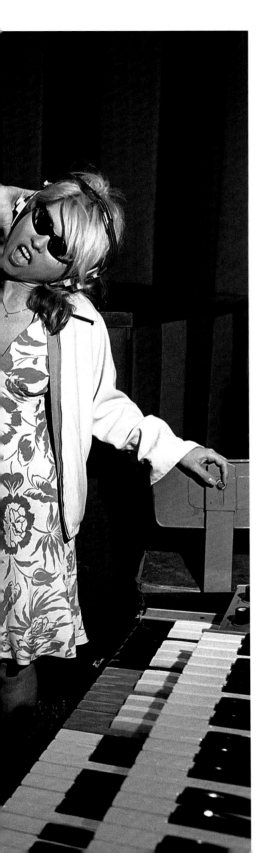
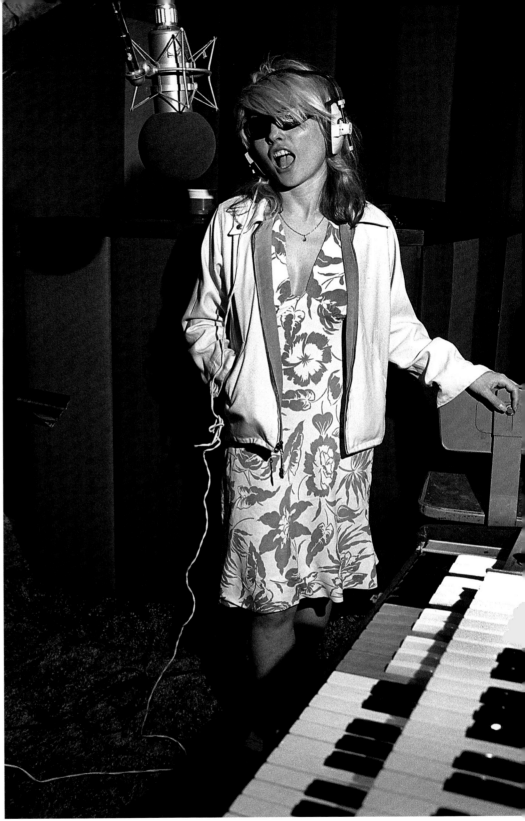

8·LIVE AT THE SPECTRUM

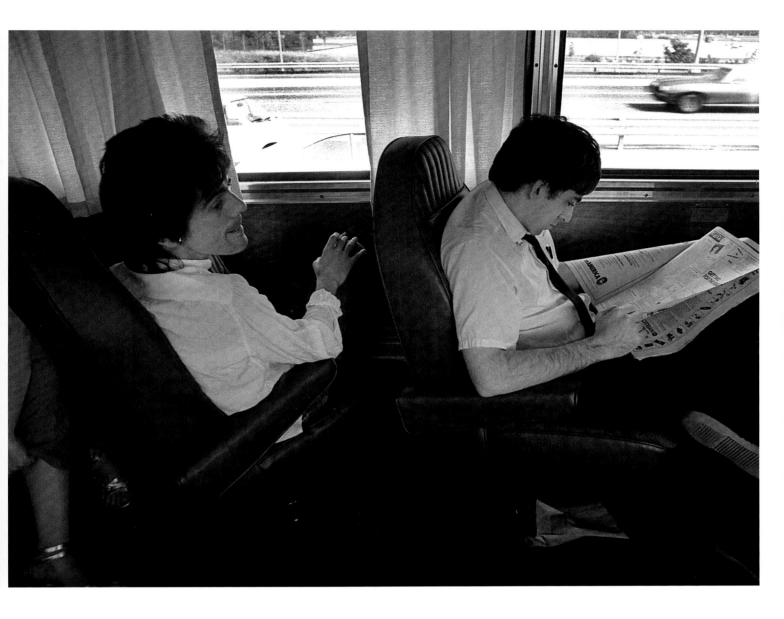

On the Friday, at around midday, we boarded the tour bus for the Spectrum arena in Philadelphia, where Blondie would be supporting Alice Cooper. The band, their close friends, management, Mike Chapman, Beverley and I settled down for the drive south, with me shooting various black-and-white images on the bus as it sped down the freeway. When we arrived at the venue, we went to the green room, where the band relaxed and filled in the time before the show. My impression was that the gig was a great break from the day-to-day recording sessions and a chance to perform live music. The band played a set list of 22 songs, ending with 'Jet Boy', which was rather apt as I would be London bound the following day. Memorably, Debbie met Alice Cooper's snake prior to show time, though we would miss the Alice Cooper show and the snake's performance, which was a shame. Straight after Blondie's set, everybody was back on the tour bus to New York. Lights dimmed and we crashed out.

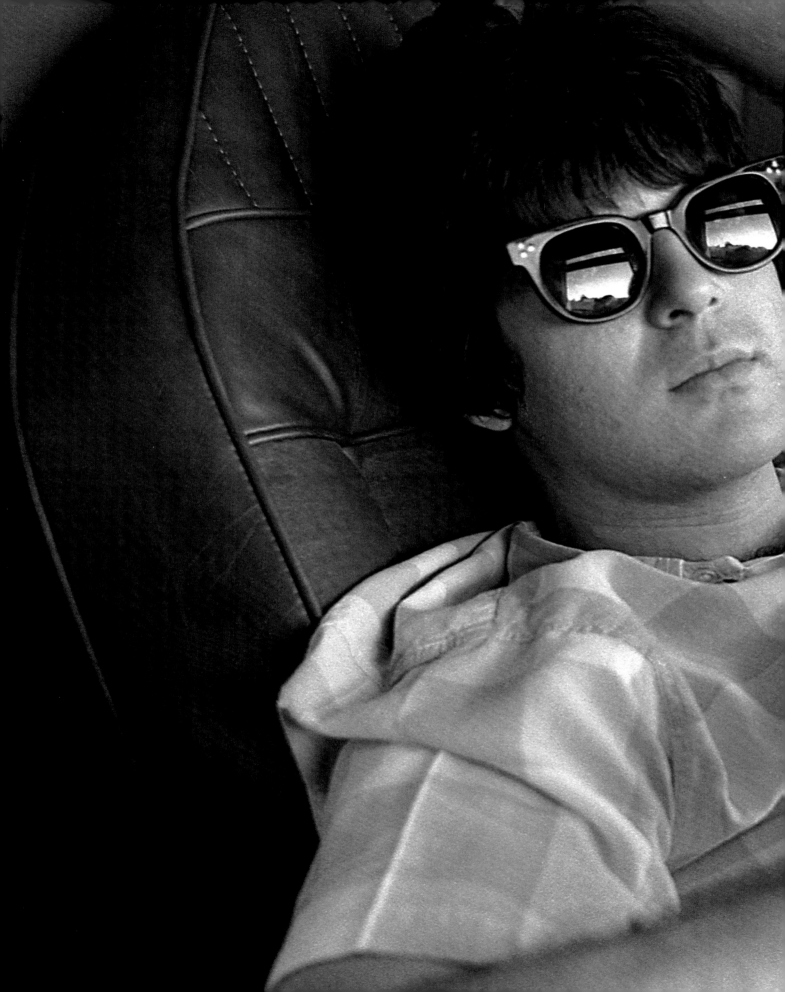

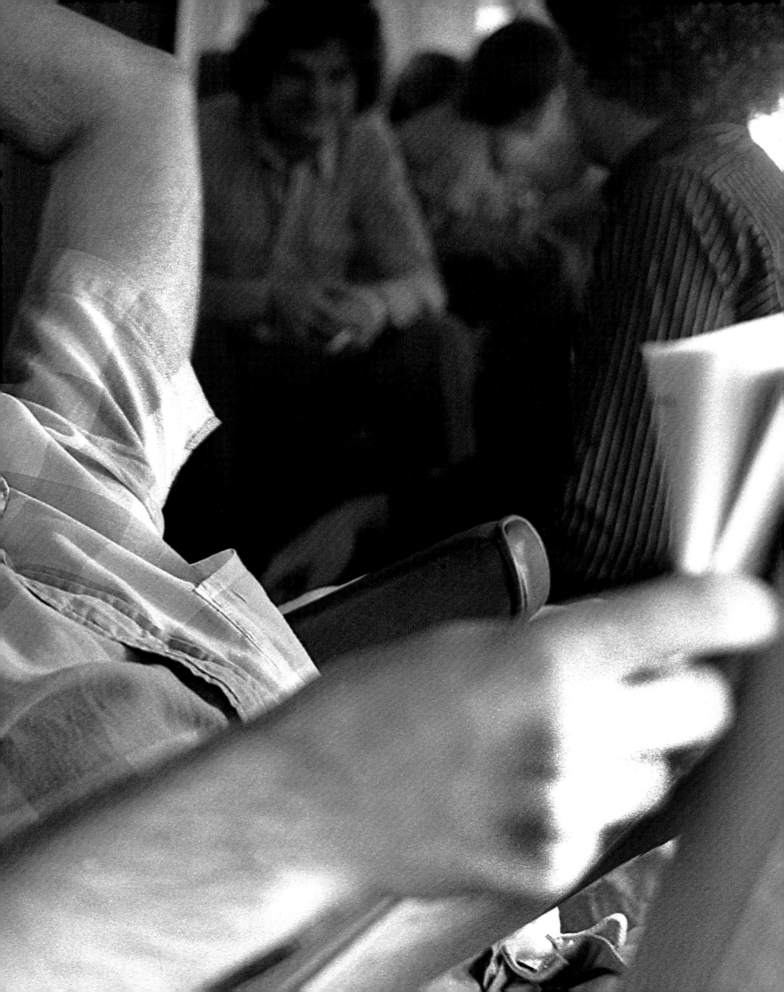

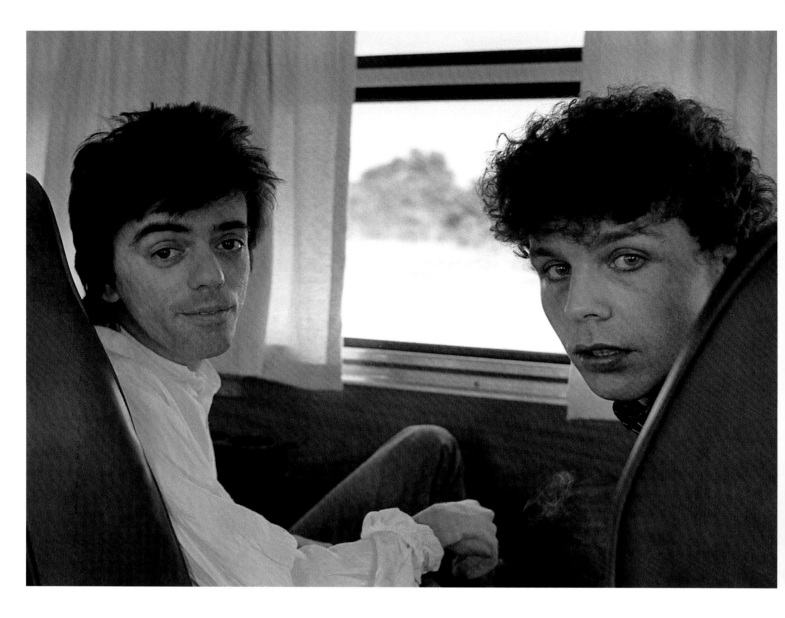

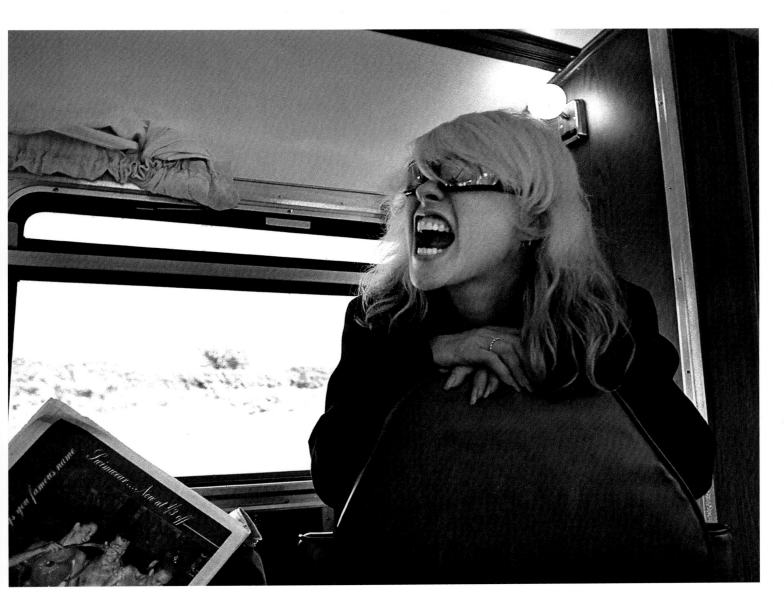

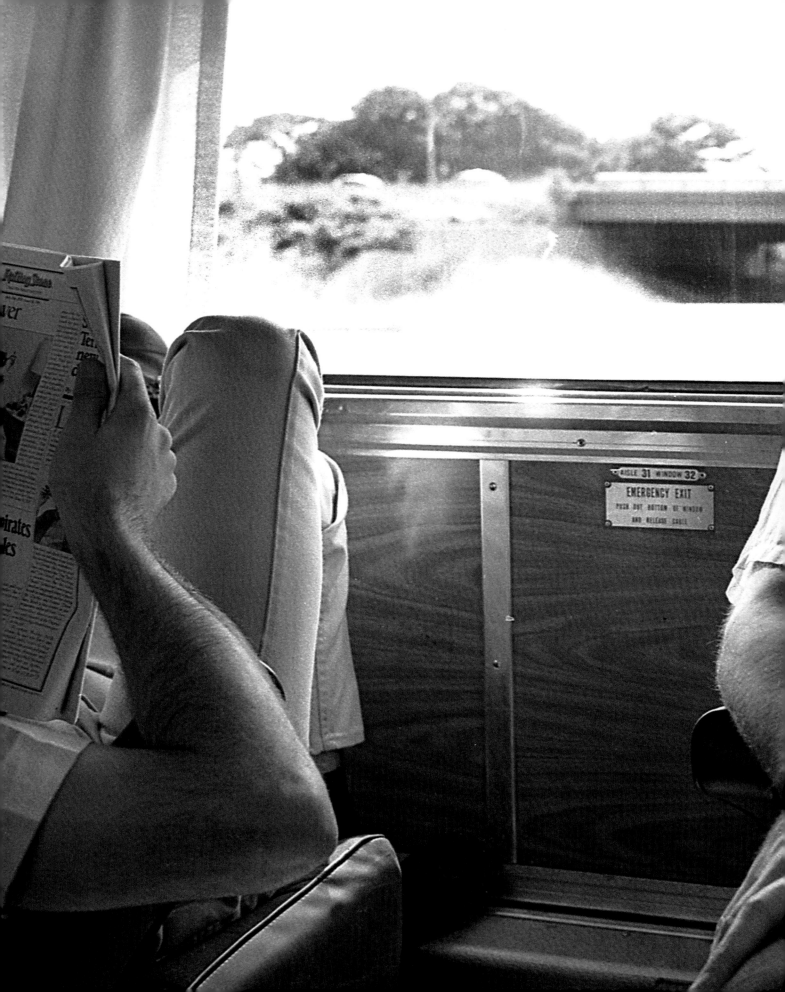

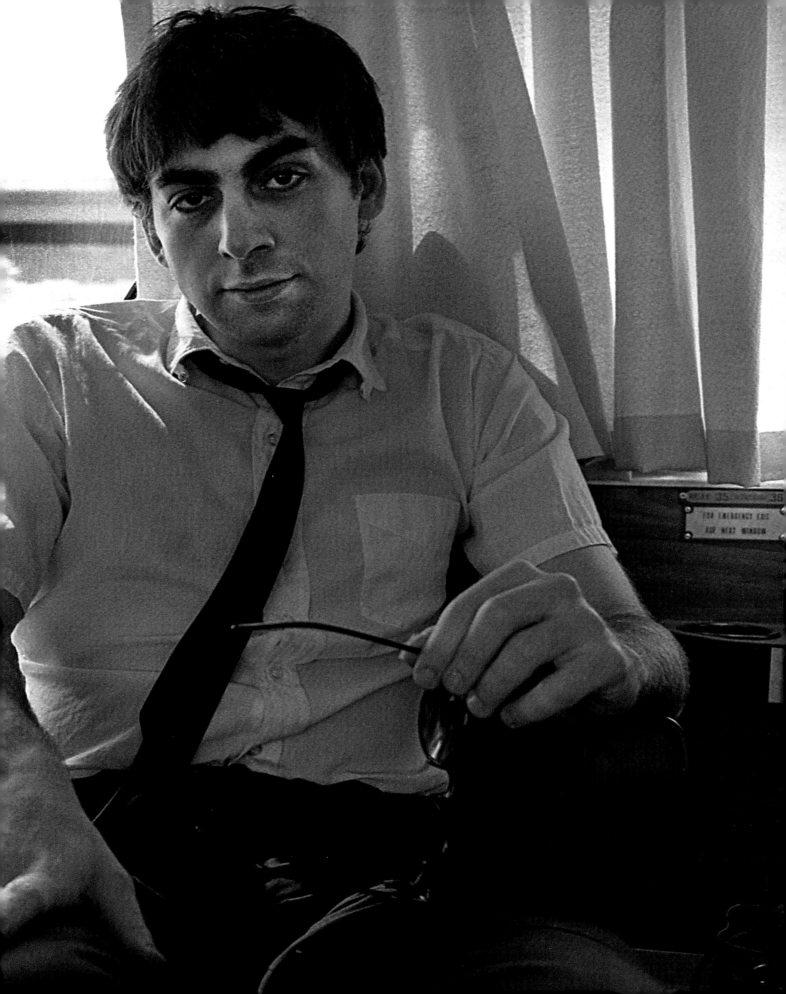

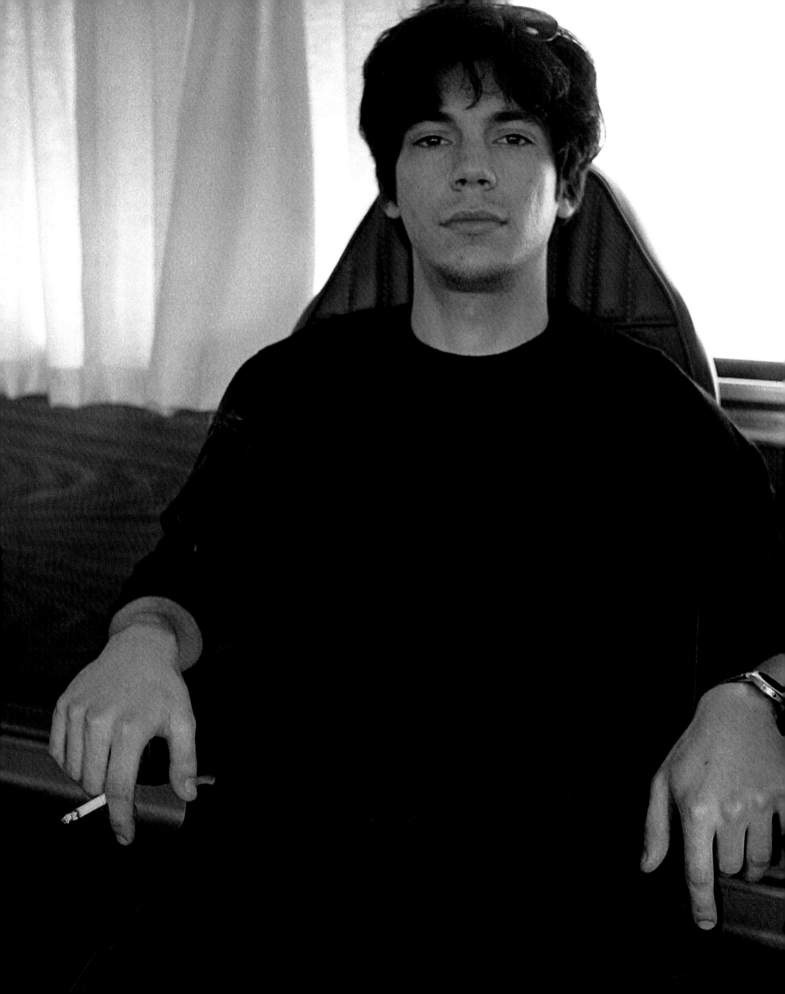

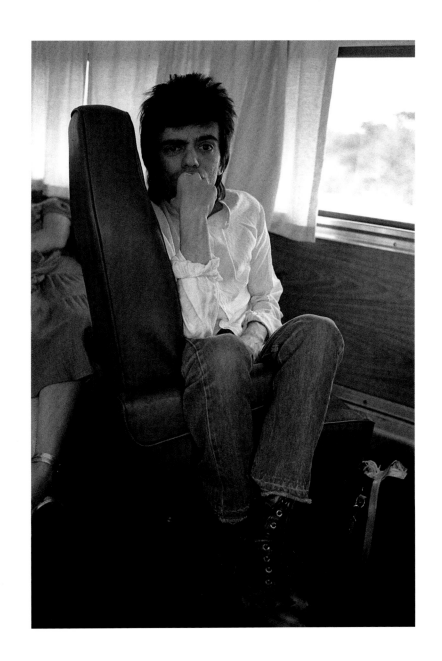

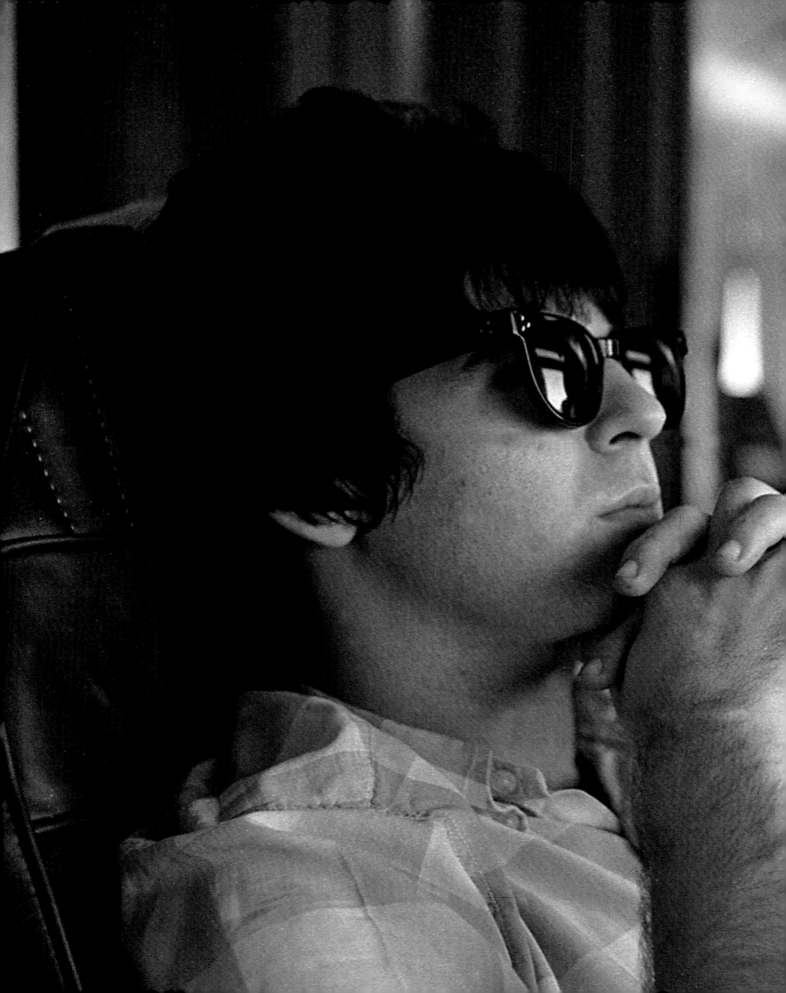

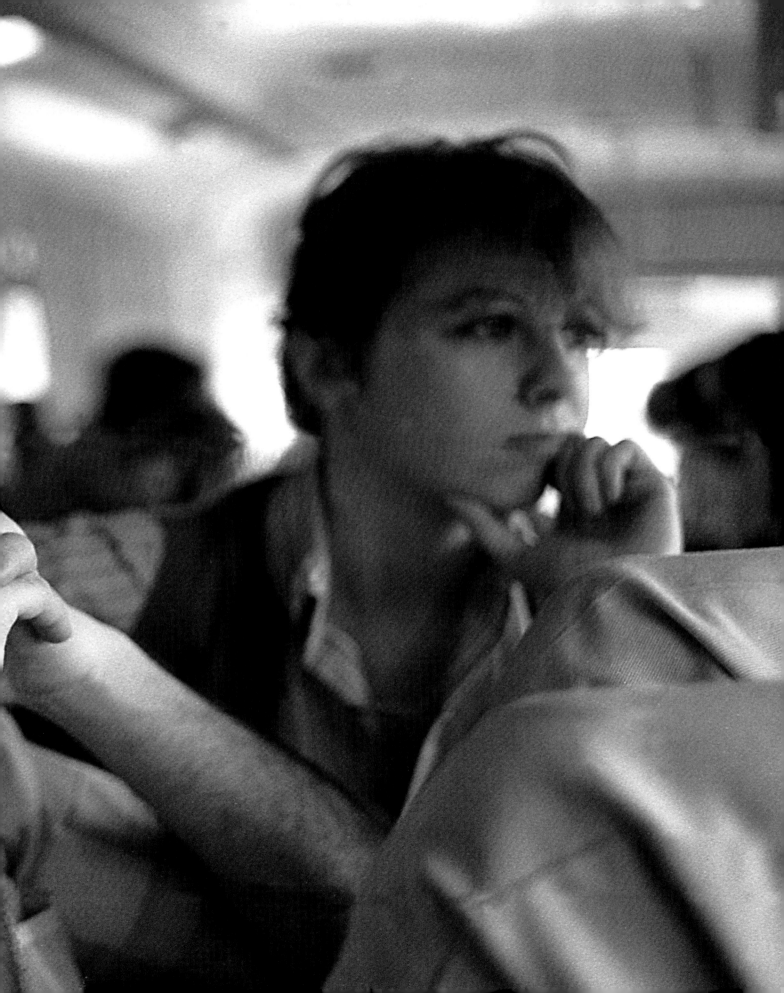

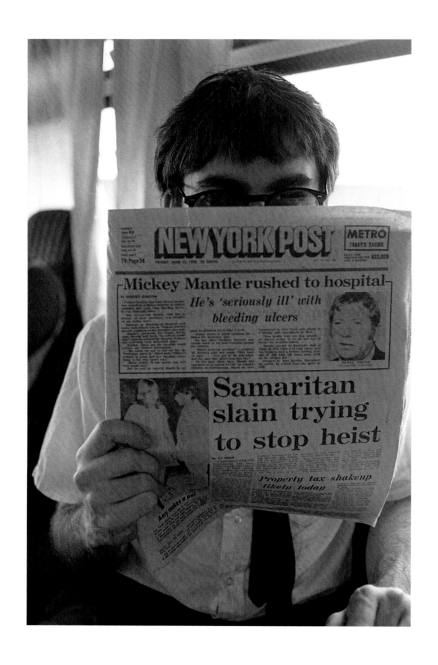

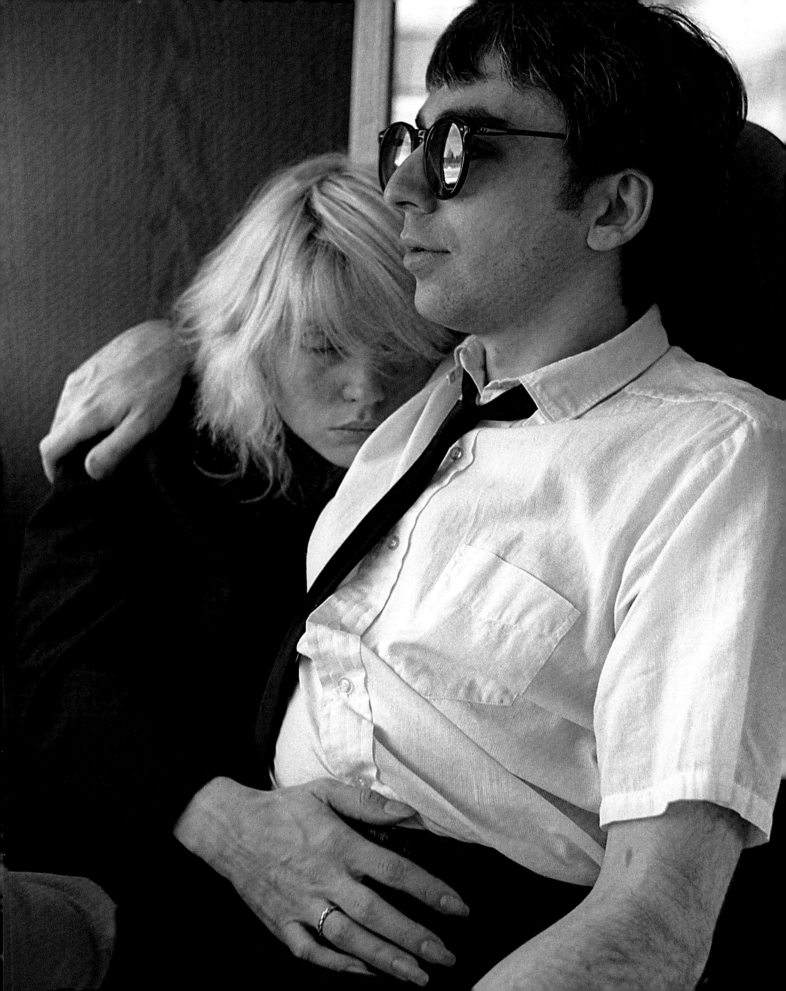

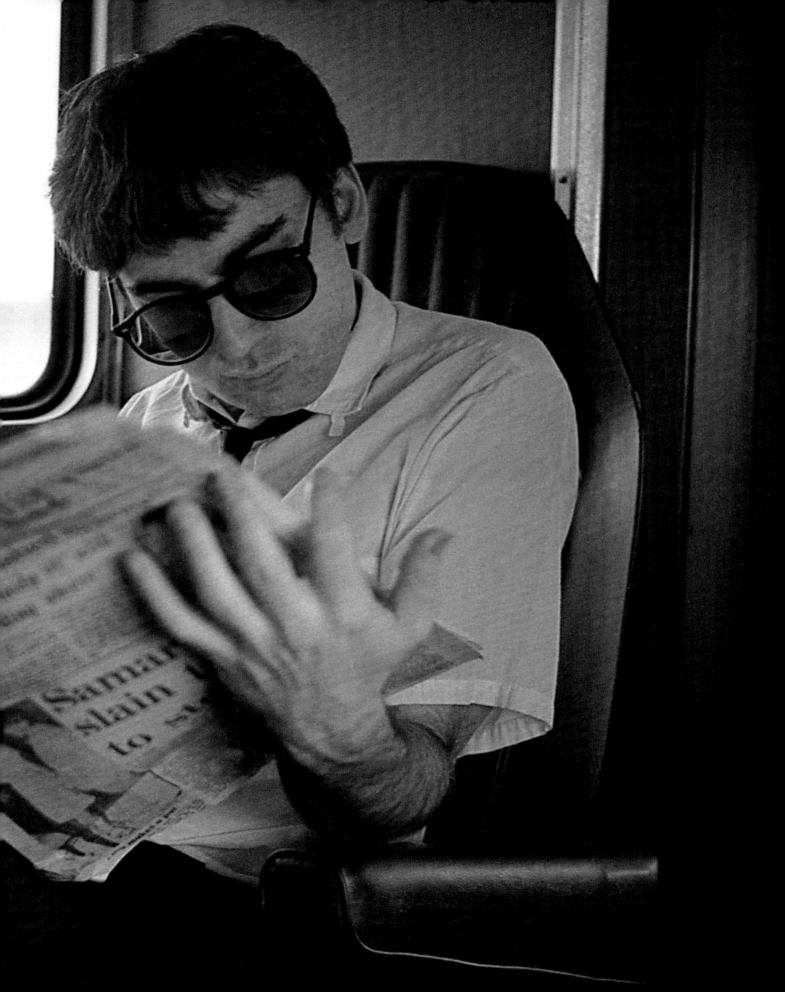

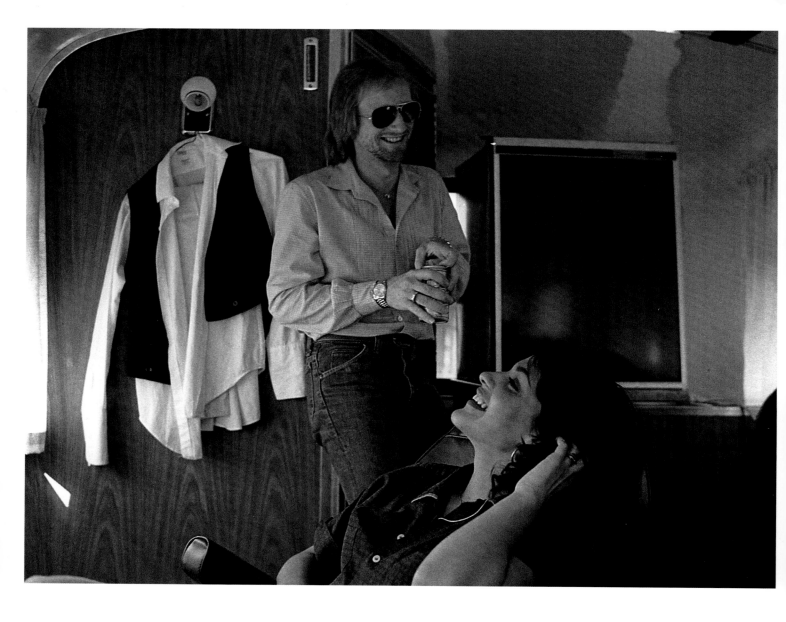

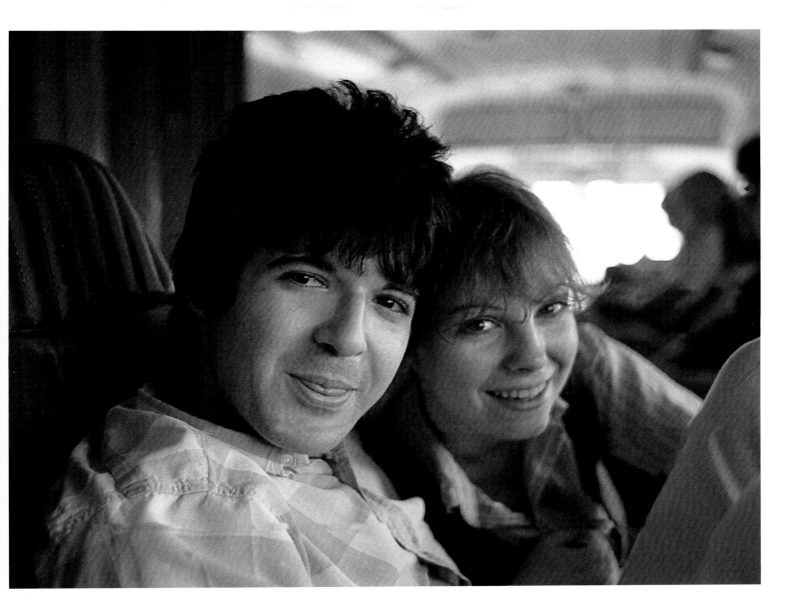

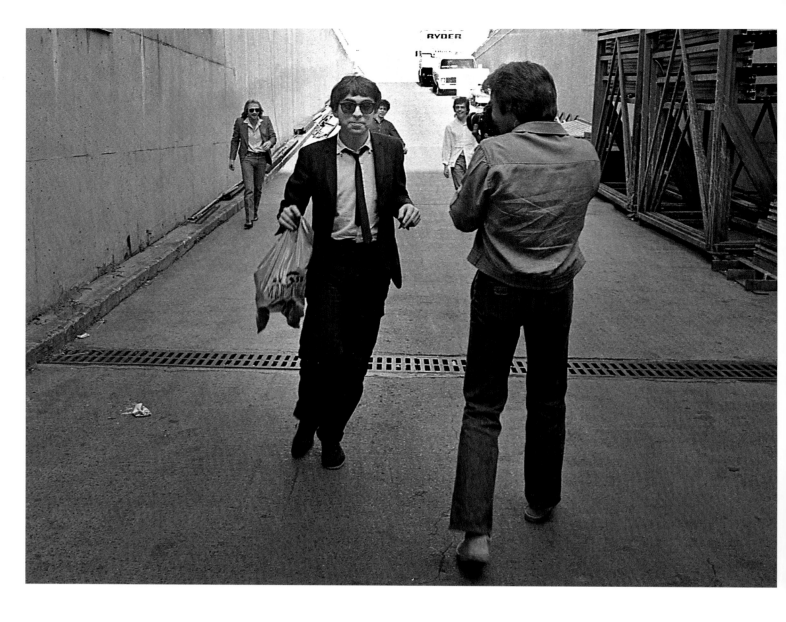

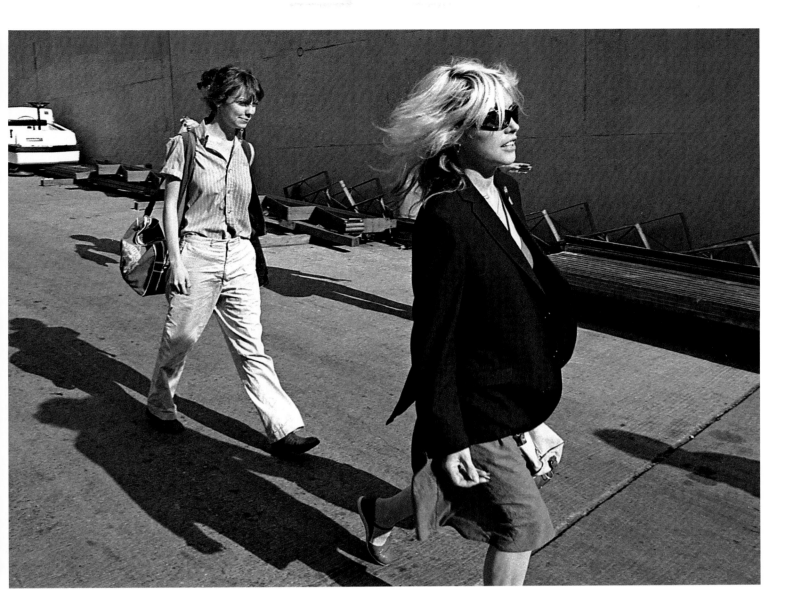

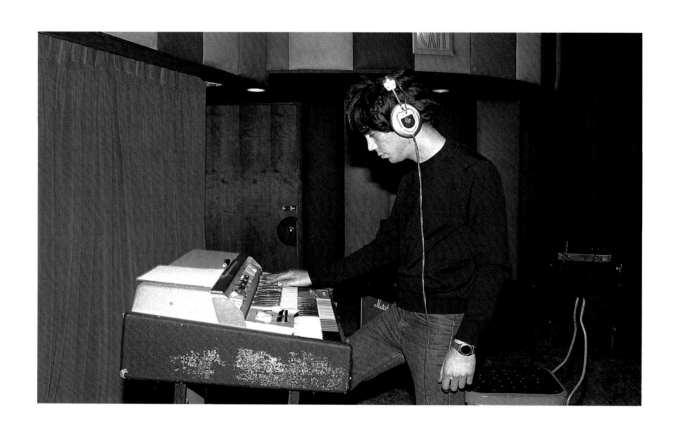

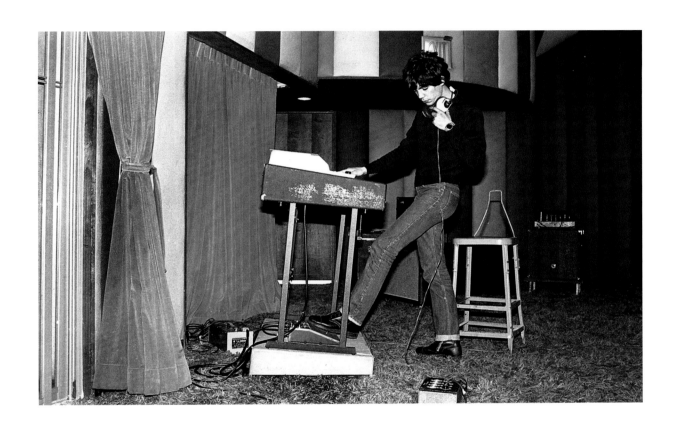

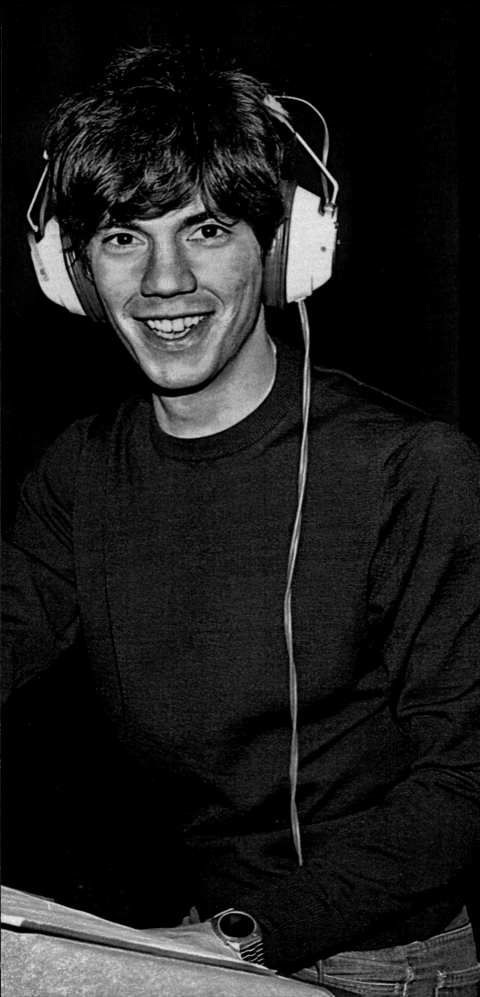

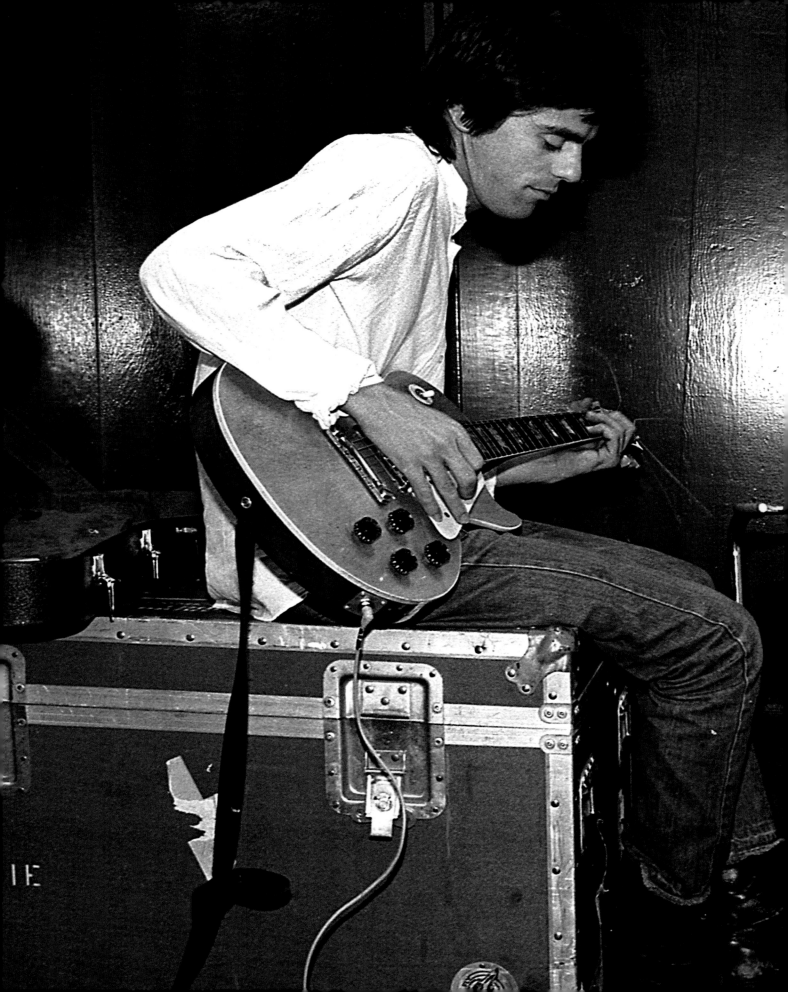

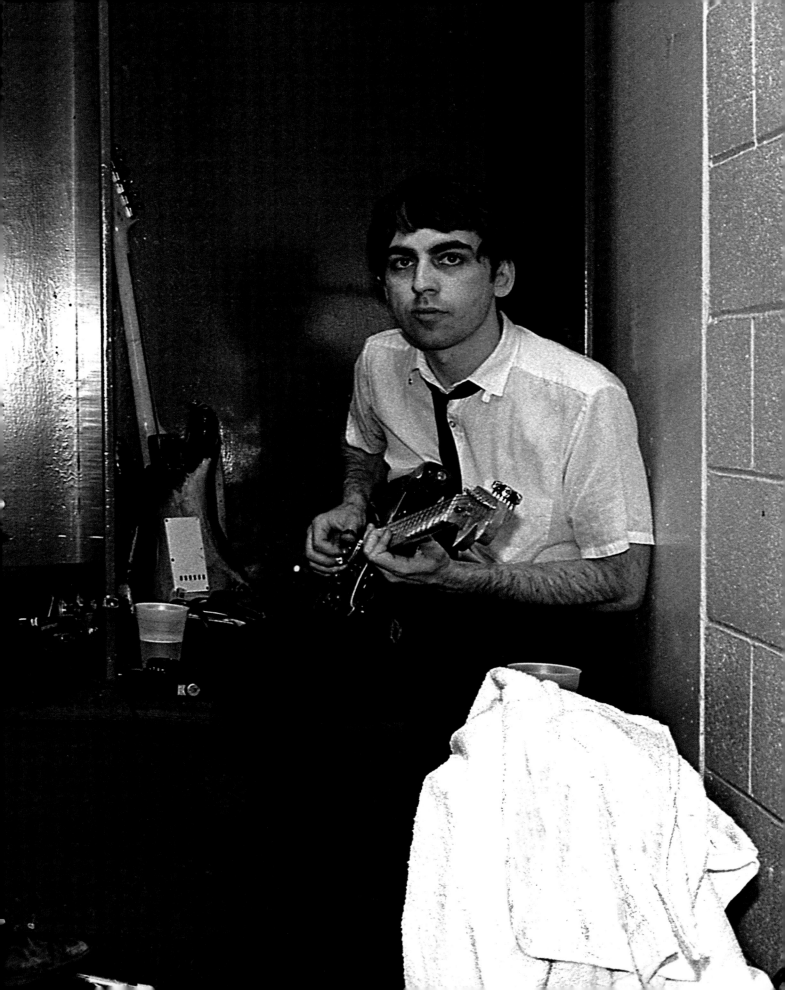

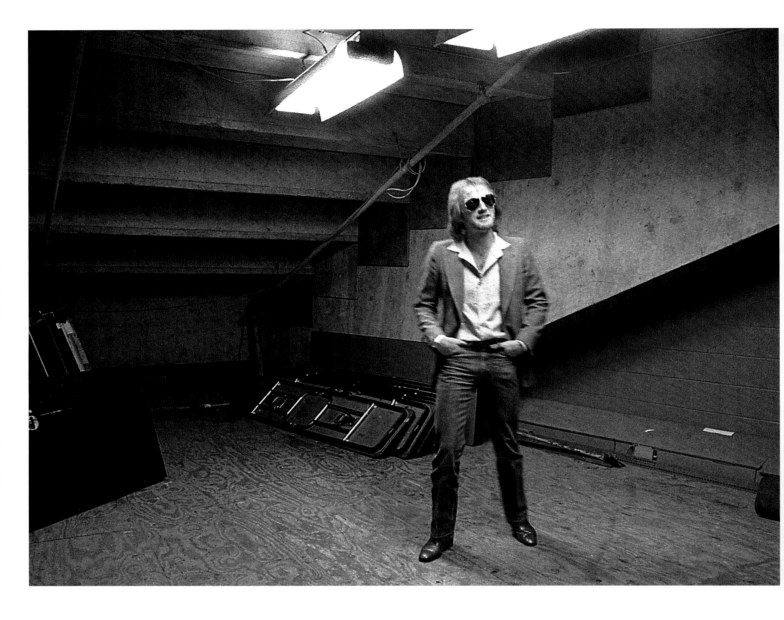

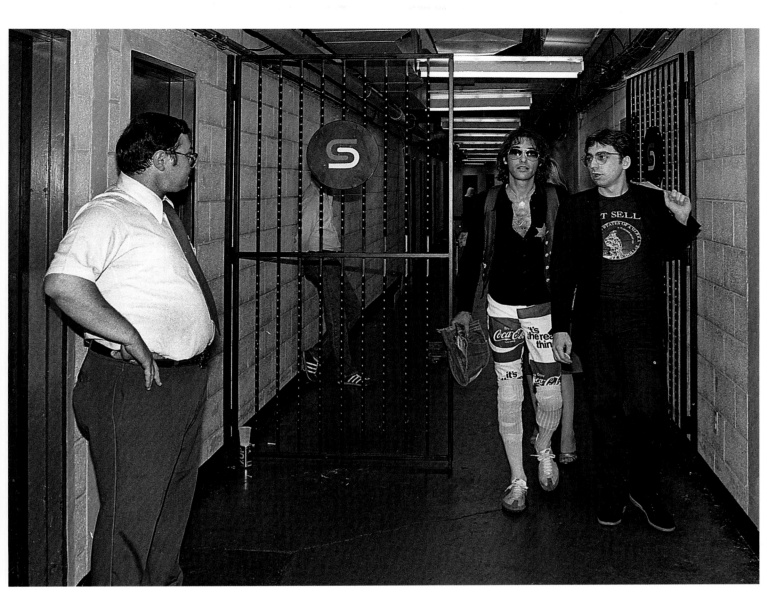

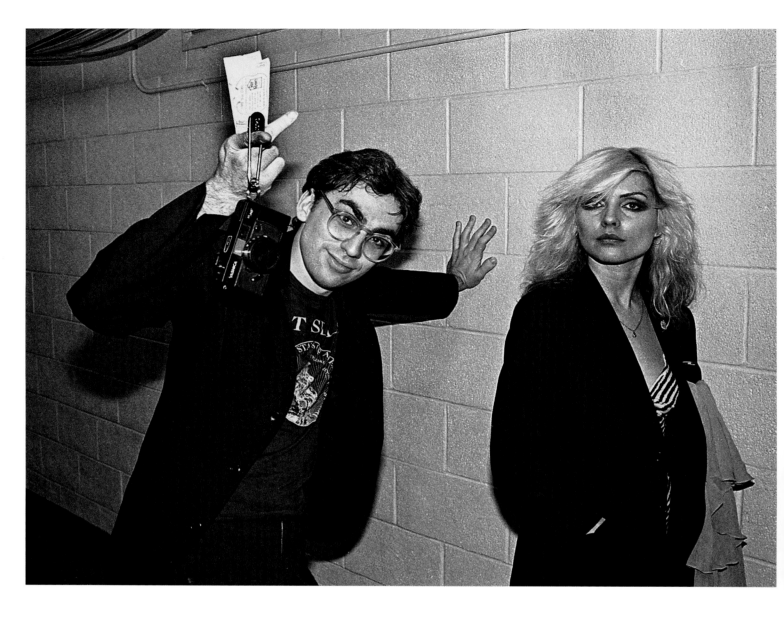

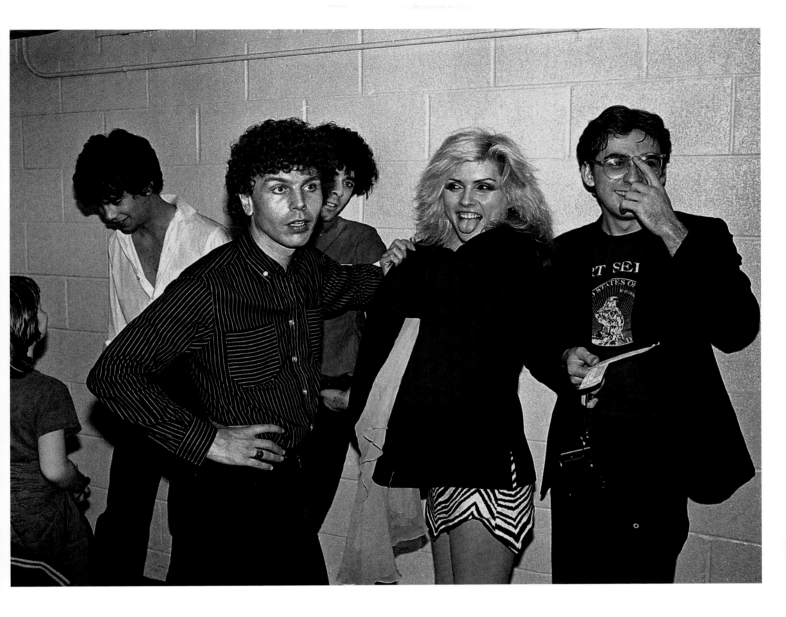

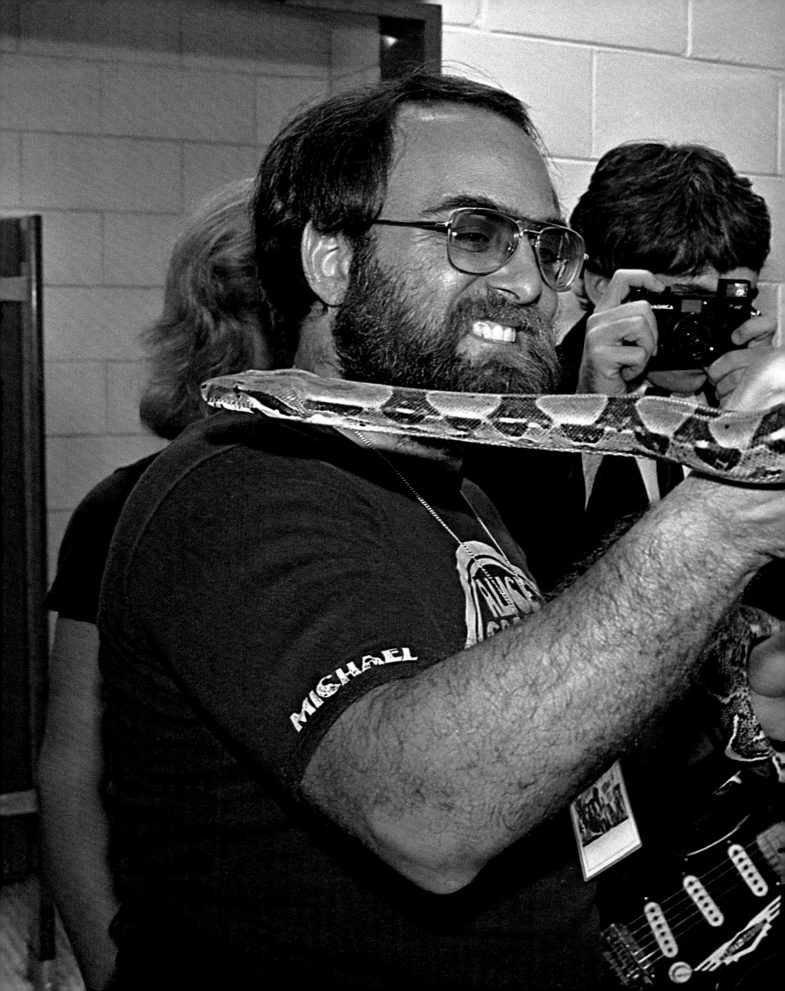

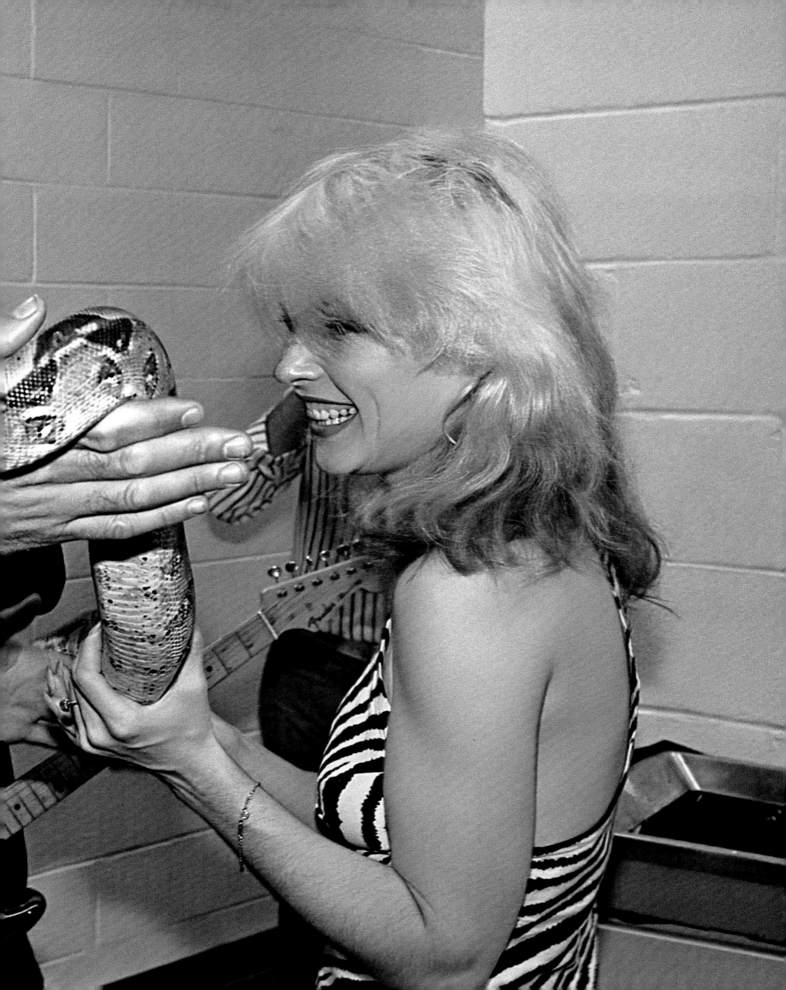

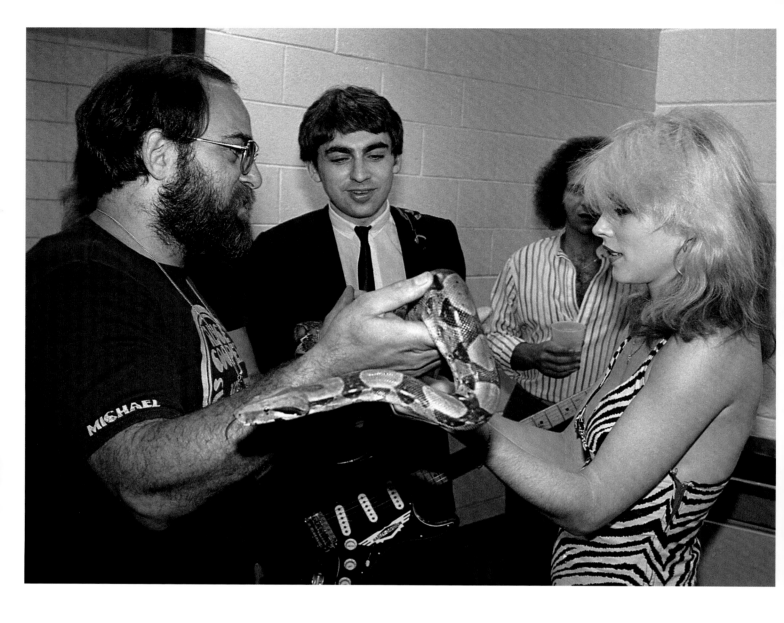

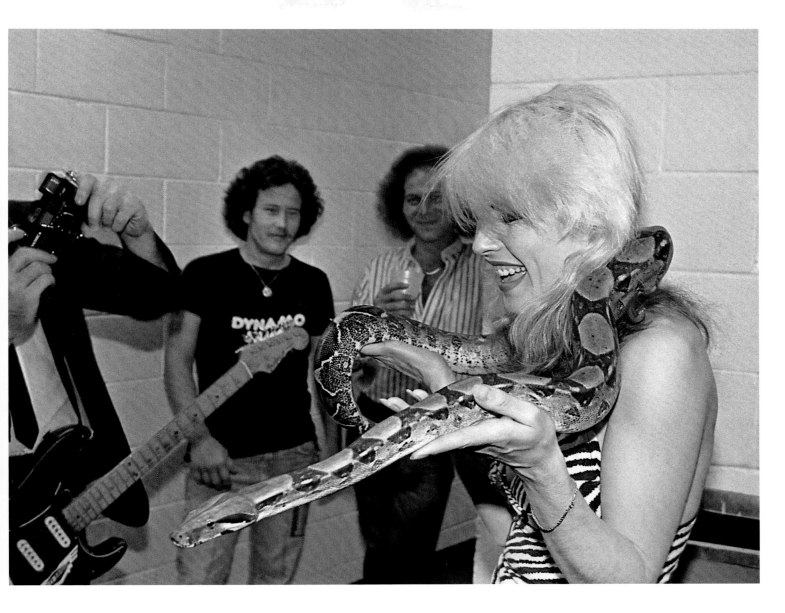

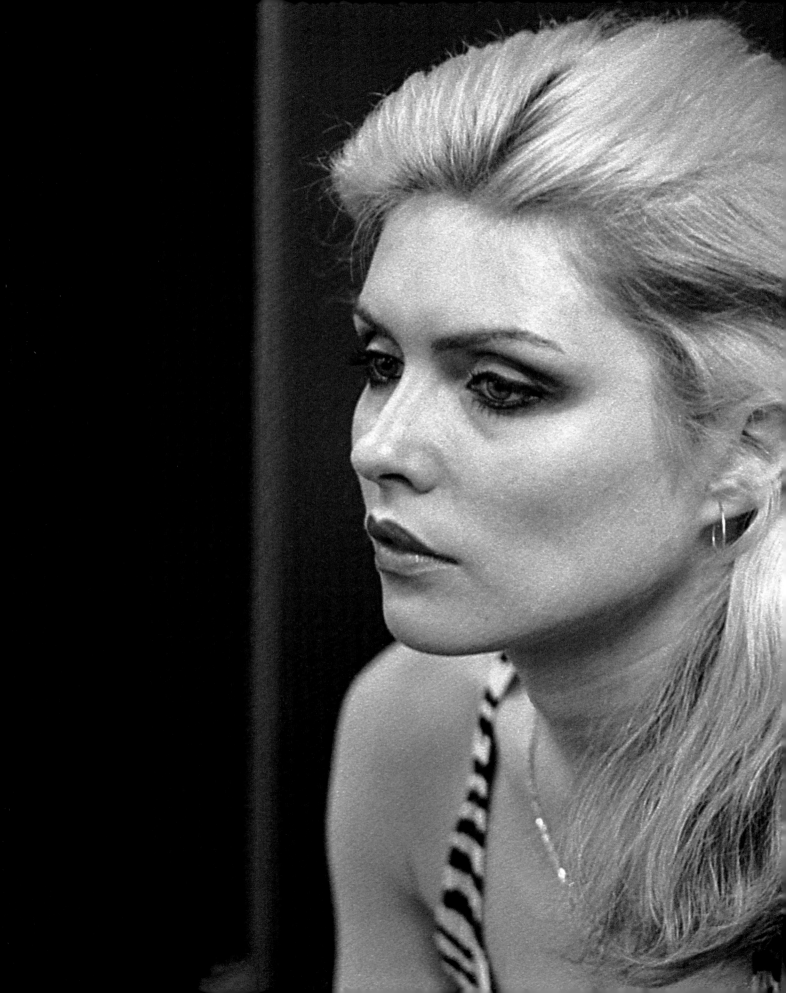

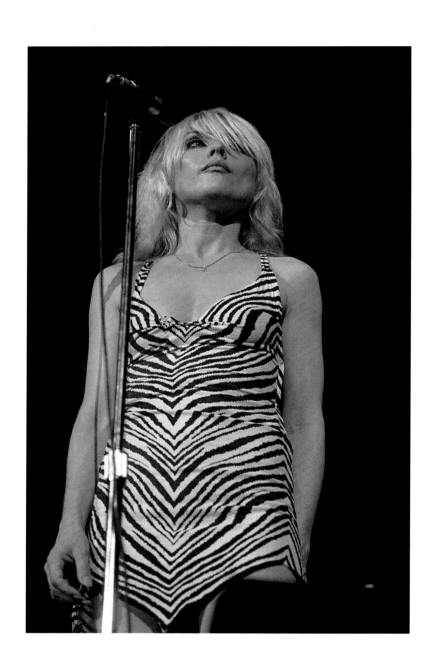

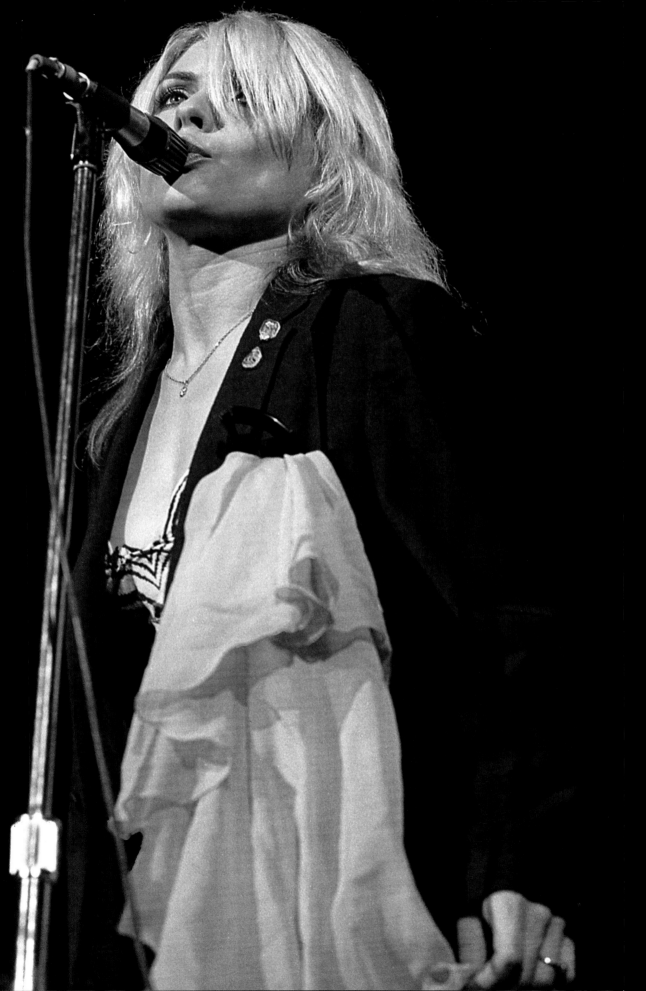

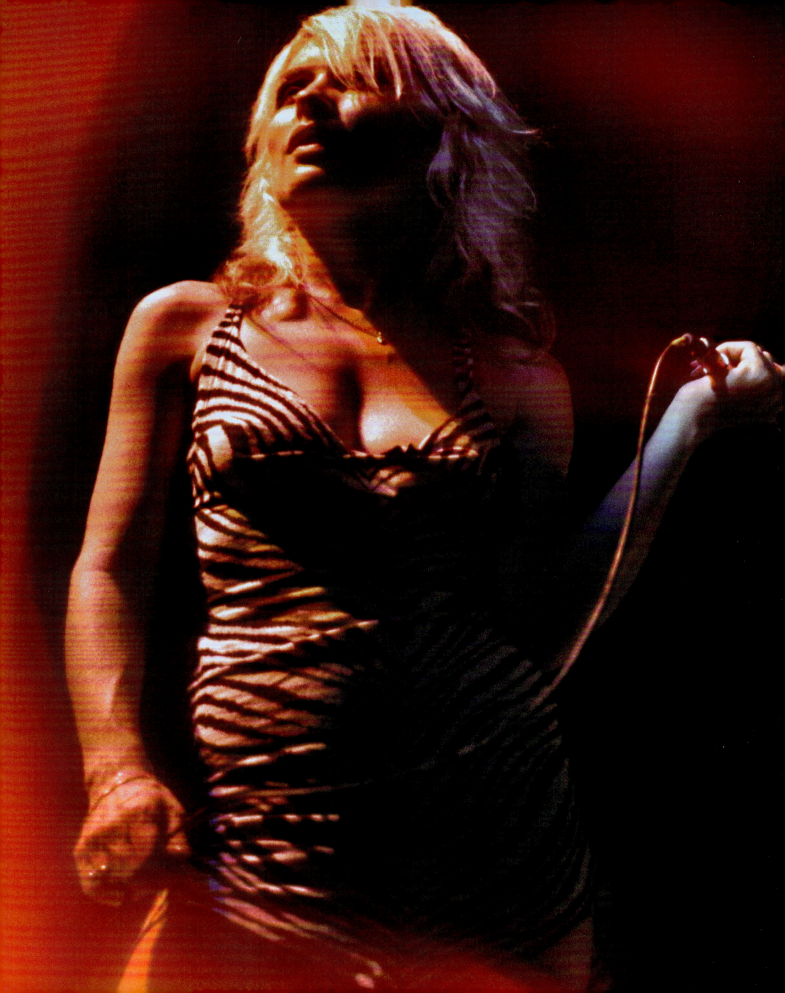

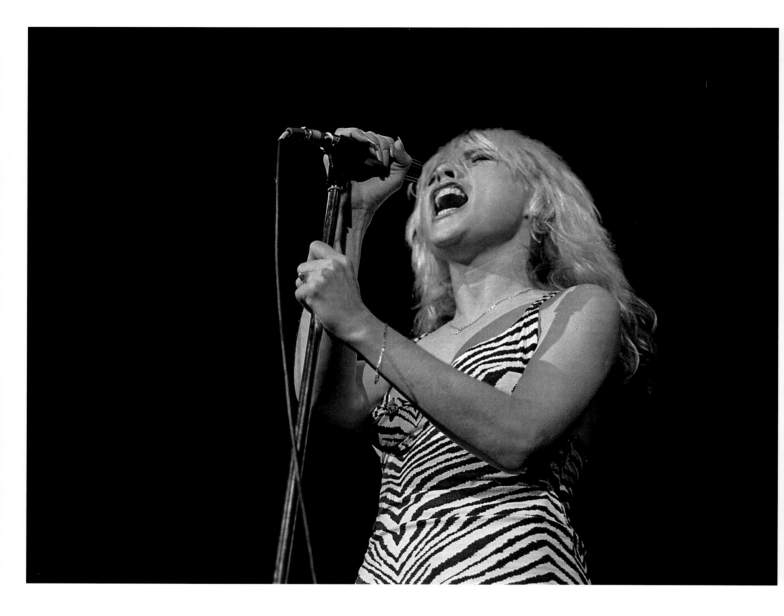

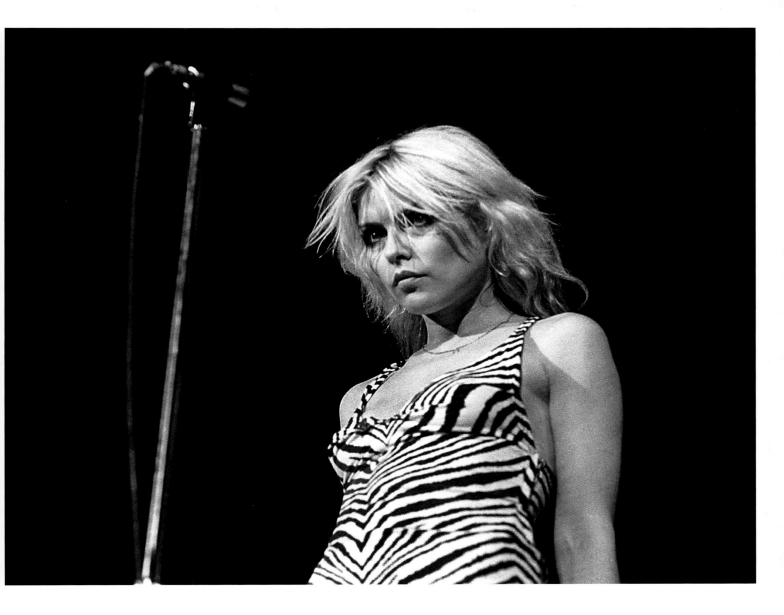

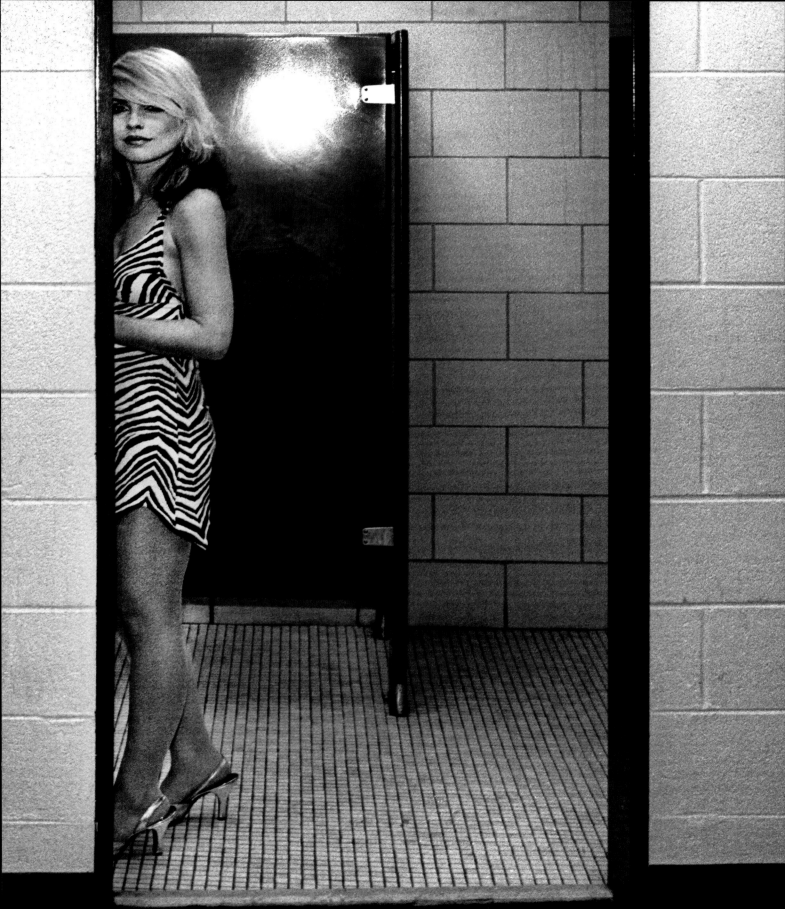

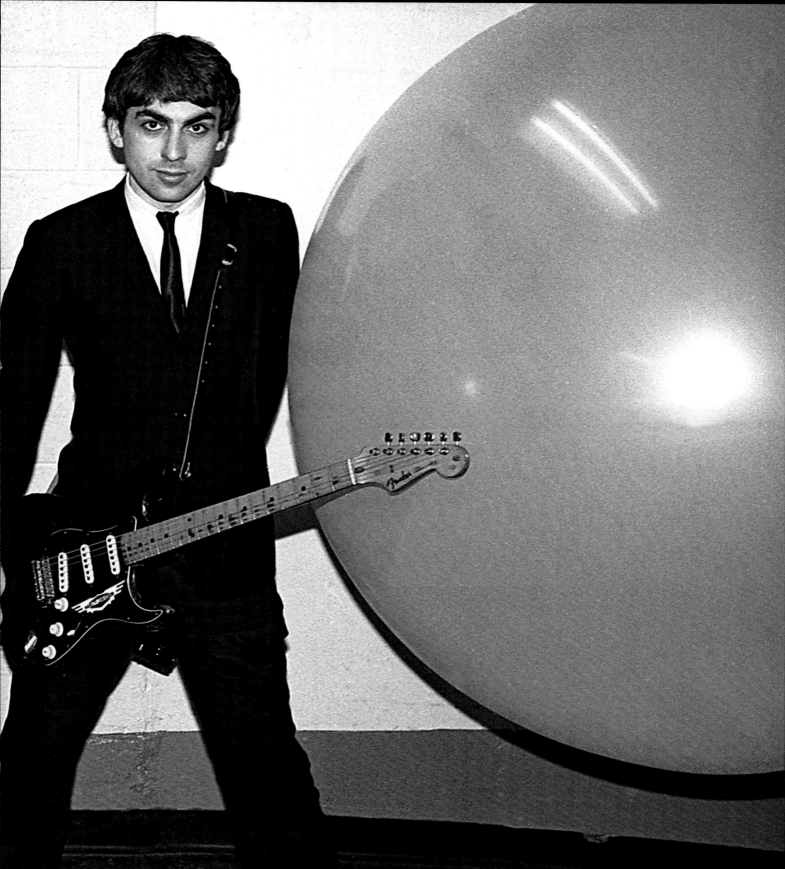

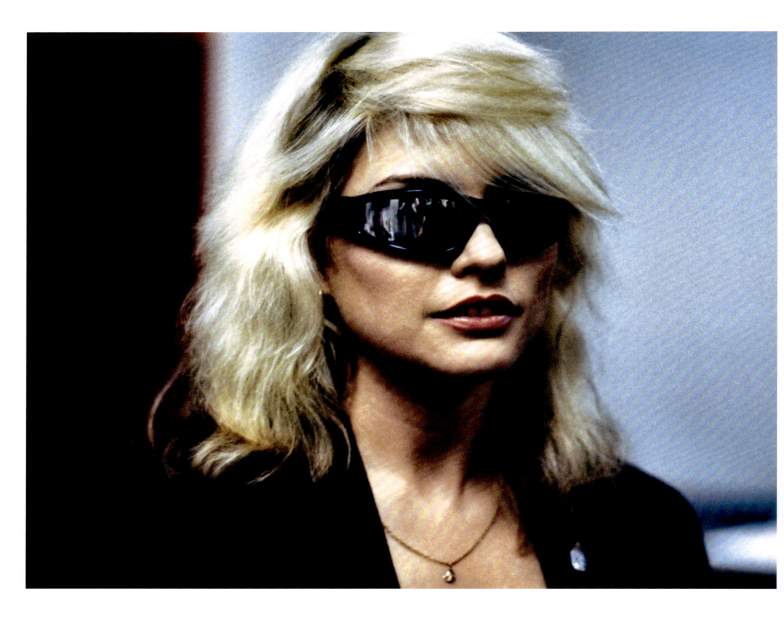

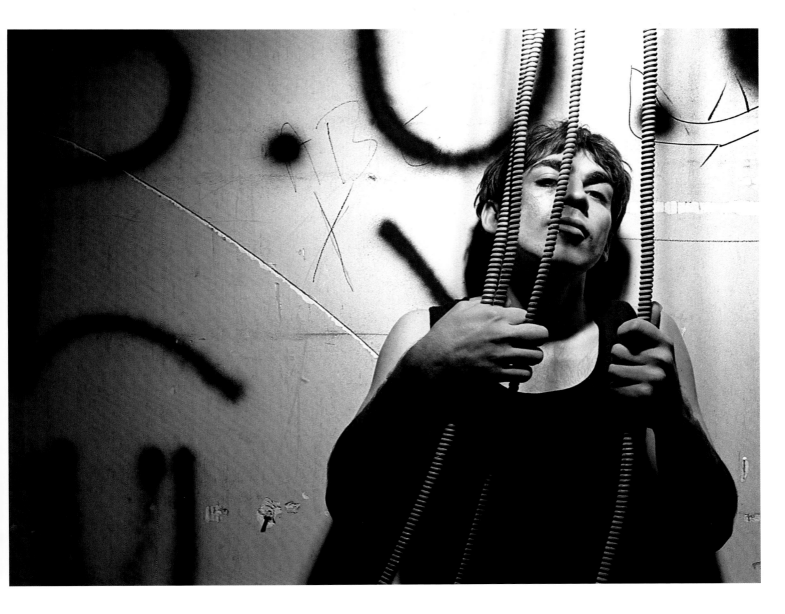

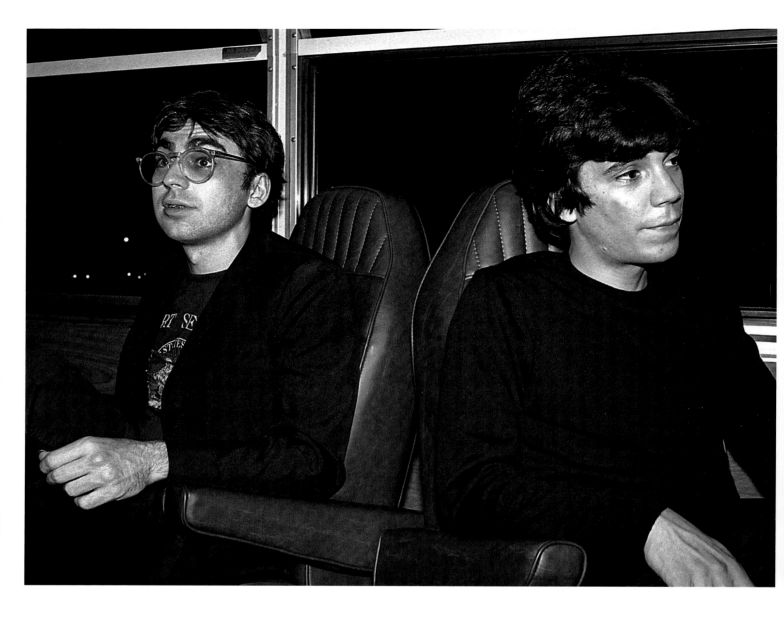

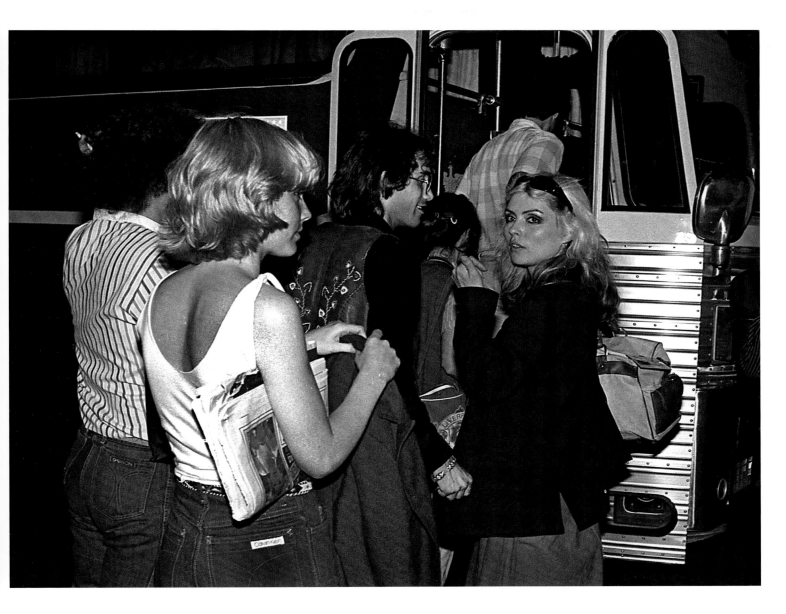

9·BLONDIE IN CAMERA

On returning to London, I spent a few days processing all the film from my various shoots in New York. There were at least 40 rolls of 36-exposure transparency and black-and-white 35mm films to develop. In the analogue era, the colour transparency film would need editing on a light box. Black-and-white film was processed and contact-proofs printed, before presenting them to the client, Chrysalis Records.

Later, in June 1978, I made the presentation to Chrysalis art director Peter Wagg and head of PR Sue Foster. I had worked hard to produce a varied set of images of the band that would satisfy the ever-increasing demand for Blondie imagery. There was a need for new press photographs, record cover and promotional material for the planned launch of the 'Picture This' single and *Parallel Lines* album in August. The presentation went well and, before leaving the Stamford Place offices, I mentioned that I had enough material from both New York shoots for a photo exhibition.

Early in July, I had a call from Sue Foster asking if I was still interested in a photo exhibition. The press and marketing department thought it would be a good idea for the launch of the next Blondie single and, by the way, the band would be in the UK in August to attend and open the exhibition. From that point on, things started to move with great speed. *Telegraph Sunday Magazine* scheduled their cover story for 6 August, so we chose to open the exhibition the following week on Monday 14th. Chrysalis found the Mirandy Gallery in Glentworth Street off the Marylebone Road, and with the help of my art director friend Bill Smith and Geoff Axbey of *Telegraph Sunday Magazine*, we edited and arranged the framing of 51 prints of various sizes, including three life-size cutouts of Debbie Harry and a six-by-four-foot cloth print to hang from the gallery ceiling. It was decided to give the fans a chance to buy prints. They would be sold to benefit the Juvenile Diabetes Research Foundation, a charity that Blondie's manager Peter Leeds supported. Meanwhile, Chrysalis and *The Telegraph* sent out invitations to media and industry guests, and both planned their own promotions. The record company printed posters and magazine ads for the 'Picture This' launch, while *The Telegraph* produced a large fly poster that was pasted all over London and other major UK cities in the first week of August 1978.

The weekend before the opening, the framers delivered the prints and Chrysalis supplied posters and press kits. I gathered a group of friends and we all worked on and off all weekend hanging the exhibition. It was trial and error with the design, but the team included record-cover designers and magazine art editors, so we soon got to grips with hanging and levelling the prints on the gallery walls. It was amazing that the two corporate organisations sponsoring the event, along with the band's management, let our little group of amateur exhibition curators have full control of the show. They didn't see the fruits of our hectic weekend labour until half an hour before showtime and Blondie's arrival at Glentworth Street.

When we arrived at the Mirandy Gallery a couple of hours before the grand opening, we found a small group of fans camped out on the pavement. I made a last-minute check on the exhibition and helped the record-company team with stacking press kits and rolling posters. By midday, the press and music industry guests had started to arrive; the first to sign the visitors book were Megan Bos and Peter Mazel from *Popfoto* magazine in Amsterdam. Just before the band's arrival, I went out onto the street to find fan numbers had grown to at least four or five hundred, blocking the path of the 74 bus to Camden Town. Excited fans surrounded Blondie's Daimler limousine as it pulled up. I had my camera at the ready and it was great fun shooting the hordes before taking up position for the presentation of the silver discs and the opening of the exhibition by Chrysalis CEO Chris Wright. Formalities over, there was the usual scrum of press photographers shooting portraits of Debbie posing among the life-size cutouts taken on the roof of the Record Plant. The band wandered around the show talking to journalists and record company types. The framed white-label LP I had had framed was on display beneath the giant print of Debbie's 'lick shot' hanging from the ceiling. There were fans in the street and a diverse group of scribblers in attendance; *Cosmopolitan, 19, Men Only* and *Deluxe*, to name a few. I imagine that Blondie's long-time publicist Alan Edwards was happy with both *The Telegraph* coverage and the exhibition helping to promote Blondie to a wider mainstream audience. Welcome to Mike Chapman's post-punk hit machine, Blondie.

The exhibition ran until 25 August and my partner Beverley ran the show as a steady stream of fans visited and purchased many of the framed prints. The three life-size cutout prints were so popular that all three were stolen while Beverley was distracted on the sales desk. I was always annoyed by their kidnapping, so in 2018, on the 30th anniversary of the heist, I produced a limited edition of the same image made to 1.6 metres, Debbie's height. I had a couple of photo sessions that week so could only sit in at the gallery for a few days, but it was interesting listening to fans' comments about the photographs. When the exhibition closed, I chose a couple of signed prints for myself, and the unsold images were given to Chrysalis to adorn the office walls. It was the end of my involvement with the band. The year 1978 was a marvellous experience. By this time, I was a busy music photographer and, over the next 15 years, went on to work with many other artists, including U2, The Jam, Genesis, Elton John and Wham!.

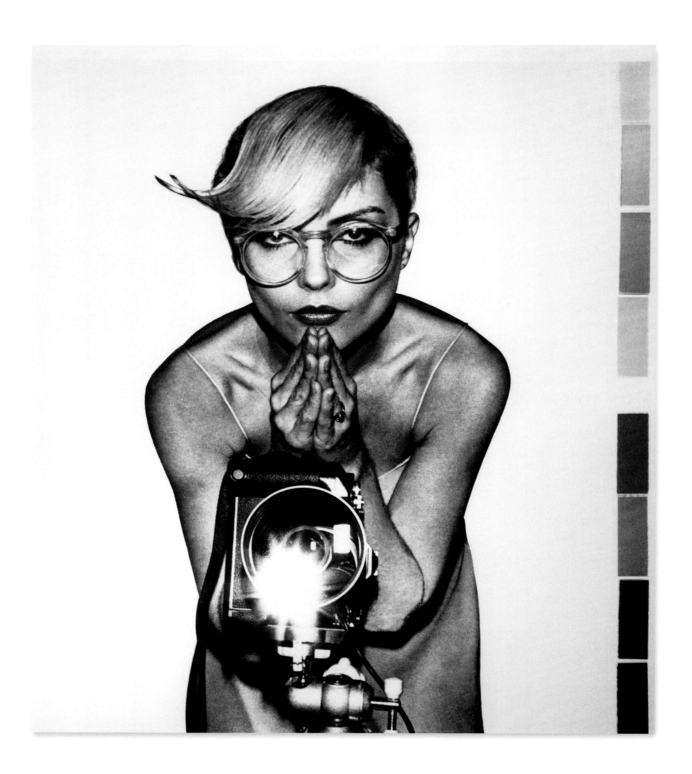

BLONDIE invites you to an exhibition of photographs
"Blondie in Camera". By Martyn Goddard. Meet Blondie 12.30pm.
14th August at the Mirandy Gallery, 10 Glentworth St. NW1

Open : 14th August to 25th August 1978, 10am to 5.30pm
RSVP Sue Foster: 408 2355

Presented by Chrysalis Records in Association with the Telegraph Sunday Magazine

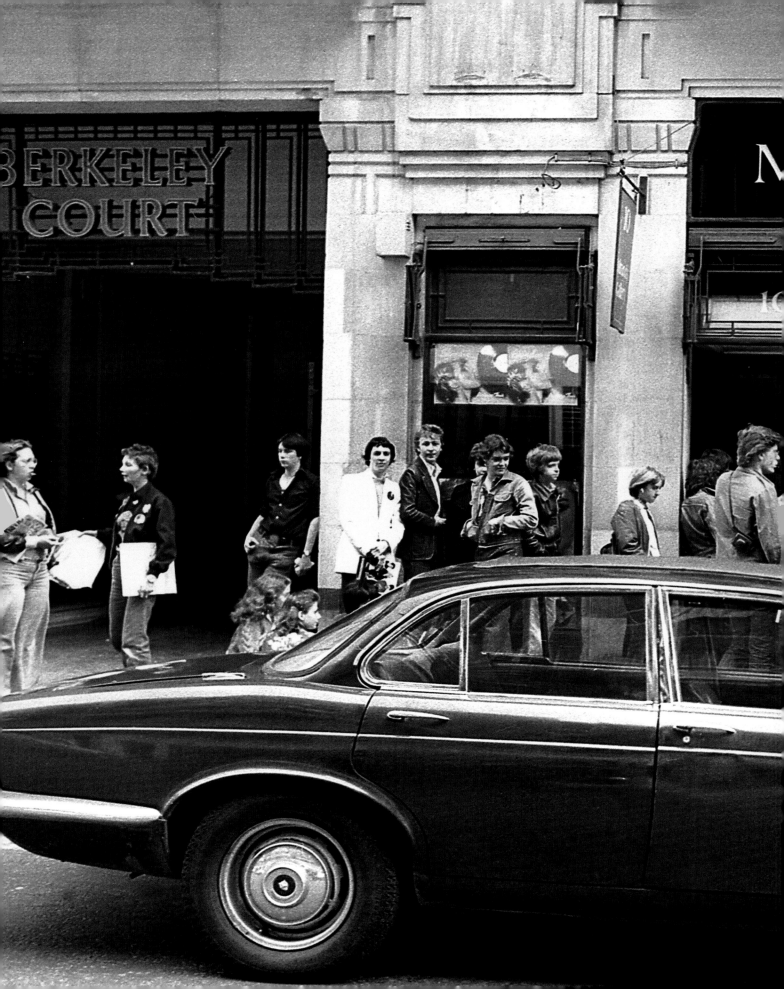

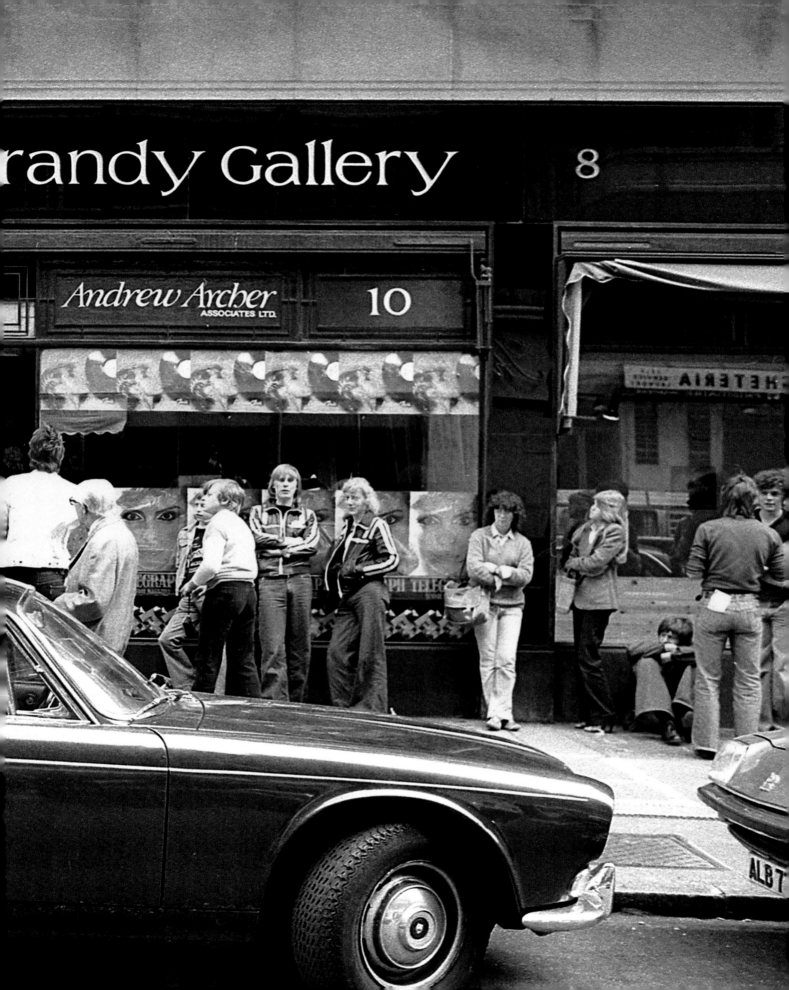

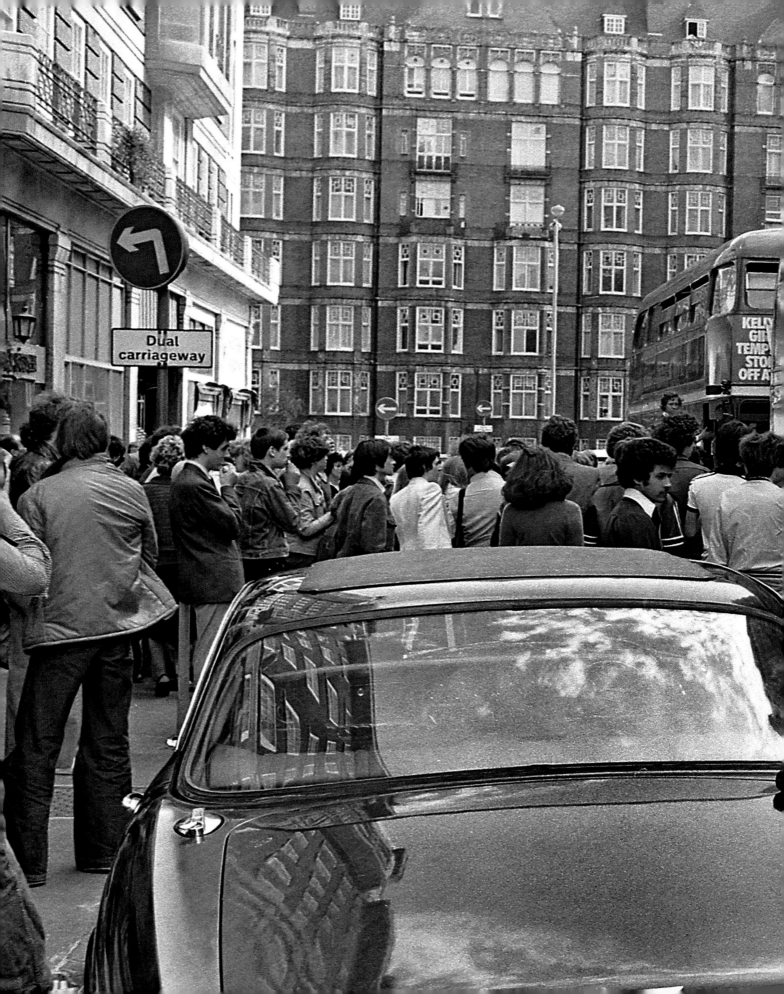

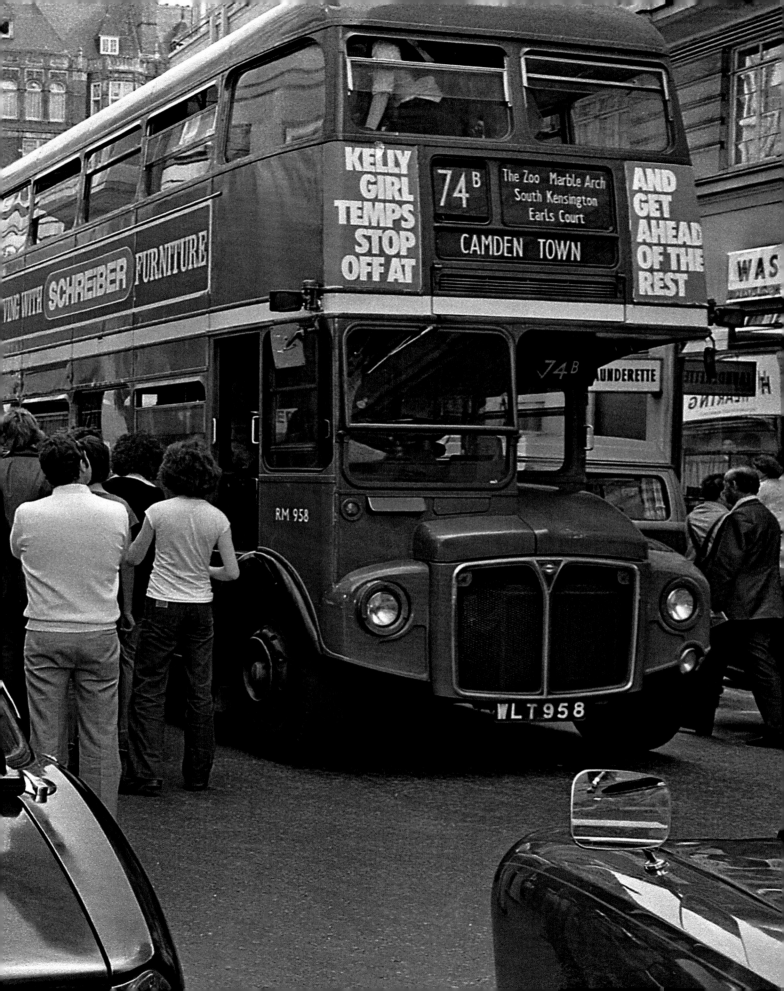

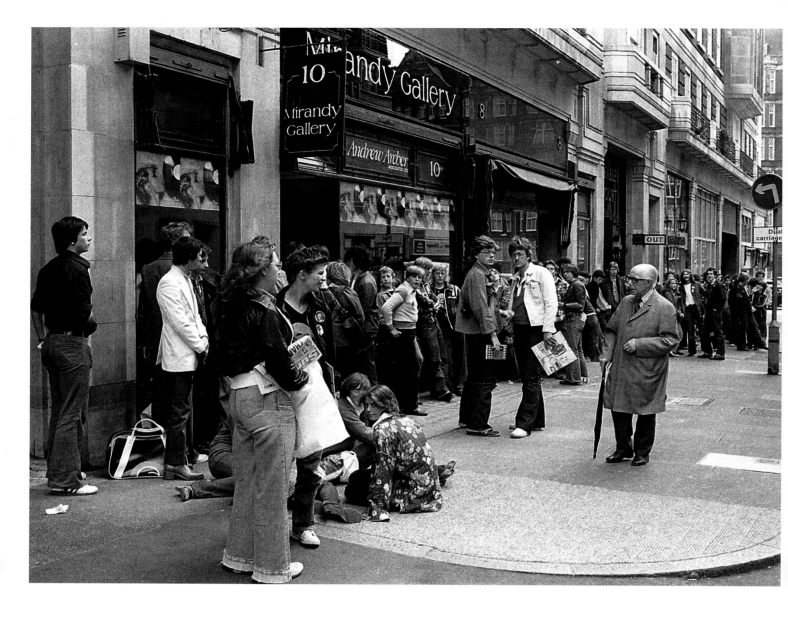

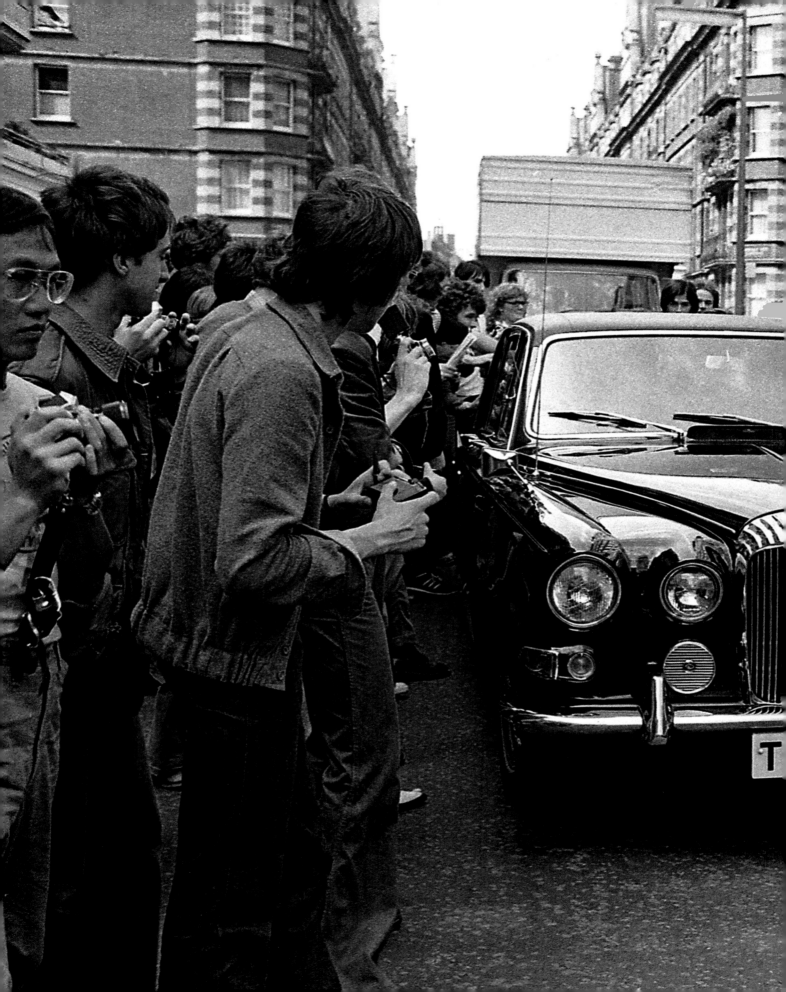

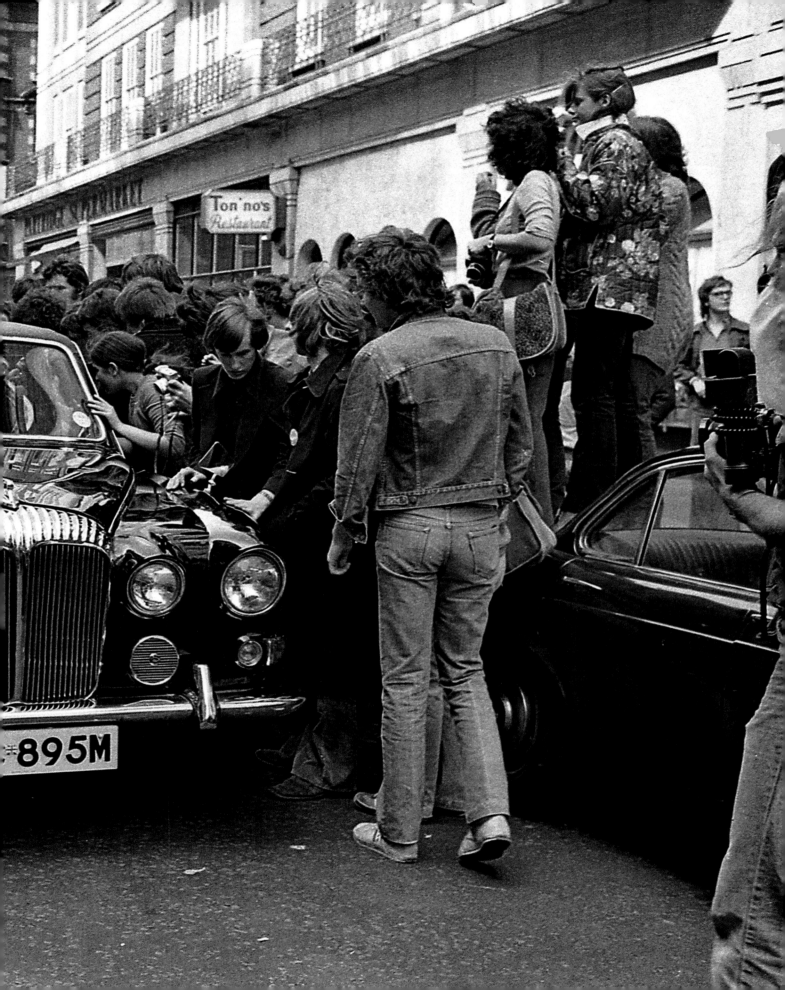

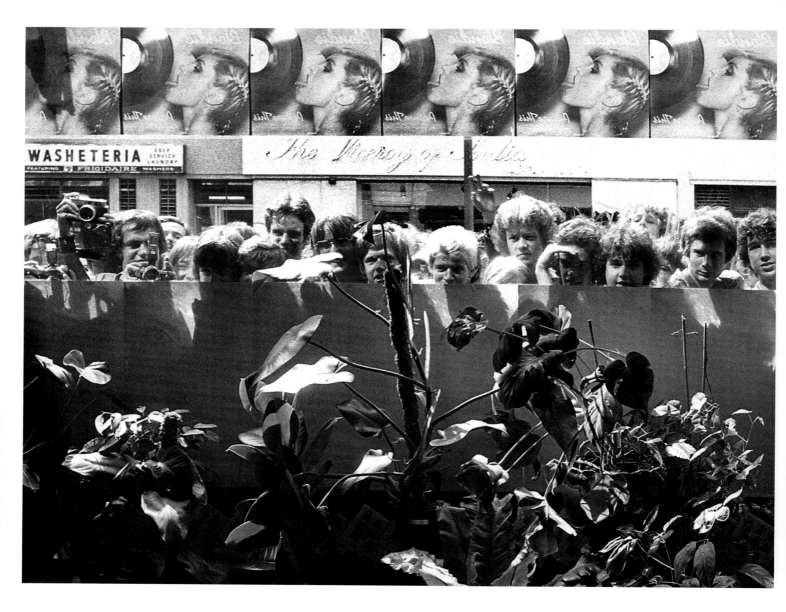

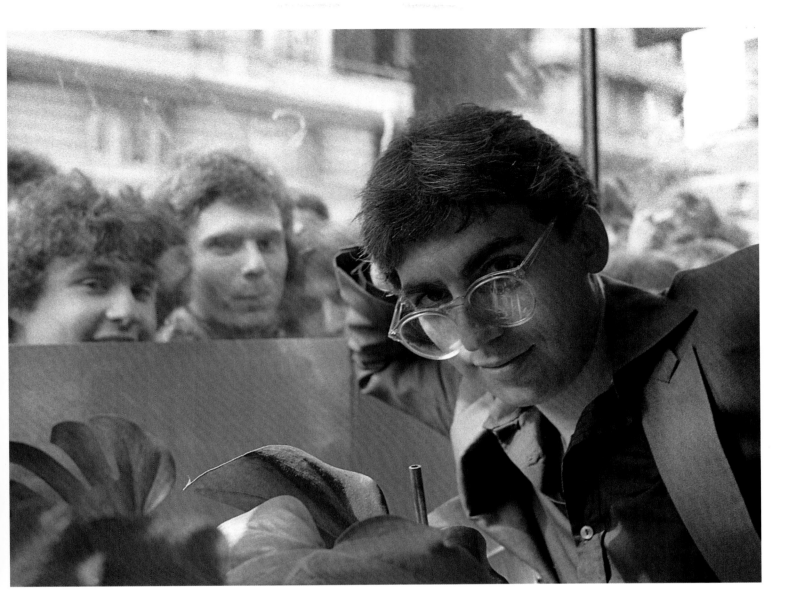

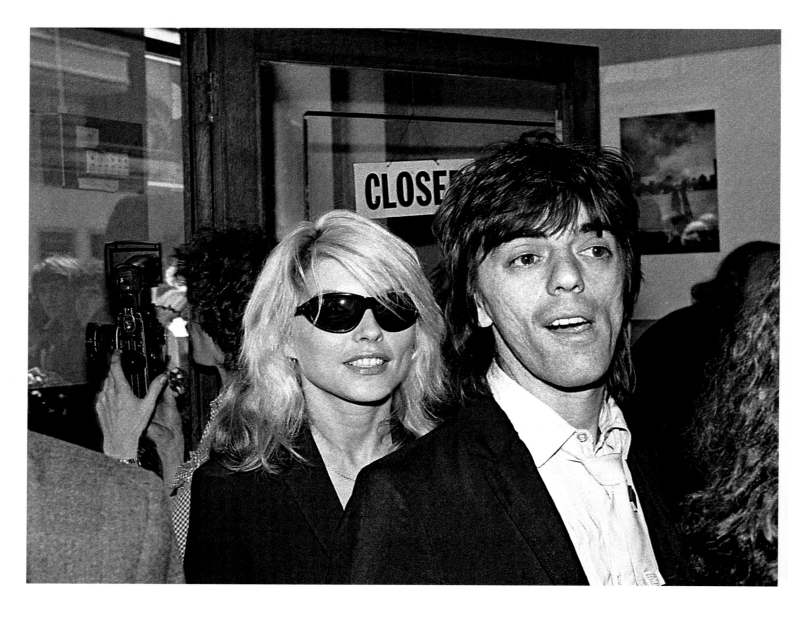

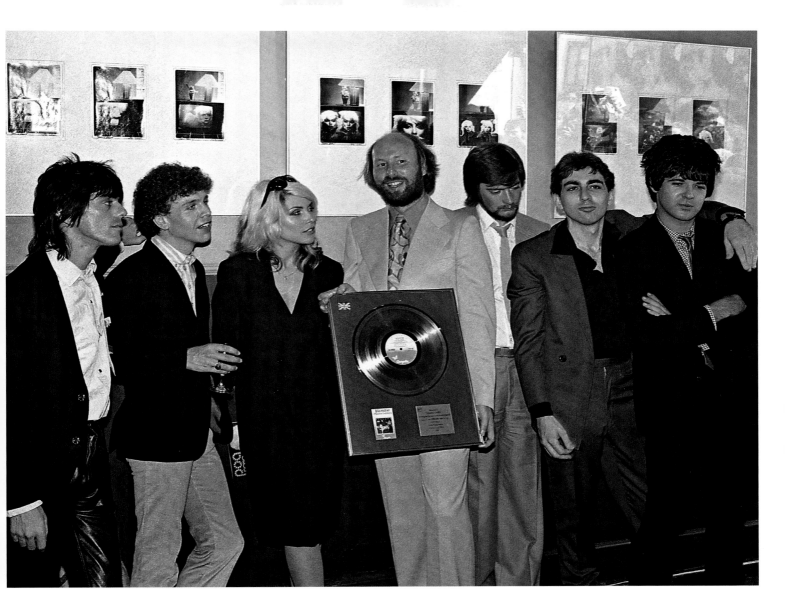

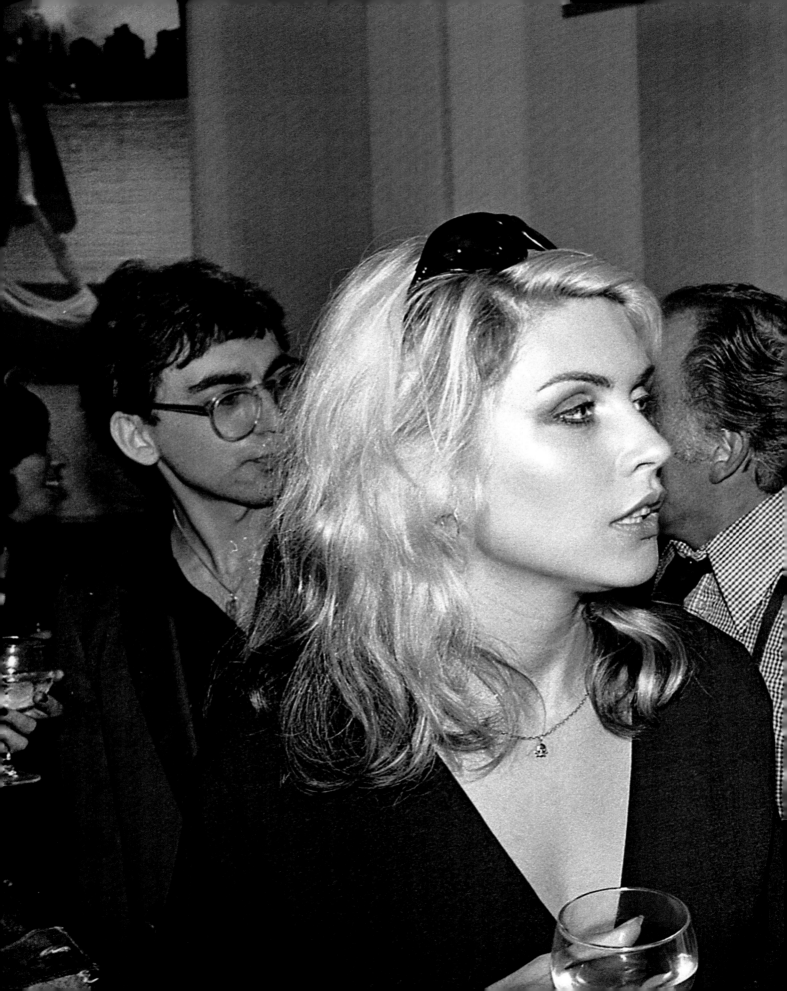

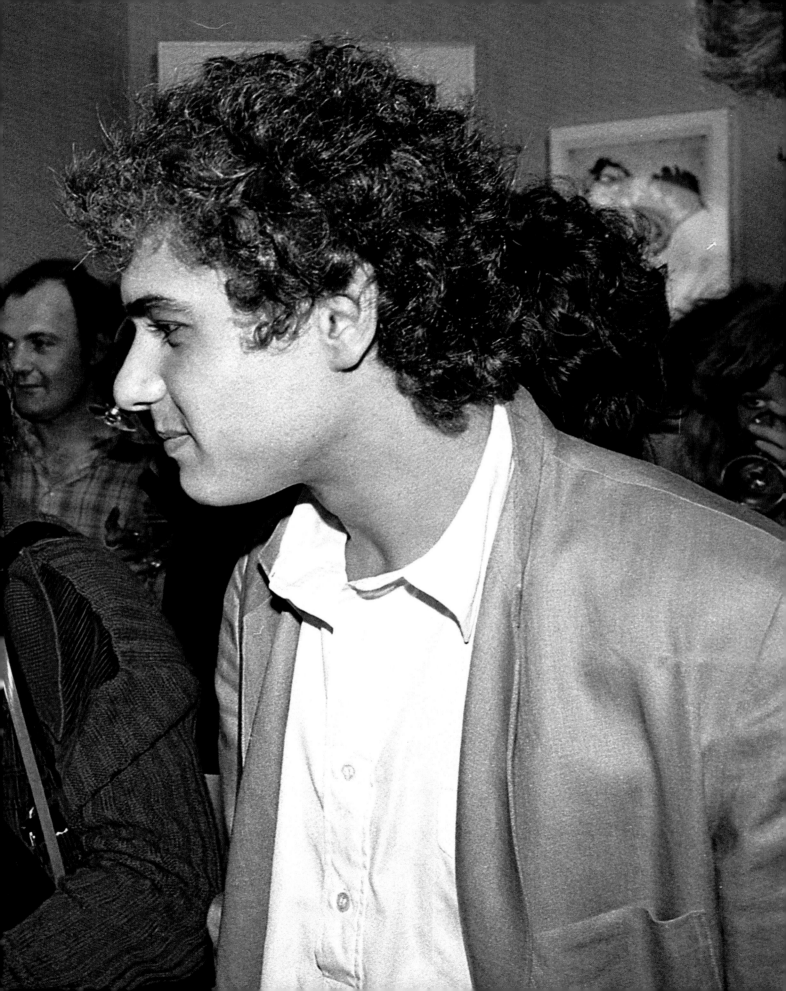

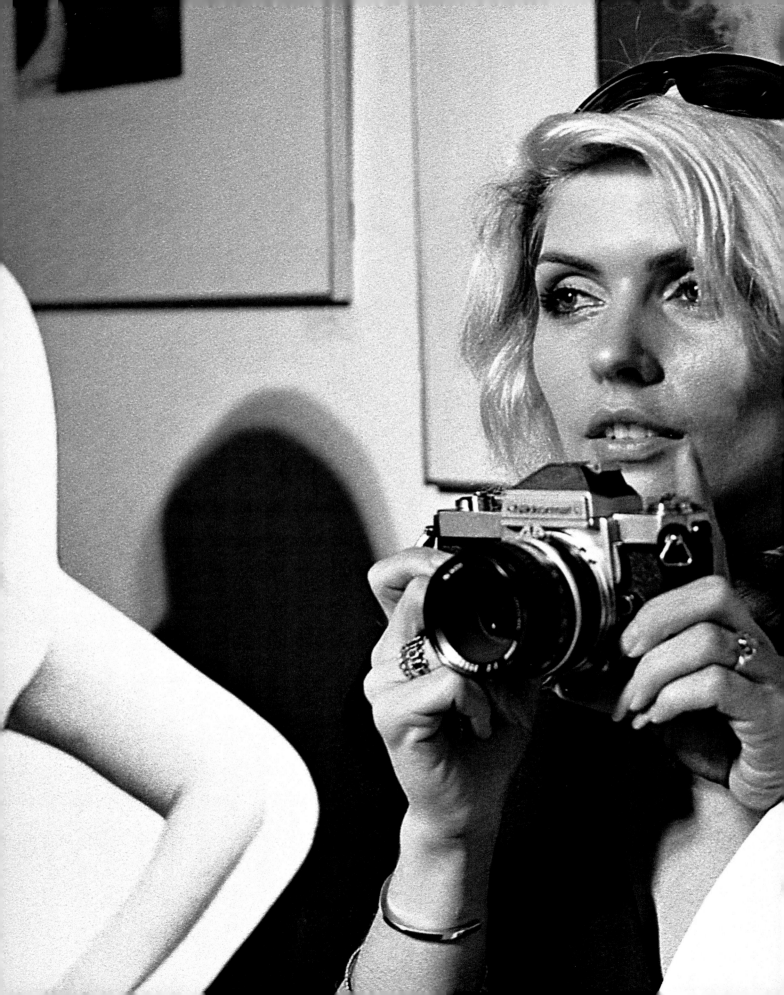

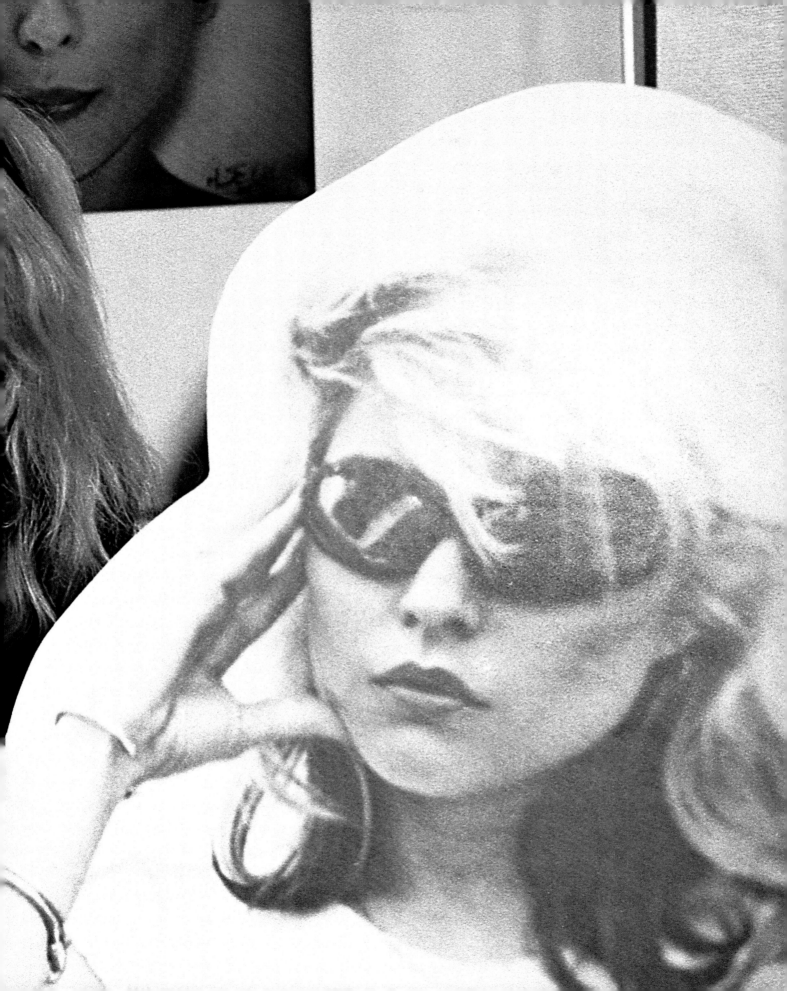

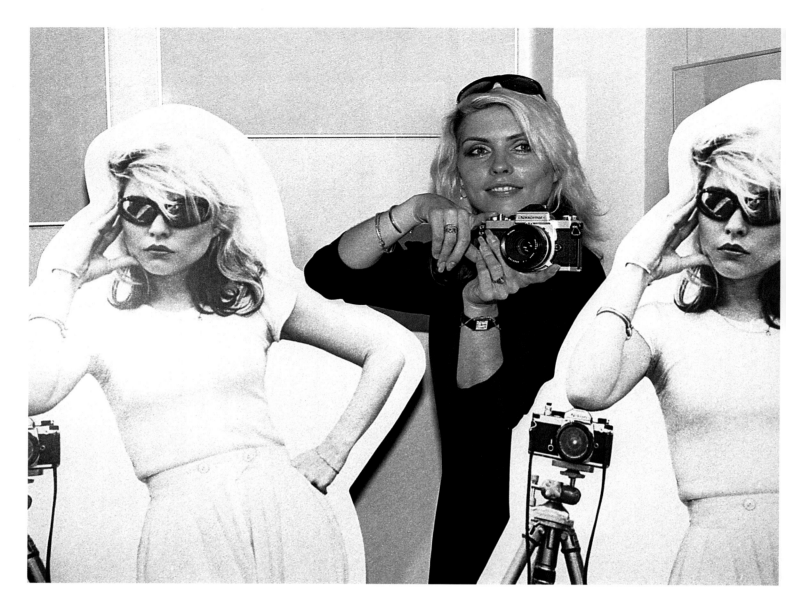

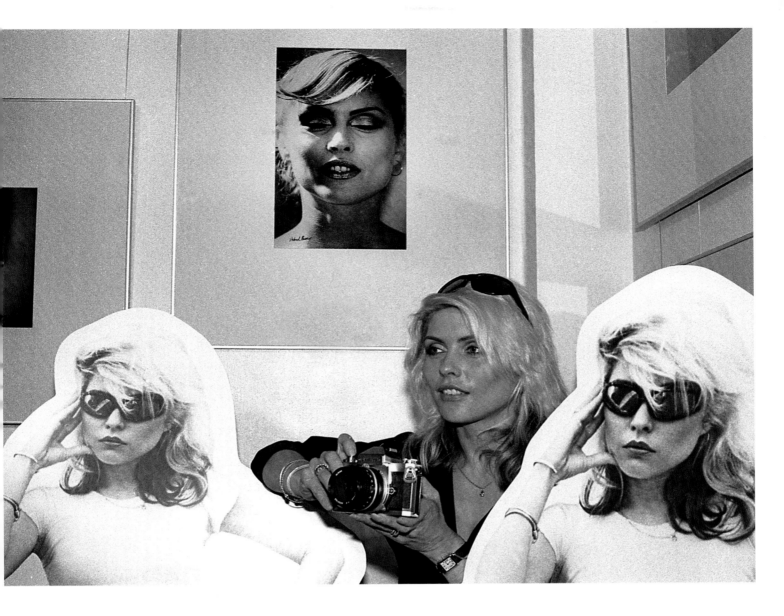

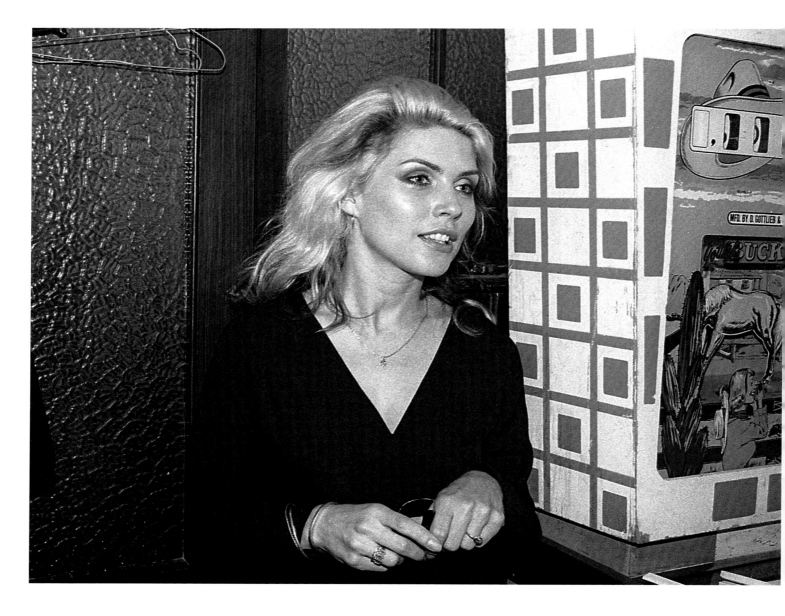

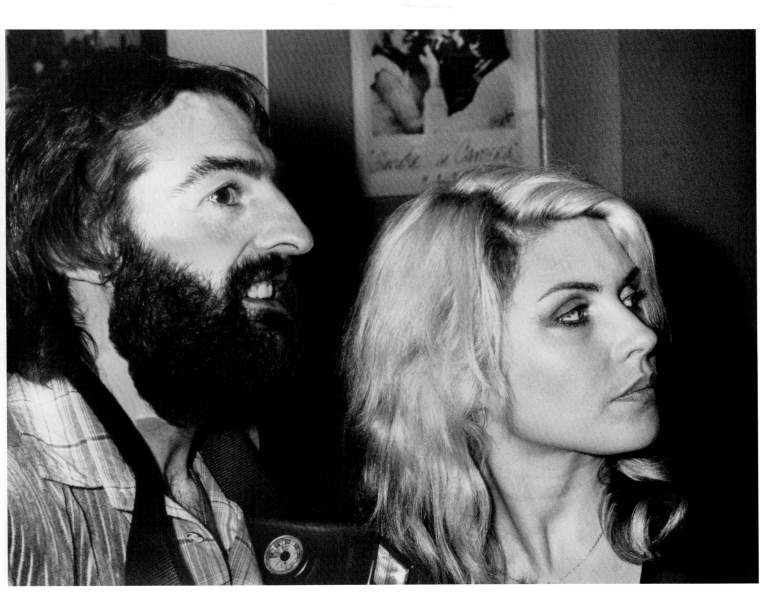

10. LEGACY/ POSTSCRIPT

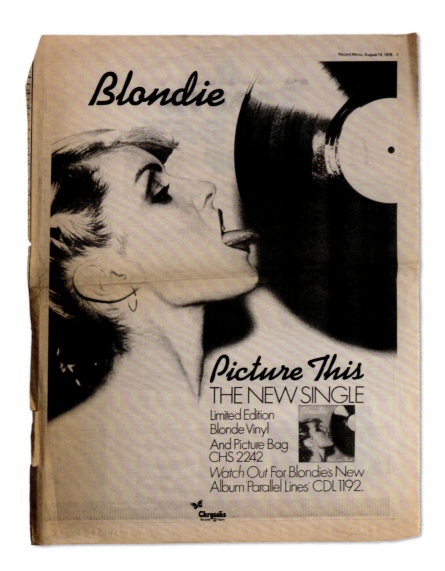

I have never escaped that year of 1978 with Blondie. I tried to repeat the process with another New York diva, Madonna, but *The Telegraph* didn't bite this time. All through my career photographing the great and good of the music industry, the Blondie sessions would continue to come up in conversation, in front of and behind the camera. The photographs and tear sheets in my portfolio gained me assignments and introductions to important clients. One of the group images shot on the Record Plant rooftop ended up on the *Best of Blondie* album sleeve in 1981. Even in the mid-1990s, when I had become an automotive photographer, art directors would ask about Blondie.

Now I have stepped back from major photo shoots, I have had the time and incentive to search through my archive and scan the old negatives and transparencies which are now used in books, TV documentaries and Blondie merchandise. Several photo galleries sell my limited-edition prints. I was at a record fair in London in 2017, promoting one of my books, and a man came up to the table, opening a book to the image of Debbie Harry licking the white label. 'Did you shoot this picture?' he asked. When I replied in the affirmative, he said, 'Well, now when I sign a new band, I show them that photograph as an example of what works as a great rock image'. He bought my book, ordered a 60-by-40-inch print of the image, gave me his card and walked back into the crowd of record collectors. The card read 'Craig Kallman, CEO of Atlantic Records'.

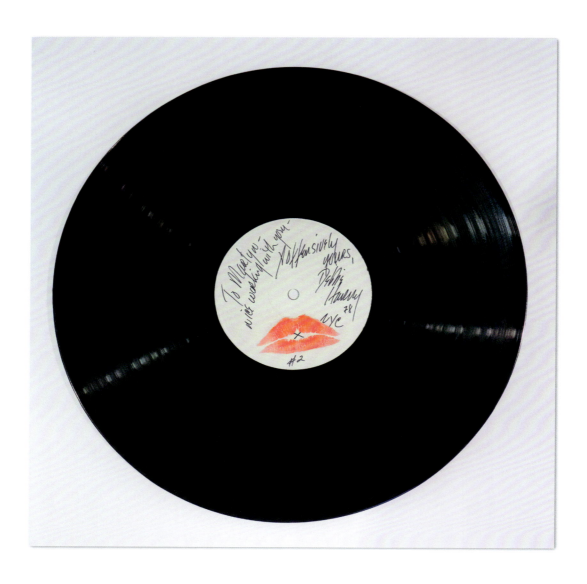

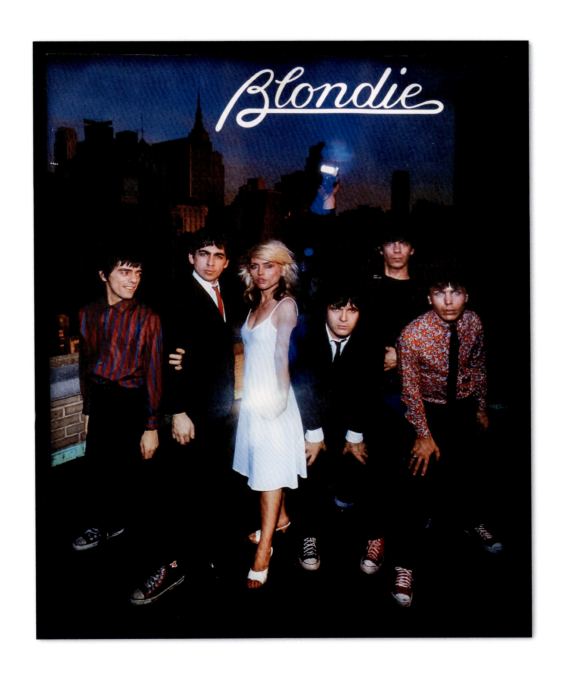

A SVELTE, smiling Debbie Harry and her band breezed into London last week to celebrate the opening of an exhibition of Blondie pics at the Mirandy Gallery in Marylebone.

The photographs, taken in New York by British photographer Martyn Goddard — whose past subjects include the Bay City Rollers, Andy Warhol and Dennis Healey's wife Edna — depict the members of Blondie striking playful poses in various domestic and street-wise settings.

Over 200 fans, some of whom had camped overnight, crushed against the plate glass gallery front to snatch a glimpse of the luscious Deborah. Flash-guns popped and pencils jotted as Ms Harry — oozing the breathless glamour that is such a part of these socialite whirls — announced her impending marriage to lead guitarist Chris Stein.

Will this lead to a rash of male suicides? *Thrills* pondered the question while going through the pockets, sorry, gossiping with anyone who looked remotely famous, and was foolish or drunk enough to get up close. These included Robert Fripp and The Boyfriends, plus luminaries of the fashion world, most of whom didn't seem to know how to take a joke.

Growing weary of all the razamatazz, *Thrills* crept away early, thereby managing to miss the mob scenes that ensued when Debbie, still nursing a fixed smile, tried to slip off into the afternoon heat in a waiting limousine.

The exhibition runs until August 25.

BLONDIE DROP IN

NME - July 8.1978

Blondie's DEBBIE HARRY on the other side of the camera — for a change!

BLONDIE return to Britain next month for the first time since their February tour — but they won't be gigging here. They're coming in specially for the August 14 opening of an exhibition of Blondie pictures, taken in New York during May by photographer Martyn Goddard. The show is at the Mirandy Galleries, 10 Glentworth Street, N.W.1, and it's open until August 25 — admission is free.

The group stop off in London en route for a European tour, so they won't have time to play any dates here. But it now seems likely that they'll be back to headline a string of dates later in the year, as opposed to their previous plan not to perform here until early 1979. Meanwhile they're currently completing their third album in New York.

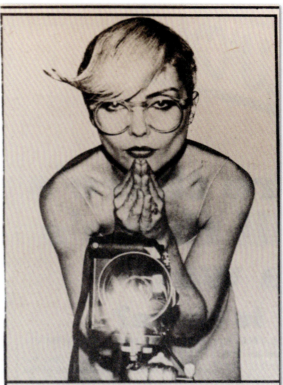

YOU CAN LOOK . . . but you can't listen! Blondie, featuring Debbie Harry (pictured above), return to Britain in August for the first time since their February tour — to open an exhibition of Blondie photographs!

The pictures are the work of Martyn Goddard, and were taken in New York in May this year. The exhibition will be open to the public from August 15 to August 25 at the Mirandy Galleries, 10 Glentworth Street, London NW1. Admission is free.

Blondie will open the exhibition on August 14, but won't be playing any live dates in Britain. However there is now a possibility that the group will be playing dates here before Christmas — not Spring next year as previously announced. They're currently completing their third album in New York.

E. NEWS 27/7/78

Ad Lib
by JOHN BLAKE

BLONDIE, featuring the lip-smacking Debbie Harry, are visiting Britain for a surprise tour in September which kicks off at Hammersmith Odeon on the ninth and finishes at the same theatre on the sixteenth. Debbie will arrive in London earlier to open an exhibition of photographs taken of Blondie in New York by Martin Goddard. It's at the Mirandi Gallery in Glentworth Street, Marylebone, on August 14.

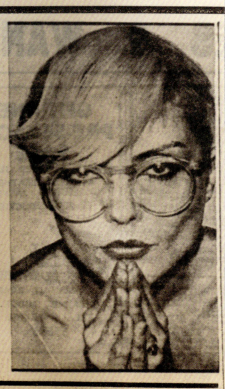

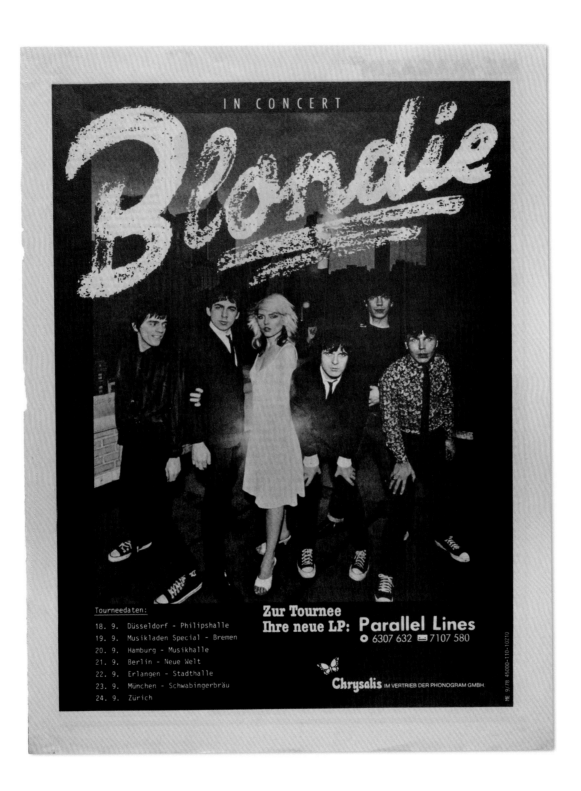

BLONDE ON BLONDIE

Cynthia Rose meets Debbie Harry, America's latest cult heroine

It's not surprising that the publicists of the rock biz often seem more hip than the stars they groom, for they are the image-makers who camouflage the nitty-gritty of a mundane life on the road. But Blondie's Deborah Harry seems to have given herself over to their ministrations completely; gone is the peroxided dumpling who sprang about like a spastic spider on her very first UK gig. Seated inches away from me is a self-conscious adult Star in black jeans and tennis shoes — a Perfect Face, who replies with perfect ease but little enthusiasm. The pressures of her watchful management are everywhere: in her careful responses and corrections, in the way conversation is always steered back to the brand-new album. Debbie herself is exhausted, withdrawn, and polite by default — nothing moves her enough for her to get angry. After hundreds of interviews, she knows the questions and angles backwards. She is direct and straightforward, in her flat and all-American voice, but prefers not to venture opinions. 'I'm not stupid,' she says with grim humour, 'But when I answer questions I sound like it.' Hardly stupid I would say, but certainly looking a little swamped by the PR machine of new fame. The lady whose face launched a thousand leather suits looks a little marooned on the hotel's plastic sofa....

Debbie Harry's foot size is eight-and-a-half ('That's big,' she points out ruefully), and she wears a size nine dress. But to a growing legion of fans, her vital statistics read more subtly: Monroe pout, wraparound sunglasses, go-go boots and miniskirts, skin slick with suntan oil and — inevitably — Loose Zippers. For, as her professional self Debbie Blondie, she is hooked on romance and falls relentlessly and repeatedly for every sort of guy: police officers, psychics, surf nuts, high school heroes, spies, sex offenders and even, occasionally, other ladies. Debbie Blondie can be a jaded cradle robber when she sings a number like *No Imagination* but she is also the awkward worshipper who posts *Fan Mail* to a distant superstar. Sometimes teen dreamer, sometimes urban sophisticate, Debbie Blondie's daily life follows a certain routine — school, the pool, the pier, a place in the front (or back) seat of some boy's car...and plenty of curling up in front of the colour TV.

Debbie Harry, on the other hand, has seen the American dream from both sides. She grew up in Hawthorne, a small town in industrial New Jersey, where she was a cheerleader 'but got talked about'. She worked her way through a series of jobs: cocktail waitress, health club assistant, secretary, doughnut shop counter girl, Playboy bunny. 'I did those things only because I had to,' She points out now. 'Some people do that for life, but I only did it because I had to have money, I did it until I found a way out.' Her first attempts at escape were blunt and unsuccessful — she spent brief periods as a kept lady in California, a groupie to New York City's avant garde art and music fringe, and a dues-paying member of that same city's junkie population. 'It was pretty disgusting,' she has said. But determination and shrewd observation ('I was starting to think it was about time girls should do something in rock and roll') won out.

During a stint in a three-girl group called The Stilettoes, the newly-blonde Debbie met a young guitarist named Chris Stein. He convinced her to help him recruit a new band, which quickly became known as 'Blondie'. Their group played around numerous slumside lofts and clubs in search of the poise and experience they so badly needed. Debbie Harry, the solo vocalist, created a style all her own, half-exploitation and half-humour. She became famed for deliberately tacky garb and unexpected stage antics. 'One night at CBGB's, I wore a wedding gown onstage for *Rip Her to Shreds*. I ripped the dress off and I said, 'This is the only dress my mother ever wanted me to wear, 'cause we could never agree on clothes', and nobody laughed.'

By 1976, along with bands like Television and The Ramones, Blondie signed for an album. The album showcased a whole American inheritance — B-movies, science fiction, soap opera romance, and schoolgirl agonies — set to great pop tunes. It was readymade cult material, just as Debbie was a readymade cult heroine.

Then Iggy Pop asked the band to support his comeback tour, on which David Bowie also participated as a back-up musician. The combination of Blondie's pop and Pop's hard rock proved successful. Says Debbie, 'I think it's probably really different working with Iggy and Bowie and working with just Iggy. Bowie was the brains on that tour. He was the *boss*.'

Shortly afterwards, a modest audience caught Blondie supporting Television at the Hammersmith Odeon, and were wowed by the band's idiosyncrasy and energy. The commercial word spread even more quickly, and the group were bought out of their first contract for an impressive sum by Chrysalis Records. The photogenic Debbie soon became the most photographed face in rock since David Bowie — and it became necessary to stress Blondie's unity as a group. The pressures of this swift rise led to several changes of personnel, but after a second album (*Plastic Letters*) and two Top Ten singles, the band seems settled as a team of six. With Debbie on vocals, Chris Stein on lead guitar, Frank Infanti on support guitar, Nigel Harrison on bass, Clem Burke on drums, and Jimmy Destri on keyboards, Blondie have completed their third album, *Parallel Lines*.

Deborah Harry now has the apple slice of American Pie — a regular income from a job her parents can approve of, a fashionably healthy devotion to yoga, and a fiancé. (After five years together, she and Chris Stein recently announced their engagement.) All the members of Blondie consider their involvement in rock and roll 'a family thing'. Debbie explains that *Parallel Lines* has to do with the connections the band has sensed between themselves and on all their travels — connections between all those for whom rock and roll is 'a way of life'.

Blondie will be appearing at Hammersmith Odeon, London, September 9th.

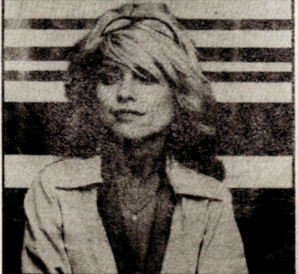

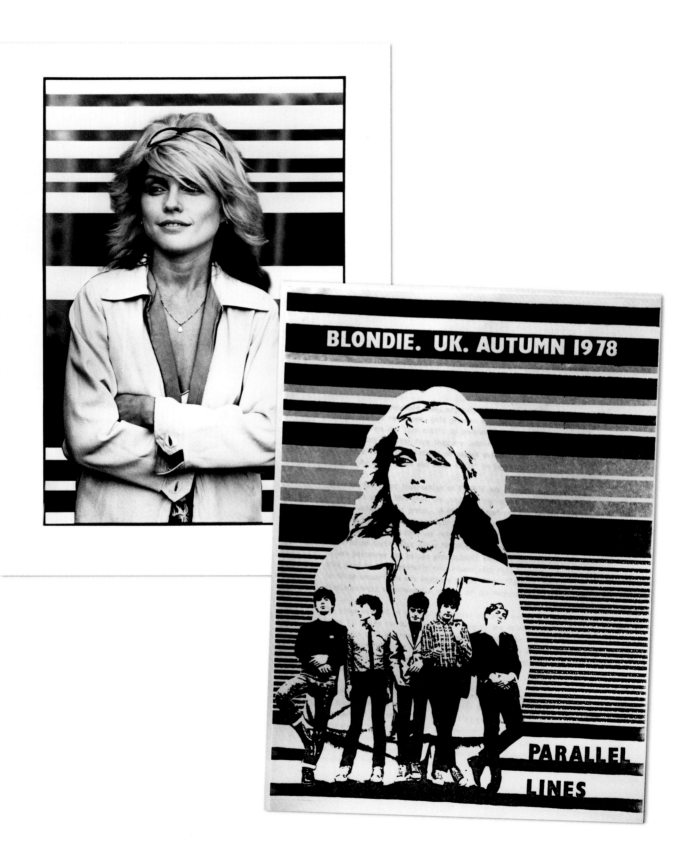

11. PICTURE CAPTIONS

pp.2–3 Debbie Harry reflected in her dressing table mirror at the Gramercy Park Hotel.

p.4 Polaroid of myself photographed in front of one of the *Telegraph Sunday Magazine* fly posters in London.

pp.6–7 [left] Blondie 'Parallel Lines' picture disc. [right] *Best Of Blondie* album cover.

p.8 Debbie Harry at the Copacabana club, New York.

p.11 View of the jet engines of the Boeing 747, taken from my seat en route to New York.

p.12 My first taxi ride in New York, May 1978.

p.13 Self-portrait with a Nikon FE camera, used on my assignments in 1978.

p.14 Debbie Harry on the 6 August 1978 cover of the *Telegraph Sunday Magazine*.

p.15 Debbie Harry on a TV in my room at the Gramercy Park Hotel.

p.17 'Welcome Back Blondie' banner on The Palladium theatre, prior to the evening gig.

pp.18–19 Searchlight at show time outside The Palladium.

pp. 20–21, 23, 28–29, 33–35 Debbie Harry on The Palladium theatre stage at the home coming gig.

pp.22, 24–25 Blondie on The Palladium theatre stage at the home coming gig.

pp.26–27 Multi-prism lens image of Debbie Harry at The Palladium.

pp.30–31 Multi-prism lens image of Blondie at The Palladium.

p.32 Robert Gordon and Link Ray opening act at The Palladium.

pp.36–37 Multi-prism lens image of Blondie at The Palladium.

p.38 Debbie Harry with her parents at The Palladium party.

p.39 [left to right] Jimmy Destri, Nigel Harrison, Clem Burke, Debbie Harry, Terry Ellis, Peter Leeds, Mr & Mrs Harry.

pp.40–41 [left to right] Jimmy Destri, Clem Burke, Debbie Harry, Terry Ellis, David Johansen of the New York Dolls and Peter Leeds, Blondie's manager.

pp.42–43 New York post-gig loft party, Andy Warhol and friends.

pp.44–45 Post-gig party, Andy Warhol meets Dave Edmunds.

p.47 Polaroid snap of Debbie Harry and myself, post-shoot at the Record Plant.

p.48 Polaroid of myself on the roof terrace of the Gramercy Park Hotel.

p.49 [left] Humphrey Bogart model I bought in a comic shop on my second shoot in New York. [right] Beverley, my now wife, relaxing after one of the roof-top photo sessions.

p.50 Ms Harry and yours truly discuss the photo session.

p.51 Entry to the Empire State Building.

pp.52–53 Debbie Harry at the Copacabana press reception party.

pp.54–55 Debbie Harry and friends at the Copacabana press reception.

pp.56–57 Blondie receiving a gold disc for 'Plastic Letters' at the Copacabana club. [left to right] Chris Stein, unknown record executive, Clem Burke and Debbie Harry.

pp.60–65 Gregor Schumi styling Debbie's hair for the *Telegraph Sunday Magazine* photoshoot at the Gramercy Park Hotel.

pp.66–67 Debbie's reaction to the finished hairstyle.

pp.68–69 Chris Stein waits as Ms Harry has her hair styled.

pp.70–71 Pre-photoshoot [left to right] Chris Stein, Debbie Harry, Stephen Sprouse and unknown tech friend.

p.72 Chris Stein with tech friend.

p.73 Steven Sprouse and Debbie Harry in a Gramercy Park Hotel suite.

p.74 Nigel Harrison with a six-stringed Fender Stratocaster.

p.75 Debbie Harry in her hotel suite sitting room, turned into my studio for the photo session.

pp.76–77 Debbie Harry behind my camera after the portrait shoot.

pp.78–79 The Lick. The image that became the *Parallel Lines* picture disc. (Note the image was used the wrong way around on the record.)

pp.80–81 Hotel studio portrait.

p.82 The published original colour 35mm transparency.

p.83 Debbie with the white-label LP that she kissed for the photo session.

p.84 Debbie in the cocktail bar at the Gramercy Park Hotel.

p.85 The original colour transparency from the Gramercy Park Hotel cocktail bar shoot.

pp.86–87 Debbie Harry on the roof of the Gramercy Park Hotel, rain threatening.

p.89 Debbie shopping in the street around Union Square, New York.

pp.90–91 [left to right] Nigel Harrison, Debbie Harry and Chris Stein in midtown New York.

p.92 Twin Towers of the World Trade Centre in New York.

p.93–95 Debbie Harry in Gramercy Park.

pp.96–97 Debbie and New York cab.

p.98 Clem Burke and Debbie on a midtown New York street.

p.99 Debbie Harry in New York.

pp.100–101 Debbie Harry with Nick Lowe, Gramercy Park, New York.

p.102 Debbie and Chris in red.

p.103 New York cab.

p.104 Polaroid print of myself shooting *The Best of Blondie* photograph on the roof of the Record Plant, New York.

pp.106–107 Contact sheet of Debbie recording vocals for the *Parallel Lines* album at the Record Plant studios.

pp.108–109 Debbie Harry photoshoot on the Record Plant roof.

pp.110–11 Frank Infante on the Record Plant roof.

p.112 Frank, Debbie and Chris on the Record Plant rooftop.

p.113 Debbie Harry.

pp.114–15 Clem Burke on the Record Plant roof.

p.116 Clem Burke.

pp.117–19 Frank Infante on the Record Plant roof with typical New York water tower.

p.120 Frank, Debbie and Chris.

p.121 Debbie's reaction to yet another photoshoot.

pp.122–123 Debbie Harry with my Nikon FE camera on a Gitzo tripod.

pp.124–125 Nigel Harrison at a parking lot near the recording studio.

pp.126–27 Nigel Harrison.

p.128 Jimmy Destri chatting to locals.

p.129 Frank Infante.

p.130 Jimmy Destri.

p.131 Frank Infante.

pp.132–37 Photographs from *The Best of Blondie* photo session on the roof of the Record Plant.

pp.139–51 Debbie recording vocals at the Record Plant.

p.153 Frank and Chris on the tour bus to Philadelphia.

pp.154–55 Clem Burke relaxes on the tour bus heading south.

p.156 My wife Beverley on the tour bus.

p.157 Chris Stein on the tour bus.

pp.158–59 Debbie getting psyched up for the gig in Philly.

p.160 Frank Infante on the bus.

p.161 Jimmy Destri on the bus.

pp.162–63 Frank and Nigel on the tour bus.

p.164 Chris reading the *New York Post* on the tour bus.

p.165 Debbie with Chris. Time for a sleep.

p.166 Record producer Mike Chapman and friend.

p.167 Clem Burke and friend on the tour bus.

pp.168–71 Entering the Spectrum Arena in Philadelphia.

pp.172–173 Jimmy Destri checking his keyboards back stage at the Spectrum.

p.174 Frank Infante and Chris Stein warming up before opening the Alice Cooper gig.

p.175 Jimmy Destri.

pp.176–77 Chris and Debbie in the green room at the Spectrum.

p.178 Backstage at the Spectrum Arena. Chris Stein and friend.

p.179 Mike Chapman.

pp.180–81 Back stage before the Blondie set [left to right] young fan, Jimmy Destri, Nigel Harrison, friend of band, Debbie Harry, Chris Stein.

pp.182–85 Debbie Harry meeting Alice Cooper's snake in the green room at the Spectrum Arena.

pp.186–87 Debbie deep in thought before going on stage.

pp.188–89, 191–93 Debbie on stage in Philadelphia in the zebra dress.

pp.194–95 Debbie backstage at the Spectrum.

pp.196–198 Chris Stein.

p.199 Debbie Harry.

p.200 Chris Stein and Jimmy Destri on the tour bus back to New York.

p.201 The band board the tour bus back to New York.

p.204 The original press handout print for my photo exhibition 'Blondie In Camera' at the Mirandy Gallery, London, 1978.

p.205 The invitation to the London exhibition in 1978.

pp.206–11 Fans outside the Mirandy Gallery, London on 14 August 1978.

pp.212–13 Debbie and Frank entering the Mirandy Gallery.

p.214 Debbie and myself in the gallery.

p.215 Debbie Harry entering the Mirandy Gallery.

pp.216–17 CEO of Chrysalis Records Chris Wright opens the exhibition with his presentation of a Silver Disc to Blondie.

p.218 Fans trying to get a look at the band at the exhibition opening.

p.219 Chris Stein with fans looking in behind him.

pp.220–23 Photo call of Debbie Harry among life-size cut-outs for the press photographers.

pp.224–25 Debbie in the gallery shop.

pp.226–27 The band departs among the fans outside the gallery.

© 2025 Martyn Goddard
World copyright reserved

ISBN: 978 1 78884 314 0

The right of Martyn Goddard to be identified as author of this work has been asserted by him in accordance with the Copyright, Designs and Patents Act 1988

All rights reserved. No part of this publication may be reproduced, stored in a retrieval system, or transmitted in any form or by any means electronic, mechanical, photocopying, recording or otherwise, without the prior permission of the publisher

A CIP catalogue record for this book is available from the British Library

The author and publisher gratefully acknowledge the permission granted to reproduce the copyright material in this book. Every effort has been made to trace copyright holders and to obtain their permission for the use of copyright material. The publisher apologises for any errors or omissions in the text and would be grateful if notified of any corrections that should be incorporated in future reprints or editions of this book.

Senior editor: Alice Bowden
Designer: Mariona Vilarós
Colour Separation: Corban Wilkin

EU GPSR Authorised Representative:
Easy Access System Europe Oü, 16879218
Address: Mustamäe tee 50, 10621 Tallinn, Estonia
Email: gpsr@easproject.com Tel: +358 40 500 3575

Printed in China by C&C Offset Printing Co. Ltd.
for ACC Art Books Ltd., Woodbridge, Suffolk, UK

www.accartbooks.com